SAN FRANCISCO STYLE

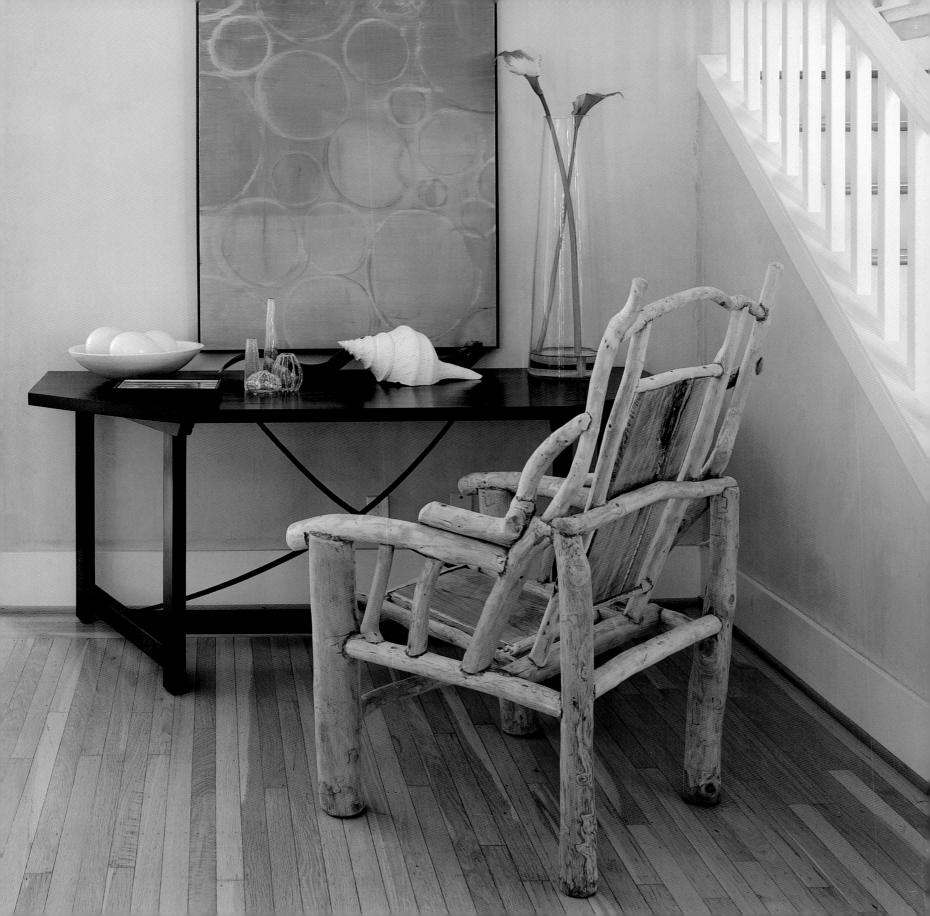

SAN FRANCISCO STYLE

Design, Decor, and Architecture

By DIANE DORRANS SAEKS

Photographs by
David Duncan Livingston

CHRONICLE BOOKS
SAN FRANCISCO

Necnun Audacia Felix

— Diane Dorrans Saeks

Text copyright © 2004 by Diane Dorrans Saeks.

Photographs copyright © 2004 by David Duncan Livingston, unless otherwise specified. Photograph p. 81 copyright © 2004 by Christopher Flach. Image provided courtesy of Christopher Flach.

Library of Congress Cataloging-in-Publication Data:
Saeks, Diane Dorrans.
 San Francisco Style: design, decor, and architecture/
by Diane Dorrans Saeks; photographs by David Duncan Livingston.
 p. cm.
Includes index.
 ISBN 0-8118-4043-3 (hc)
1. Interior decoration—California—San Francisco—History—
20th century. 2. Interior architecture—California—San Francisco—
History—20th century. I. Title.
 NK2004.S246 2004
 747'.09794'61—dc22

Manufactured in Hong Kong.

Design: Madeleine Corson Design, San Francisco

Distributed in Canada by Raincoast Books
9050 Shaughnessy Street
Vancouver, British Columbia C V6P 6E5

10 9 8 7 6 5 4 3 2 1

Chronicle Books LLC
85 Second Street
San Francisco, California 94105
www.chroniclebooks.com

SEA BEAUTY *(Page 2)* In Kate McIntyre's Sausalito house, a painting by Brad Huntzinger, an Oly table, and a handcrafted Balinese chair.

CONTENTS

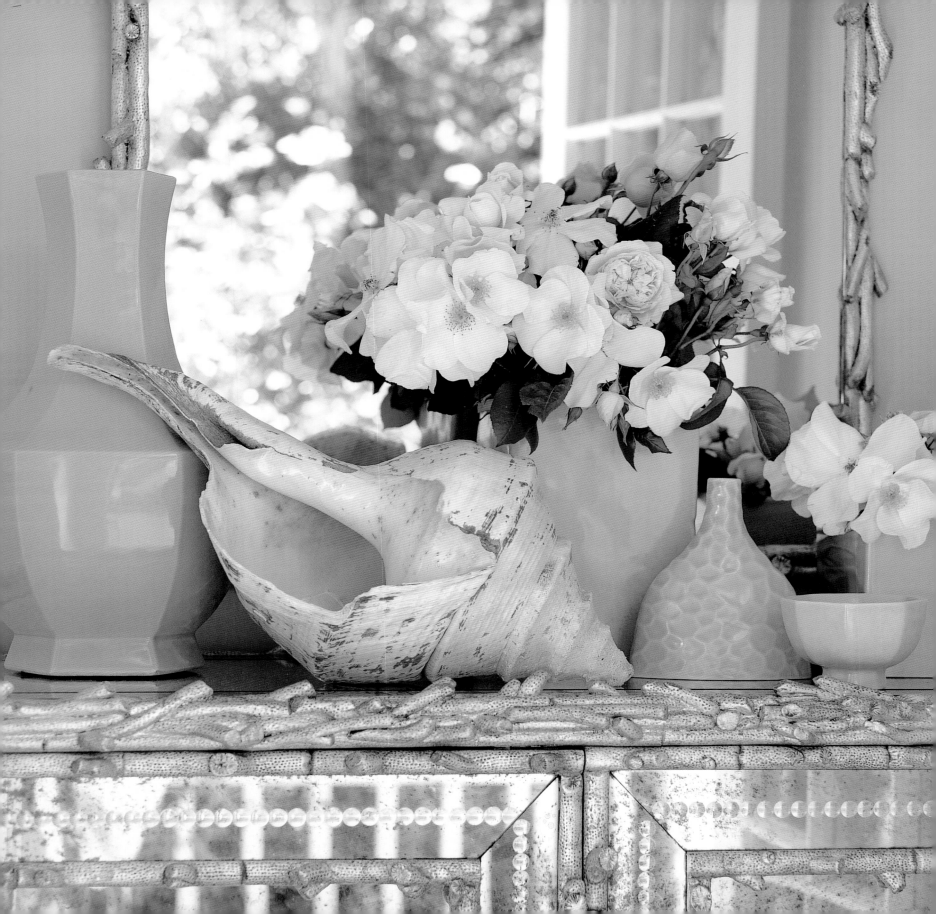

INTRODUCTION

BY DIANE DORRANS SAEKS

CLOSE YOUR EYES AND THINK OF SAN FRANCISCO HOUSES. MYTHS AND LEGENDS FLASH LIKE QUICK-FLICKS AND LIVELY GHOSTS. RAINBOW-COLORED VICTORIANS, HILL-PERCHED MODERNIST BOXES, SUN-STRUCK HOUSEBOATS, GILDED PACIFIC HEIGHTS MANSIONS, NORTH BEACH PADS, AND BRICK-WALLED HIGH-TECH LOFTS FLY INTO FRAME.

San Francisco houses of the popular imagination are the residential equivalent of a poem by Lawrence Ferlinghetti, with free expression for the first verse, poignant and thoughtful reveries on life for a rhyming couplet or two, a dash of nostalgia and wit, a splash of irreverence, and a charming conclusion. Yes, that was then, this is now.

The hazy-daisy Summer of Love and psychedelic tie-dyed lives of the Haight Ashbury have faded, like a dream. Artistic souls of today are likely to be designing elegant interiors, crafting chic furniture, and working as decorative artists as well as practicing zazen and saving the planet. A South of Market loft forgoes hard edge to be dressed with Russian Empire chairs, rare Japanese porcelains, or an Italian terra-cotta bust of Hercules. And for those who prefer bay views from Sausalito, Belvedere, or the Oakland hills, a small cottage with luscious collections and capacious chairs makes life splendid.

San Franciscans meditate on the gray-green waters of San Francisco Bay and on wisps of white fog billowing around the Golden Gate Bridge. Geography is destiny.

Conservative, history-revering San Francisco (yes, San Francisco) is like the free-thinking college student who fled to France to study life, literature, art, and architecture, returned with

CARVED CORAL AND CELADON
(Opposite) Kate McIntyre bids a Sausalito welcome to friends with Oly ceramics, garden roses, a silvered buffet of carved "coral" wood, and antiqued mirror doors. The buffet and silvered mirror are by Ironies.

THE CHIEF BENEFIT OF THE HOUSE IS THAT IT SHELTERS DAYDREAMING.
THE HOUSE SHELTERS THE DREAMER, THE HOUSE ALLOWS ONE TO DREAM
IN PEACE. THE HOUSE IS ONE OF THE GREATEST POWERS OF INTEGRATION
FOR THE THOUGHTS, MEMORIES, AND DREAMS OF MANKIND.

—Gaston Bachelard, *The Poetics of Space*

a head full of European history, and set out to live those centuries of gilt and mirrors in California. Other Californians insist that interior design and architecture must perfectly reflect its time—just as jazz and modern dance, video art and trip-hop sprang from the moment and move the culture forward.

The weight of city codes, which view Victorians as the vernacular, still prescribe architectural styles, limiting forever the experimentation and bravado that give Los Angeles its chaotic geometry, hill-defying engineering stunts, and generations of blockbuster architecture. Vertiginous streets give San Francisco residents a quirky sense of permanence and enhance their sense of otherness, all to the lowing of foghorns. With European architectural history to fall back on, personal style, individuality, and dream-fulfillment become the driving forces for some of the most interesting interiors.

A San Francisco hillside house pays homage to classic contemporary Italian design—and the art of crafting the perfect surfboard. A young artist paints dreamy, timeless landscapes in a Hayes Valley apartment. A revered designer gathers the antiques of his Scandinavian childhood closely around him. In Pacific Heights, a young architect and her husband collect art of their generation. Paris flea markets, Milan furniture fairs, and Asian crafts all inspire.

It's a deft balancing act surviving on earthquake fault lines, but Californians are used to living on the edge. Dwelling in paradise requires a certain bravado. Sausalito clambers over pine-shaded hillsides, embraced in permanent springtime. San Francisco keeps flashlights and water in storage for the earthquake that seldom comes.

The coastal highway winds through the fog. Just beyond San Francisco the land is unbuilt, protected forever for hiking, communing with nature. A state of grace, indeed. 🏵

CONTINENTAL DIVIDE *(Opposite)* For Anthony Hail and Charles Posey, pleasure includes a pair of Louis XVI (late) chairs with smooth leather cushions, blanc de chine, centuries-old carpets, orchids, and creamy walls with original watercolors —and sunshine.

CLASSICS

L'armoire est pleine de linge
Il y a même des rayons de lune que je peux déplier.

THE WARDROBE IS FULL OF LINENS
THERE ARE EVEN MOONBEAMS WHICH I CAN UNFOLD.

—

André Breton
Revolver aux cheveux blancs

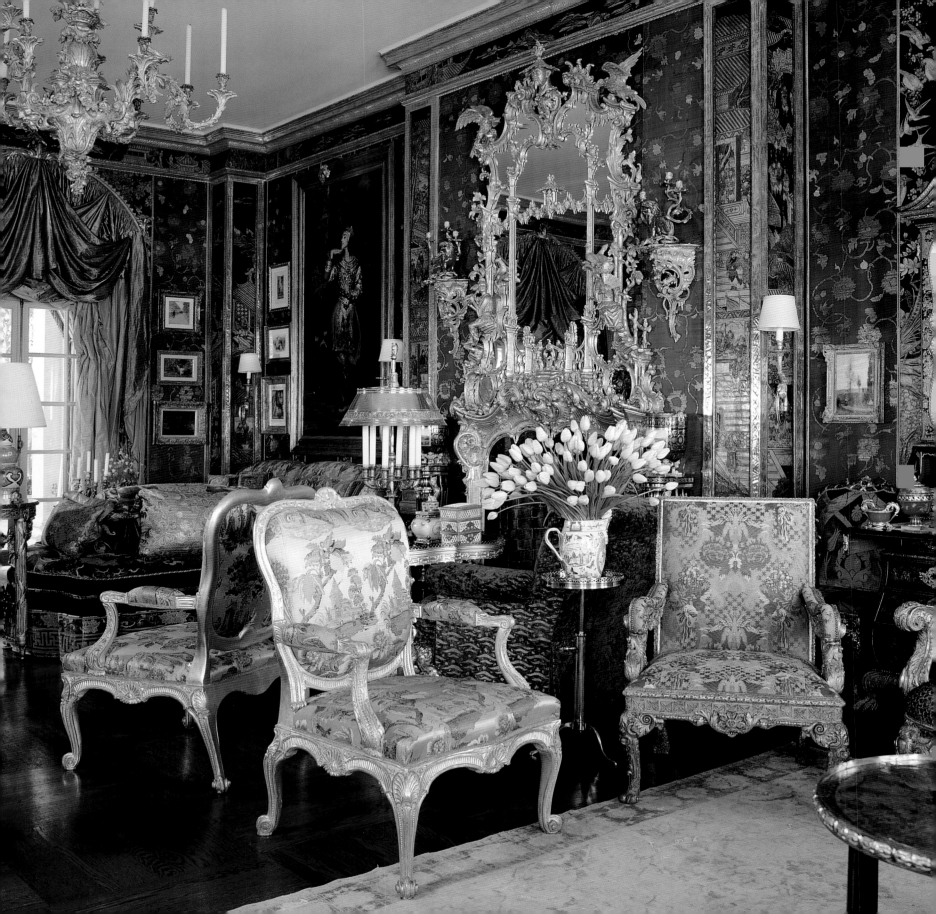

PROVENANCE AND PASSION

ANN & GORDON GETTY IN PACIFIC HEIGHTS

With a passion for fine historically accurate interior design and a backup team of artists, gilders, carvers, textile specialists, a curator, and specialist designers, Ann Getty has spent more than fifteen years orchestrating, designing, polishing, and perfecting the interiors of her family's sumptuous residence.

Swooping down on rare and stately English antiques, following international auctions, finding an exquisite mother-of-pearl—inlaid Moroccan bed and Indian palanquins, and selecting every gilded frame, chair, faded antique carpet, and handcrafted overmantel, she developed a deep erudition of the inner workings of decor. In 2003 she founded her own interior design firm, Ann Getty & Associates.

Later, with her muses and husband, Gordon, cheering her on, the glamorous Getty launched her new fifty-piece Ann Getty House furniture collection with a cocktail party at the San Francisco Design Center. A paleoanthropologist of note, Ann Getty is also an obsessed, hands-on designer. She worked until midnight before her company debut sewing cushions and arranging her furniture designs in elegant and richly detailed vignettes. She had the scrapes and scratches to prove it.

"Yes, just look at my fingers," laughed Getty, waving her injured digits at the cheek-to-chic opening. "There was stitching to be done to the cushions, and I had to do it."

Battle scars notwithstanding, Getty greeted fans warmly and acted as a knowledgeable curator for her stylish silk-swagged room at Shears & Window. She described in detail the Anglo-Indian painted chairs, gilt Louis XV side chairs, and water-gilded Georgian side chairs in her collection.

On display in the showroom, which duplicates the grandeur and recherché taste of Ann and Gordon Getty's San Francisco residence, were museum-worthy Getty family originals (a ravishing eighteenth-century tortoiseshell bookcase, gold leaf—lavished mirrors) as well as replicas of her favorite antiques from her own collection.

TAPESTRIES AND GUSTAVIAN RIGOR *(Pages 10–11)* The grand foyer of Anthony Hail's townhouse, with a view to his living room.

A TRIBUTE TO CRAFTSMANSHIP AND CONNOISSEURSHIP *(Opposite)* Ann and Gordon Getty brought together a lifetime's collection of museum-worthy furniture and paintings in their living room, which sparks and shimmers with gilding, carving, silken antique textiles, and a new overmantel. Chairs include a pair of early-eighteenth-century giltwood armchairs designed by John Vardy for Spencer House, London, early George III carved giltwood armchairs, and a George II giltwood chair from the collection of David Garrick. The chair seats and backs are upholstered with of-the-period silk brocades. The French Imperial silver-gilt library table lamp, center, by Martin-Guillaume Biennais, Paris, 1809–1819, is adorned with applied arms of Napoleon's mother. The hand-carved giltwood over-mantel and fireplace surround was created by Agrell and Thorpe, Mill Valley, California, 1996. Among artists represented in the room are Jacques Emile Blanche, Camille Pissarro, Gustav Moreau, Odilon Redon, and Giovanni Tiepolo.

Getty's designs are noteworthy for their originality, bold character, sensuous layering, and superb craftsmanship. But before the replicas, before the design firm, she spent decades devoted to international art and antiques study, as well as harrowing trips into remote corners of China, India, Ethiopia, and Egypt to study ceramics, carving, antique textiles, and archaeology.

From the drawing rooms of the great houses of England, Getty gathered George II gilded chairs, and in London and Paris she scooped up seventeenth-century brocades, patched eighteenth-century hand-woven silks, and discovered ormolu-mounted porcelain figures of the rarest order. Her rooms, with antique fabrics and carved panels patterning the walls, Coromandel screen–inspired moldings, and a multitude of small-scale Impressionist paintings, portraits and gilded console tables, are opulent settings for an afternoon tête-à-tête overlooking the Palace of Fine Arts and a theatrical stage for glamorous civic and family balls.

The Gettys' Pacific Heights house was built in 1906 to a classic design by architect Willis Polk, and it gracefully offers a grand foyer and entry hall, an interior courtyard, and gracious, hospitable rooms, where the Gettys, generous philanthropists, entertain.

After her four boys left home, Ann Getty began a large-scale redecoration of the house, which had originally been designed by Sister Parish. Today the rooms glow with baroque splendor. Birds and butterflies painted on antique silk panels glimmer on the walls of a bedroom. An antique tortoiseshell box and Syrian/Turkish painted wall panels seduce in a guest room. A Sevres porcelain table made for Napoleon (its mate is installed in Buckingham Palace), elaborate gilded benches and tables from Spencer House and Badminton, a silk-upholstered glass Anglo-Indian chair with the look of carved crystal, Impressionist paintings, and chinoiserie walls all offer delight.

"I love the heft and boldness and guts of English antiques," said Getty, who is also a jewelry designer, a champion of art education, and an avid collector.

"I was fortunate to find a pair of eighteenth-century chairs and a dramatic carved and gilded console table from Ditchley, Winston Churchill's country residence," she said. "I think of the carver working two hundred years or so ago. It's the craftsmanship and vision and sheer beauty I admire."

In the meantime, Getty's schedule includes designing decor for a dozen clients, making trips to Rajasthan and Burma to find antique textiles and decorative carvings, supervising a retinue of craftspeople, and working on a collection of modern designs under the Ann Getty Home label. The multitalented Ann Getty is more than up to the challenge. ☞

GLOW OF GOLD *(Above)* The musical clock on the George II table is by John Mottram, London, c. 1795. The Japanese Arita porcelain leaping carp potpourri jars are mounted on ormolu, c. 1700. The vase is Chinese celadon porcelain, late eighteenth century, with Louis XVI ormolu mounts.

PRESENCE OF ANCESTORS *(Opposite)* In the Getty dining room, a Venetian mirrored cabinet, late eighteenth century, stands on an ornate giltwood base. The cabinet was formerly in the collection of Arturo Lopez Wilshaw. Wall moldings were crafted to simulate the colors, texture, and details of a Coromandel screen. On the gilt sconces are a series of Qianlong (1735–1795) Chinese porcelain figures, including court ladies, famille rose candleholders, and a pair of Chinese porcelain figures of women holding trophies of good fortune, from the collection of Consuelo Vanderbilt. The *verre eglomisé* reverse-painted mirrored walls were created by Frances Binnington, San Francisco.

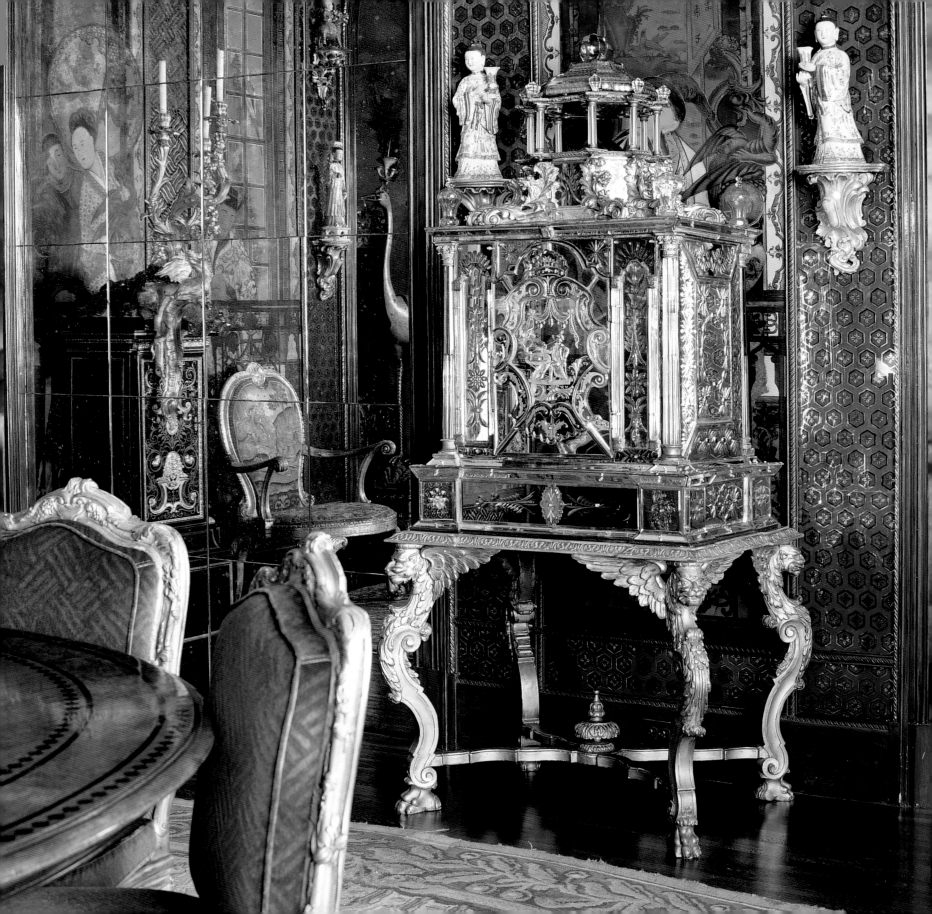

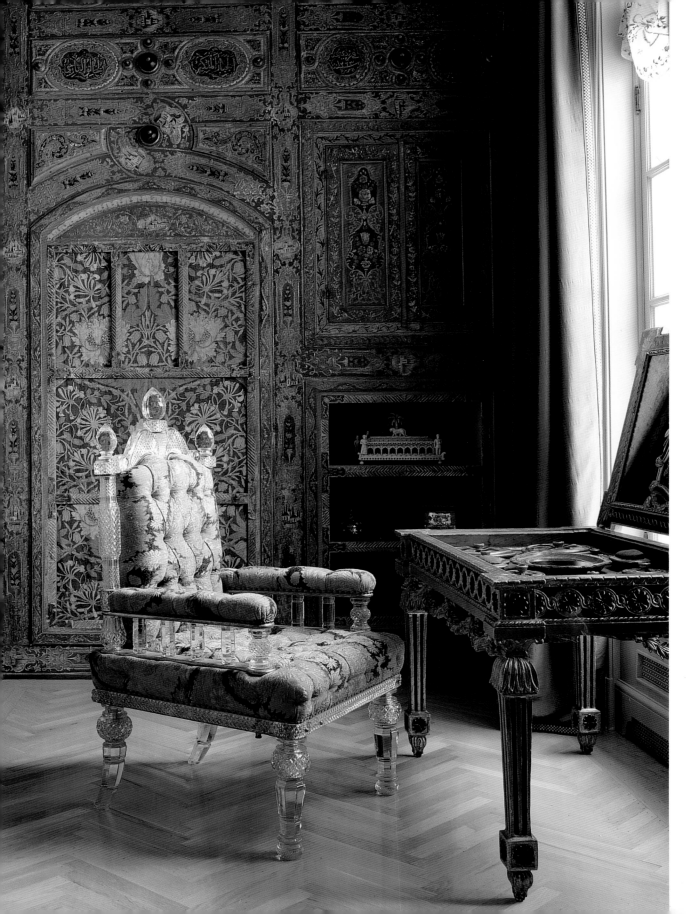

TIME AND MEMORY (*Opposite and right*) Ann Getty acquired the handpainted, gilded, and semiprecious stone–ornamented Syro-Turkish paneled room (c. eighteenth-century) in London and turned it into a fantasy bedroom and dressing room for guests. On the floor of the bedroom is a rare Bessarabian tapestry-woven carpet, c. 1890. The rooms are a treasure chest of exotica: an early George II gesso and water-gilded table, c. 1730, along with a Turkish scribe's table (on floor), a nineteenth-century Egyptian coffee table of sandalwood inlaid with arabesques of bone, Tiffany Favrile glass lamps, a brass-footed eighteenth-century Indian painted palanquin (used as a daybed), and eighteenth-century Ottoman textiles. The mother-of-pearl and wood inlaid bed design is based on a throne at the Topkapi Palace in Istanbul. For further delight: a late-seventeenth-century Indian ivory and sheesham wood cabinet on a George I cabriole-leg fruitwood stand, paintings by Delacroix, Anglo-Indian eighteenth-century engraved ivory side chairs, and exquisite embroidered textiles. The cut-glass crystal throne chair by F. & C. Osler, with a crested back surmounted by three faceted bright-cut finials, was crafted in Birmingham, England, in 1894. The neoclassic green glass and mirror-inset dressing table c. 1800, right, from the John Hobbs collection, was from the Villa Manin di Passariano de Codroipo (Udine), the largest and most extravagant villa in the Veneto.

TO DELIGHT THE EYE AND TOUCH (*Pages 18–19*) In a seating group in the bedroom, a late George II giltwood armchair (1740) carved with stylized leaves is upholstered with French "bizarre" woven silk with eccentric floral motifs. The cabinet was made for a Medici pope. The Palais Royal ormolu and mother-of-pearl inkwell is French, c. 1820. The c. 1770 painted and gilded bed was designed by Thomas Chippendale for Harewood House. The mahogany gueridon is German, c. 1800. Among the artists represented in this very personal collection are Balthus, Henri de Toulouse-Lautrec, Edgar Degas, and Mary Cassatt.

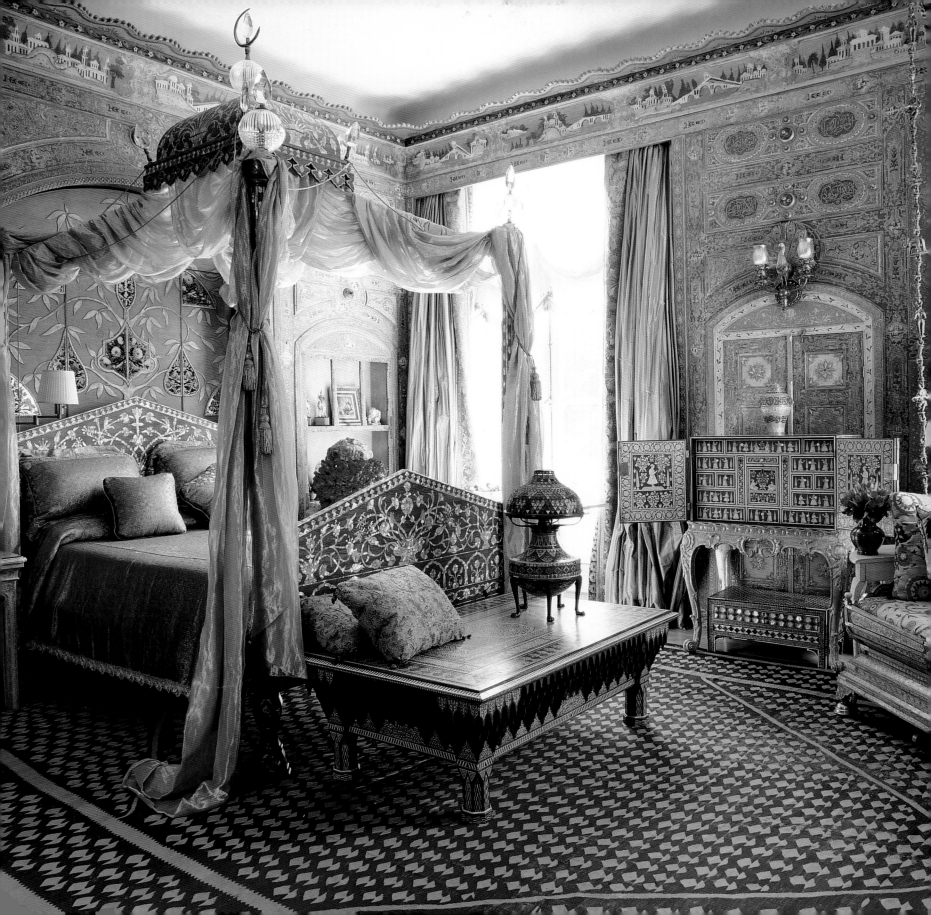

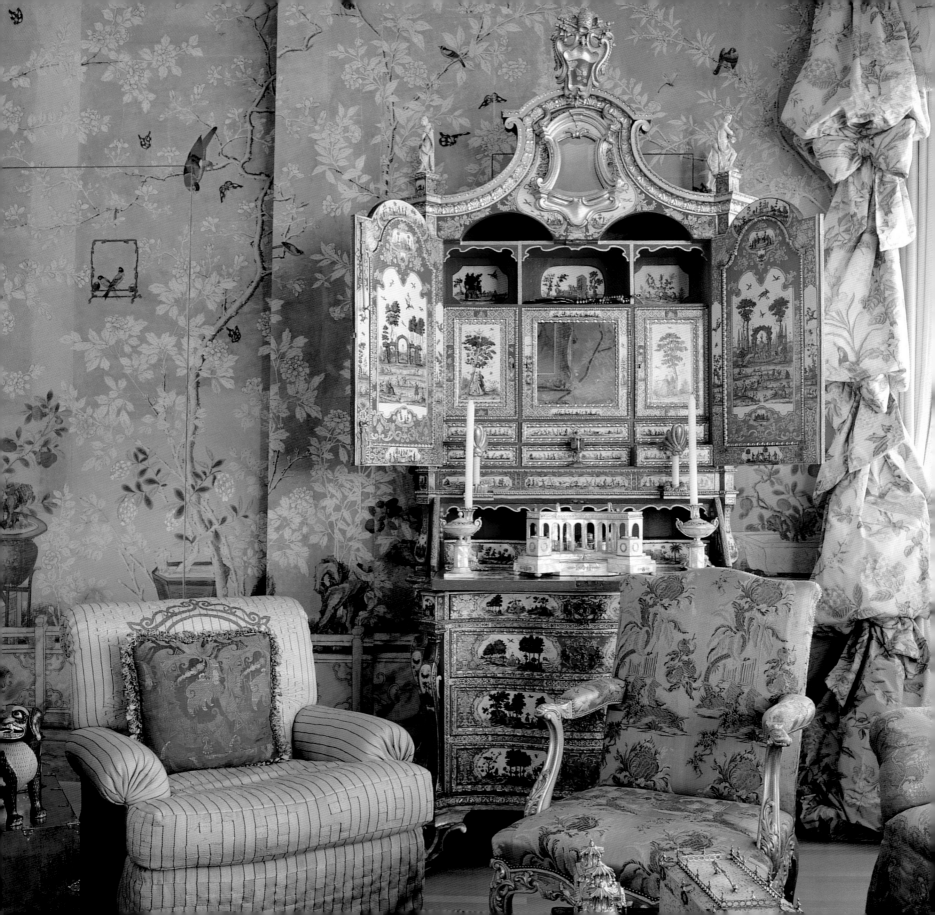

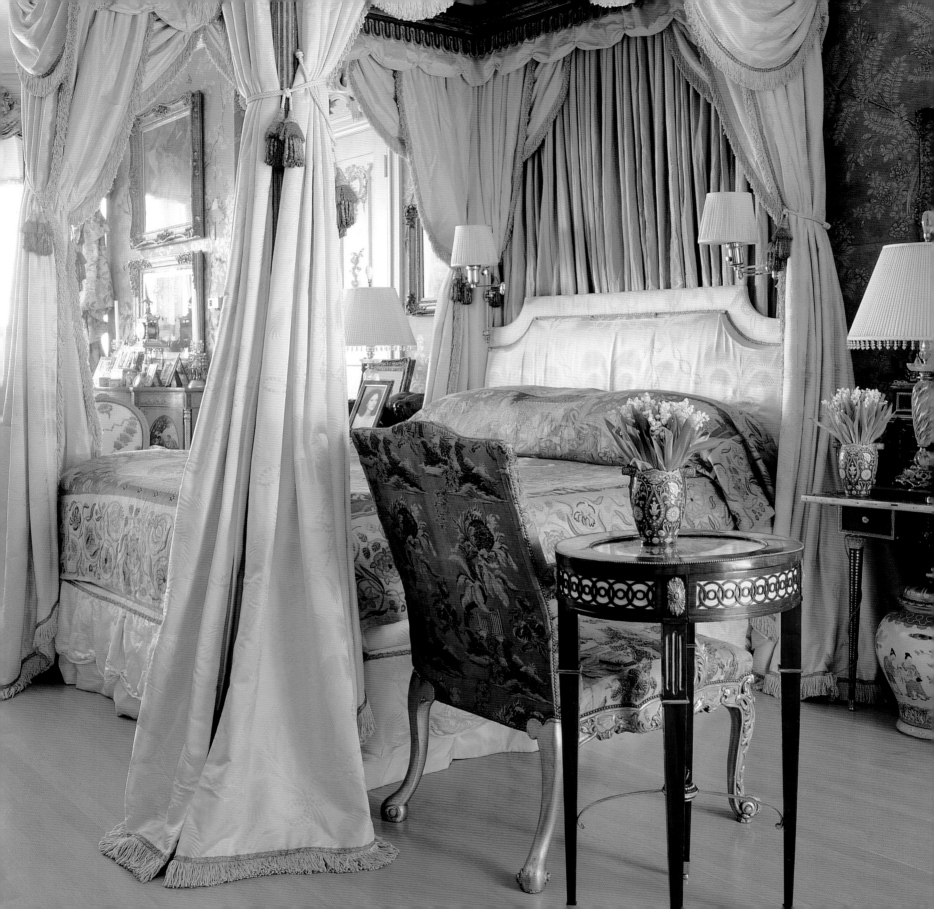

The GRAND Gesture

ANTHONY HAIL & CHARLES POSEY IN PACIFIC HEIGHTS

San Francisco interior designer Anthony Hail, who recently retired after a highly distinguished fifty-year career working for the crème-de-la-crème of society in San Francisco and in New York, always made a point of custom designing rooms specifically for each client. He never had a "look" or a "signature" that he applied to each new commission.

"I disdain the concept of instant decorating or theme design," said Hail, who lives in a handsome residence in San Francisco, surrounded by the antiques, objets, and art of a lifetime. "I never like a house to look decorated. It should appear to have happened over time. Interiors should look fresh, not too opulent, with meticulous workmanship, impeccable provenance, rich silks and linen, nothing fussy."

Hail, who studied architecture at Harvard under Walter Gropius, modestly gives all the credit for his long career span and his loyal clientele to good timing.

"I arrived in San Francisco in 1955, a golden time," said Hail, who initially worked on projects with New York designer Billy Baldwin, a mentor. "Soon after I arrived, I started work for Mrs. Henry Carter Russell, then for Whitney Warren, and two years later, Eleanor de Guigne, a woman of great taste and style, found me and she single-handedly made my career."

Hail said that his childhood spent in Denmark (he was born in Tennessee) first got him interested in—passionate about—interior design.

"I lived in a handsome manor house and was surrounded by the most beautiful country houses in the world, impeccably run," said the fastidious Hail.

One favorite was Valdemar Slott, a seventeenth-century baroque castle near Troense in the southern Funen archipelago of Denmark. This country house by the sea includes a romantic tea pavilion near the water. Still privately owned by the Juel family, it's now open to the public. It's opulent, with twelve glittering crystal chandeliers in the entry hall. Much of the furniture is Louis XVI.

THE PAST IS PRESENT *(Opposite)* A quartet of Louis XVI chairs is placed in comfortable proximity to the antique French marble fireplace. Hail's carpets include a late-nineteenth-century Karabagh from the Caucasus and a pair of sixteenth-century Ispahans. "I love the signs of centuries of wear," said Hail. Late-eighteenth-century French bronze *doré* candlesticks were found in London. A pair of bronze ibises on the mantel is eighteenth-dynasty Egyptian. An eighteenth-century Swedish neoclassical pendulum clock by Blomberg stands on the mantel beneath a Louis XVI *trumeau* mirror. The low table is a late-sixteenth-century Chinese ceremonial table with mother-of-pearl and ivory inlay. The draperies are of Randolph & Hein silk.

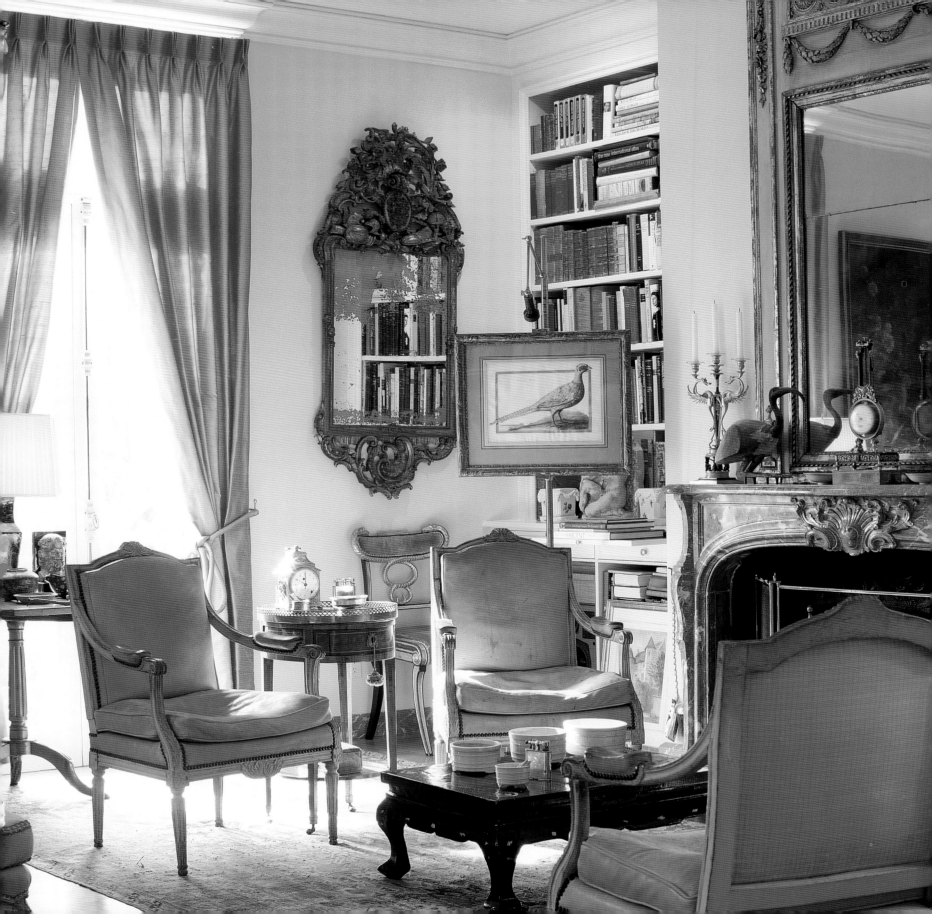

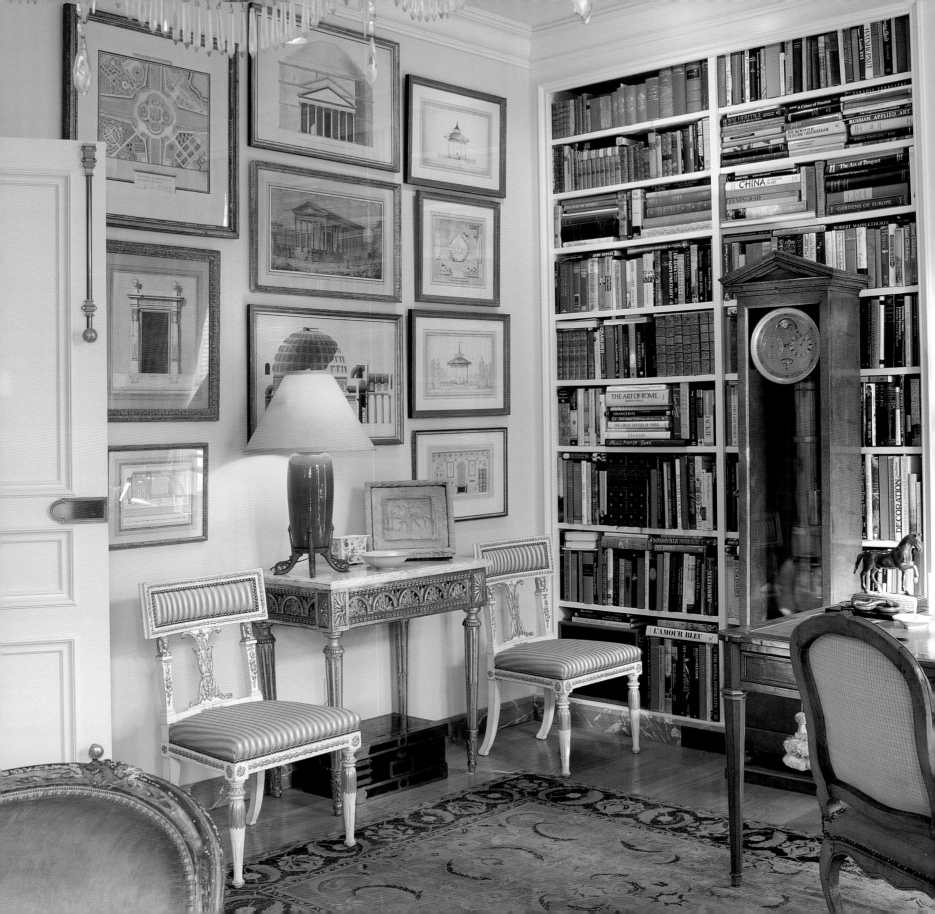

The influence of Denmark on Hail's design concepts cannot be overstated.

"Taasinge Island, a small remote island off Fyn Island in Denmark, where all the grander country houses are located, is a must for anyone interested in design and design history," said Hail. "Hvidkilde was my favorite house, in a privileged location overlooking the sea. The furniture was from my favorite period, late, late eighteenth century, and all very pure, understated, classical, and beautiful. The perfectly balanced interiors of these manor houses and castles have always been my design icons, my ideal."

The family moved to France, where his design education continued.

"We lived in a townhouse just near the gates of Versailles for a magical time when I was a boy. It was the best education. I played in the King's *potager,* and ran in Le Nôtre's gardens, saw all of the palace interiors."

In Paris, he feasted his eyes on historic interiors.

"The Hotel Lambert is still one of the most beautiful, historic private residences in Paris, overlooking the Seine," he commented. "The staircases and rooms are all superbly proportioned, gracious, and very formal. The sumptuous seventeenth-century architecture is by Louis le Vau, who designed Versailles and worked on the Louvre."

Hail traveled and created interiors for clients in Paris, London, New York, Boston, Charleston, and Los Angeles, and he worked for many years with Mr. and Mrs. James Garner in Santa Barbara.

"I know how to make an attractive background for a refined and comfortable and sociable life," he said.

A gracious life and elegant decor were intertwined for Hail.

"My interiors don't rely on pattern or bold color or opulence for effect. I always hold back a little," said Hail. "I like rooms that feel rich, but that sense of luxury is created by things like superbly detailed draperies, impeccable upholstery, leather with the patina of age, the best old Oriental rugs, bookcases full of books and albums with wonderful bindings, antique Chinese porcelain collections, beautiful light."

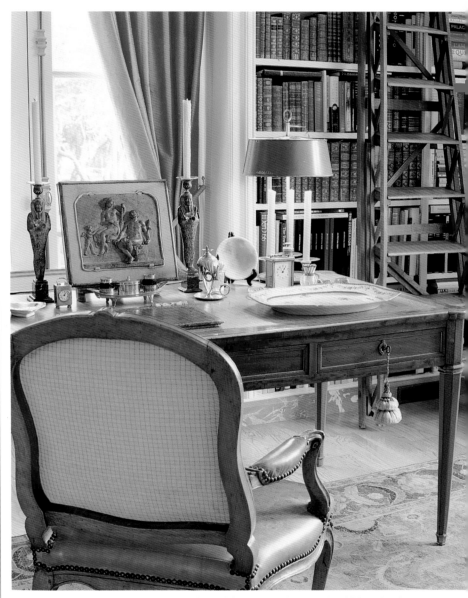

A LOVE OF BOOKS *(Above and opposite)* The desk of designer Anthony Hail. A lifelong book collector, he has walls of books on art, design, antiques, biographical histories, architecture, history, Denmark, and porcelains, many of them signed. On his desk, overlooking clipped sycamore trees, are rare French porcelains, a Bouillotte lamp, bronze figures, and Danish silver.

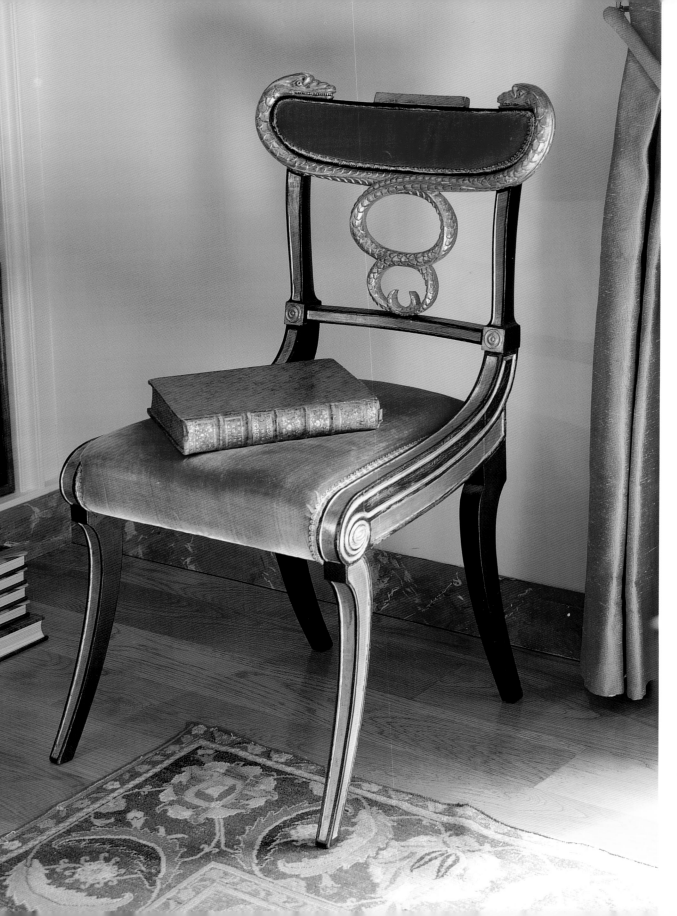

SCARLET CHAIR *(Left)* The gilded Regency chair is rather a change of pace for Hail. About these chairs he said, "They're brightly gilded and ornate and vulgar, and I really love them."

WALK LIKE AN EGYPTIAN *(Opposite, above left)* An eighteenth-dynasty ibis figure in bronze and carved wood represents Thoth, a god of wisdom. The neoclassical candelabrum in bronze *doré* is French.

NEVER JADED *(Opposite, above right and below left)* Hail, who grew up in Denmark and later in France, has a special fondness for Chinese porcelains and jades, which he has collected most of his life. He prefers simpler, classical shapes and unadorned materials. On a Louis XVI Amboyna wood table with a gray marble top, Hail has gathered a head of Bacchus, Chinese spinach jade, an archaic alligator, an Egyptian serpent, and black lamps, a pair acquired from Billy Baldwin. On a similar marble-topped table, Hail placed agate bowls, a Maria Conway bas relief, a Roman marble panther, and some jade ceremonial objects.

BLANC DE CHINE *(Opposite, below right)* Chinese porcelains, which represent more than fifty years of collecting, are arrayed on a Swedish commode in the dining room/foyer.

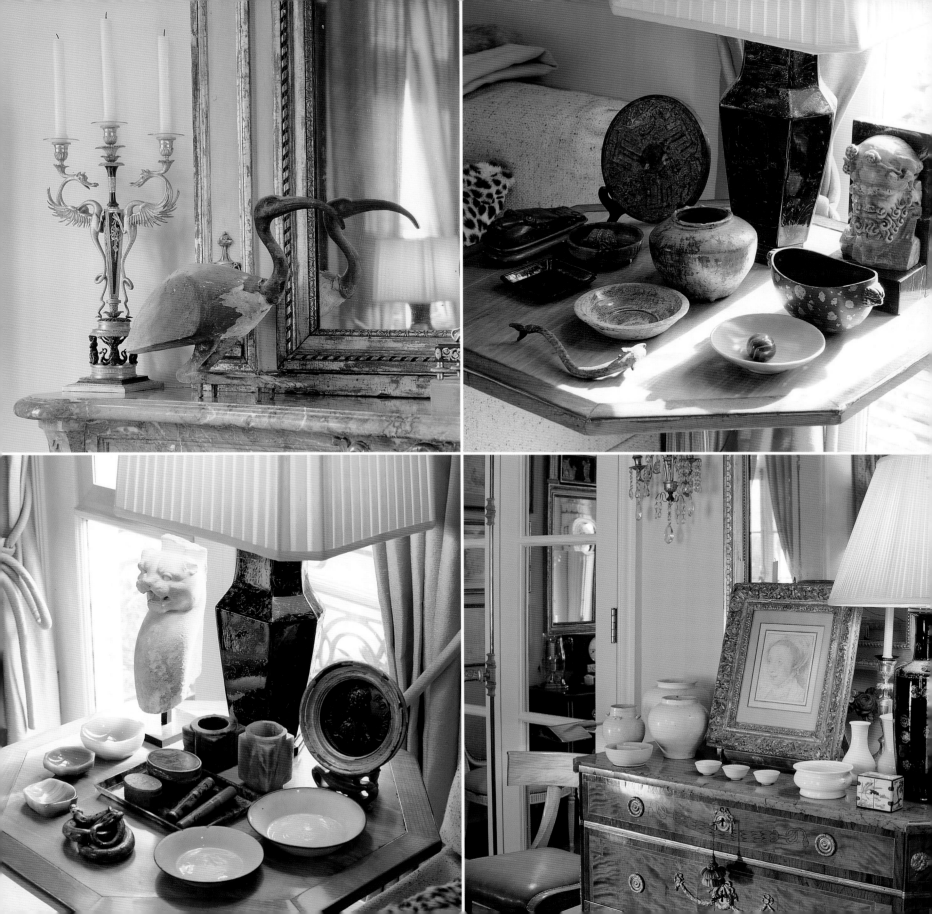

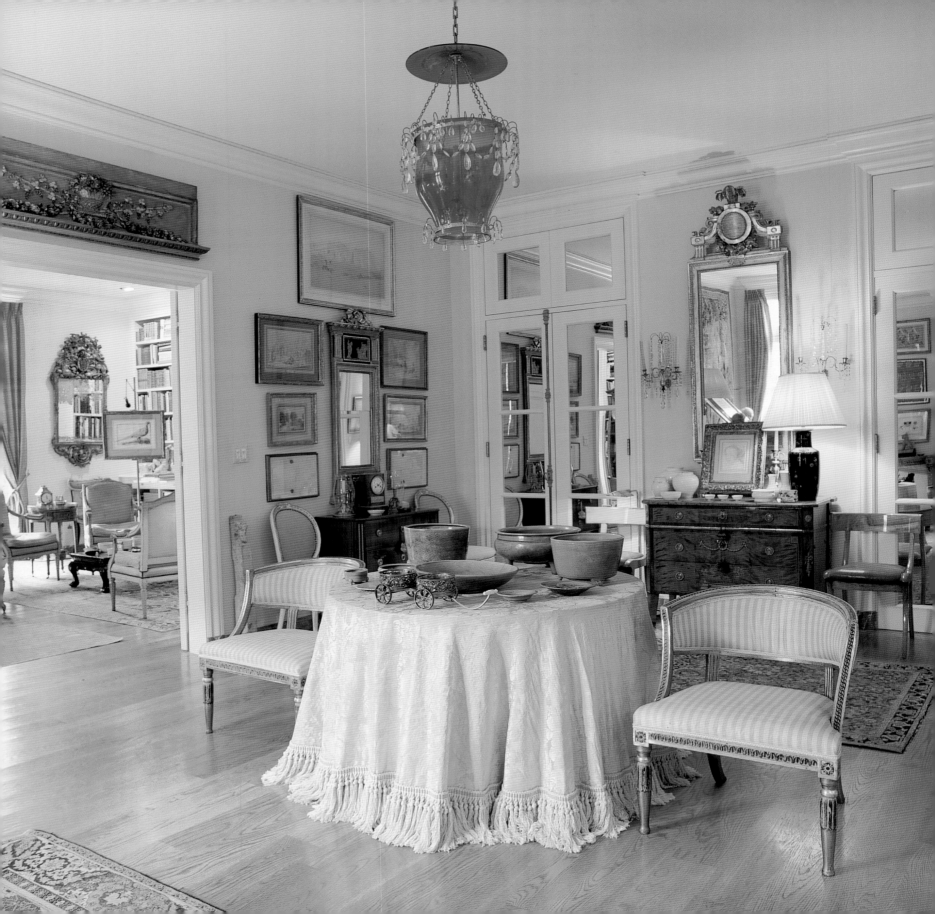

San Francisco interior designer Michael Tedrick, a longtime friend of Hail's, admires the breadth of knowledge Hail brings to every aspect of design.

"Tony has extraordinary knowledge of antiques, rare books, porcelain, art, the decorative arts, and textiles from every hemisphere, every epoch," said Tedrick. "He simply has seen the best antiques. He grew up with them and has a remarkable eye. And he knows how to make interiors look effortless."

One valuable design concept he learned from Hail, said Tedrick, was to base color schemes and color relationships on the hues of eighteenth-century Chinese porcelains.

"The colors are rich, surprising, and extremely well balanced," noted Tedrick.

Hail was in and out of fine houses at a charmed moment, when clients had access to the finest antiques plus staff to smooth and maintain their lives, said his partner of thirty-nine years, Charles Posey. The design process in those years was never rushed.

"Life was slower, home owners paid attention to detail, and Tony was able to perfect those rooms over time," Tedrick noted. "His living rooms were always brilliant, and his relationships between elements in a room was genius."

Hail treasures his lifelong connections with Scandinavia.

"Denmark and Sweden offered the best possible design education, and I am still totally in love with Scandinavian antiques," said Hail, whose town house has museum-worthy Scandinavian antiques in every room. "Danish and Swedish interiors are distinguished by a wonderful purity of line and a restraint in detail. Their 'less is more' approach was a great lesson to me. It has informed all of my work."

"Scandinavian antiques have been my lifelong obsession," he said. "My albums are full of images of Danish and Swedish antiques. The craftsmanship is superb. It has an edge. It's not pompous or gilded or rococo like French or Italian antiques. I love fine French antiques, but I love the charm, understatement, and unexpected character of Danish and Swedish more." ☞

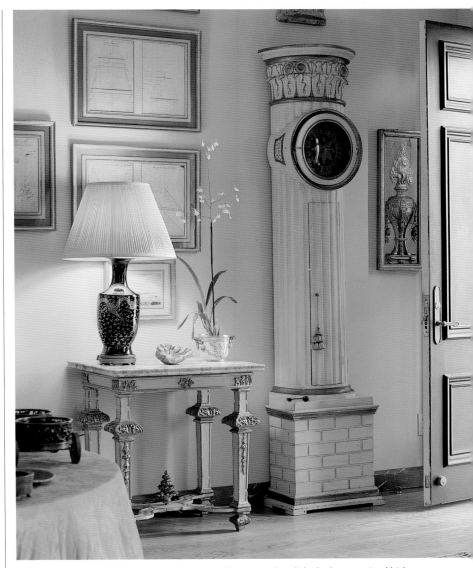

HAIL AND FAREWELL *(Above)* A painted eighteenth-century Swedish clock greets (and bids adieu to) guests at the Hail and Posey residence. Hail's collection of architectural drawings, prints, etchings, and renderings (first acquired when he studied at Harvard) cover most walls. The marble-topped table is eighteenth-century Swedish.

THE RAPTURE OF COLLECTING *(Opposite)* Hail and Posey at one time intended to use their foyer as a dining room, with the round center table as the scene of the action. However, their passionate collecting took over and the table is seldom set for dining. The foyer is decorated as splendidly as is their living room, with Swedish Klismos-style chairs, etchings, walls of books, and Russian crystal wall sconces.

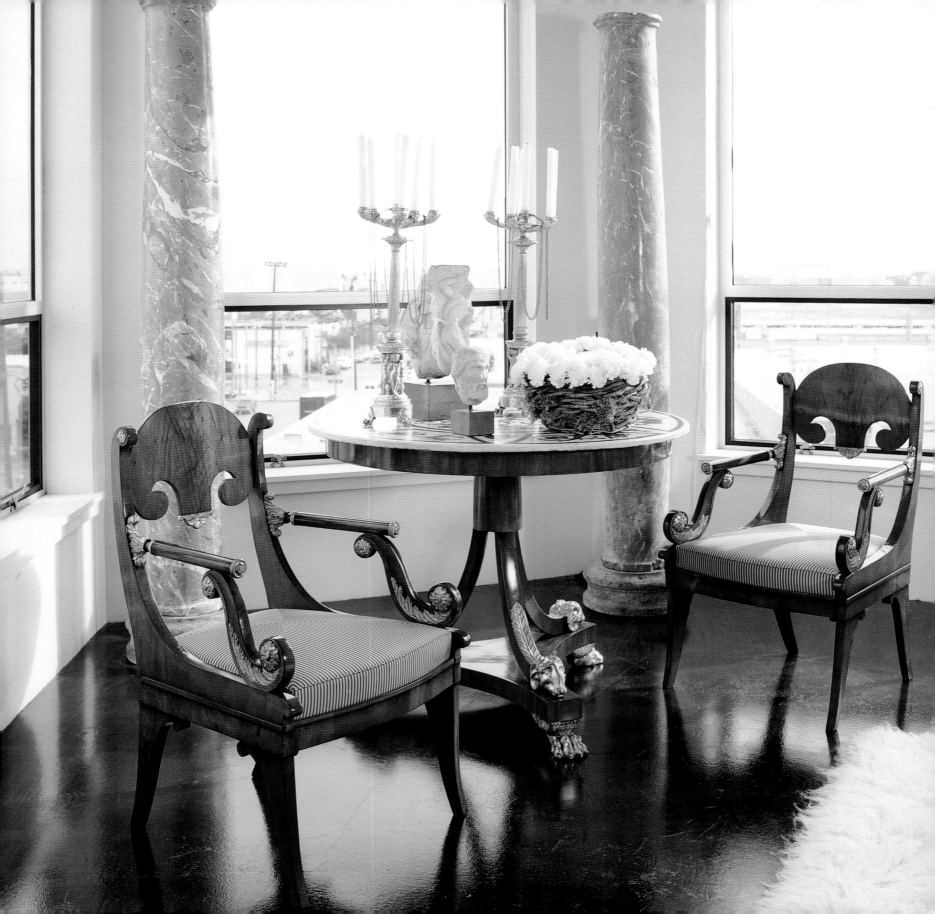

LOFTY PURSUITS

ROBERT ROY GARCIA IN HIS SOUTH OF MARKET LOFT

R obert Garcia leads a charmed life. He may not think so as he catches yet another flight to Stockholm, Japan, or London in the middle of winter, but living in San Francisco and keeping an apartment on the most beautiful hillside in Lisbon can more than make up for dark and gloomy northern nights.

Bob Garcia is a leading antiques dealer, a partner with Therien & Co.—a highly respected antiques company with galleries in Los Angeles and San Francisco—and a non-stop traveler. At least once a month he sets off to find rare eighteenth-century Portuguese carved benches, luscious marble-topped Piedmontese tables, Chinese chairs, and breath-taking Swedish neoclassical gilded chairs, Gustavian tables, and Russian chandeliers.

Faced with such splendor, Garcia needed a quiet escape for his returns to California from an endless round of frosty auction houses and hush-hush antiques salons.

He found it in an unlikely neighborhood, far from the sleek Therien & Co. antiques gallery and the glossy lives of his illustrious clients. Garcia's refuge is in a neighborhood with a busy freeway interchange, pot-holed streets, and few pedestrians. So workaday is it that it has no particular designation other than Dogpatch.

To the east, Garcia can watch cargo vessels floating in the misty shipping lanes of San Francisco Bay. To the north, a motley collection of rough-hewn industrial buildings, mechanics' shops, warehouses, a bakery, smokestacks, a cement plant, silver silos, and truck stops swim into view.

"When it's really sunny, every building silhouette and wall and metal roof seems intensi-fied, and the whole view becomes more graphic and immediate," said Garcia. "It's so much more interesting than a fancy neighborhood with nice hedges and pretty houses. Here it is not gentrified; it's a true industrial area with just a few live/work lofts dotted among the fac-tories. I feel so relaxed in this loft. With the door closed I hear no one. I can be gone for a month, and I never have to worry about whether my garden may have suffered from neglect or my neighbor has chopped down a tree. And I'm within ten minutes of the airport."

NOBLE PROVENANCE *(Opposite)* **A pair of circa-1820 Russian Empire mahogany chairs stand beside a ramshead Italian Empire table with a scagliola top. A pair of French Empire candelabra are next to two Roman marble fragments. "You won't see heavy chests and grand chairs in my loft," said Garcia. "Then it would get too serious and thought out. I don't want to lose the modern edge."**

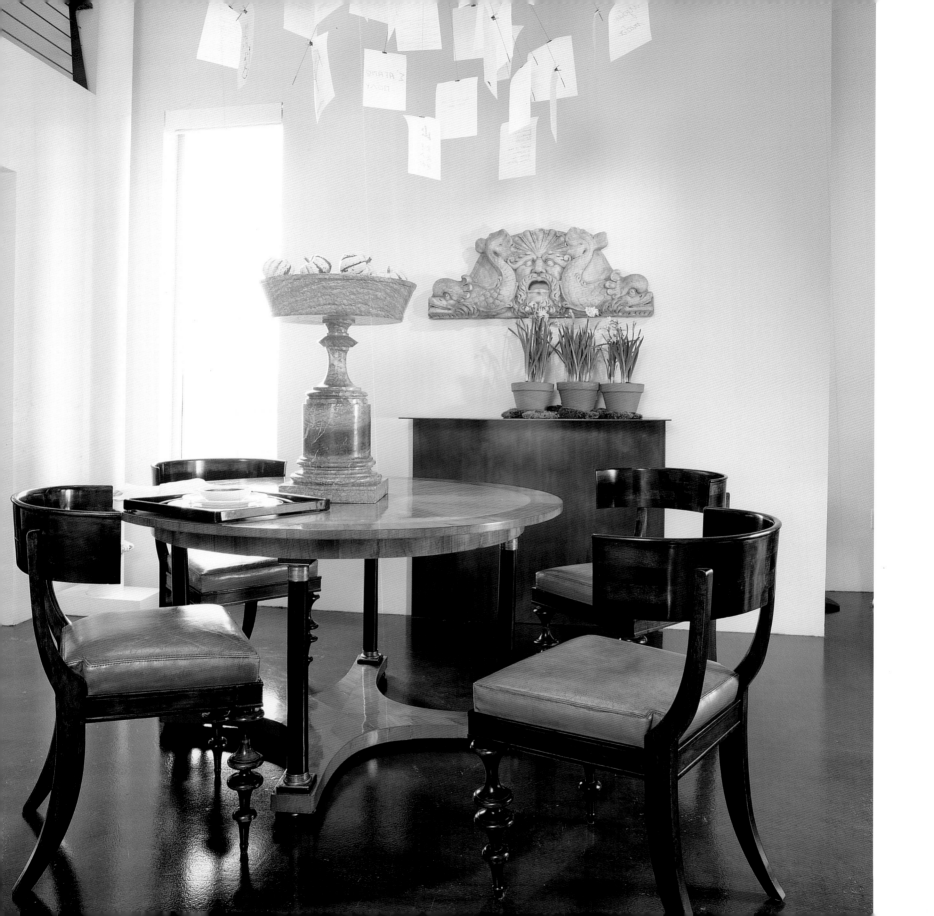

Garcia found his loft by chance.

"I had been looking in this area, and I saw the construction and concrete foundations were in place," said Garcia. "I could see already that the quality would be high."

He placed his deposit on a sunny corner loft with twenty-foot ceilings, a private entry, and tons of privacy. The fifteen-hundred-square-foot loft has twelve-foot-tall windows to the east and north and light on three sides.

After two years, he has turned it into the polished ideal of city living. The windows are shaded with refined raw silk shades.

"When I go industrial, I only go so far," laughed Garcia. "This building was just a basic volume when I acquired it, a space that was all promise and no detail. I've added antique architectural elements like free-standing columns, fig trees in overscale wood planters. I did not want to gussy up the loft architecture or add a pastiche to 'warm' it up."

Downstairs is a spacious living room cantilevered out over the back of the shingled building. A dining room and kitchen and study complete the enfilade downstairs. Fishtail palm trees, fig trees, and orchids flourish.

An early nineteenth-century French sepia scenic wallpaper panel showing a fantasy Italian seaport hovers above a large tufted leather sofa.

In the dining room Garcia placed an Italian Empire table, and above it floats an Ingo Maurer "chandelier" made of paper and wire.

"It would be so wrong, so pretentious, to have some grand, wacking crystal chandelier here," he said. "The lighting has to belong to the loft and not seem applied."

Upstairs are a sitting area, a bedroom, and an artful bathroom, which looks like a sleek piece of sculpture.

"I commissioned a steel craftsman to create, in a sense, a semi-invisible enclosure," said Garcia. The eight-foot-high walls of the bathroom, crafted in etched glass and stainless steel, enclose a shower, a washbasin, and bathroom storage.

Garcia has surrounded himself with some of his favorite antiques. A pair of Huang Hua Li taborets, a Chinese elm table, a noble eighteenth-century terra-cotta sculpture of Hercules in his lion skin, a pair of silver gilt Portuguese baroque candlesticks, and Chinese burlwood cupboards muscle up to French and Italian Empire chairs and tables. Waxed concrete floors are covered with Irish rush matting.

"My loft is a wonderful place to return to after days in Europe spent around eighteenth-century tradition-bound buildings," said Garcia. "Living here with my antiques among the industrial flats is like a breath of fresh air." ❧

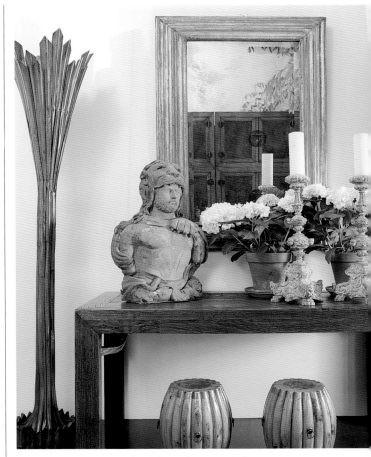

MIGHTY HERCULES *(Above)* An eighteenth-century Italian terra-cotta Hercules stands beside a palm-leaf torchère from Blackman Cruz, Los Angeles. The console table, in Chinese elmwood, frames a pair of Huang Hua Li melon taborets from Therien and Co.

FUN WITH INGO *(Opposite)* The paper "chandelier" with love letters is by Ingo Maurer. Around an Italian Empire table, Garcia circles 1820 Bertel Thorvaldsen Danish chairs based on Greek Klismos styles. The Roman *tazza* is made of *verde* marble. "Most of my pieces are early nineteenth century, with the resurgence of classicism," Garcia noted. On the wall hangs an Italian baroque marble fountainhead.

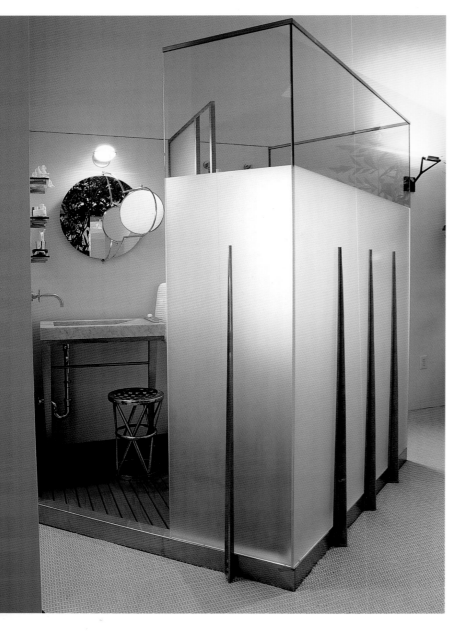

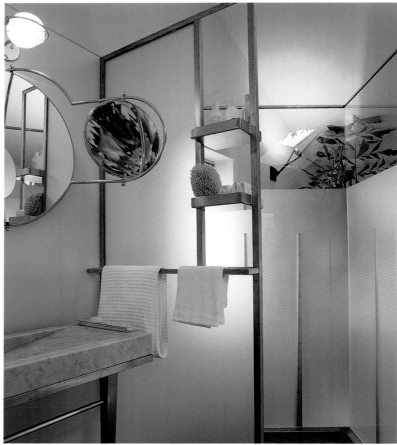

SPACE CRAFT *(Above and left)* Garcia commissioned a master metal crafter to shape the sleek, elegant bathroom in his loft. The six-by-eight-foot room, floored in teak decking, has steel ribs, an etched glass screen and Corian walls. The shipshape design includes an Italian marble counter, an Eileen Gray–designed mirror, and orbital lighting.

R & R *(Opposite)* Garcia's handsome bed, by Therien Studio, looks out from his mezzanine balcony over the living room and view below. It's screened from a sitting area/dressing room. All that Garcia requires for his deserved rest: delicious sheets, a small television screen, peace and quiet, and a good alarm clock.

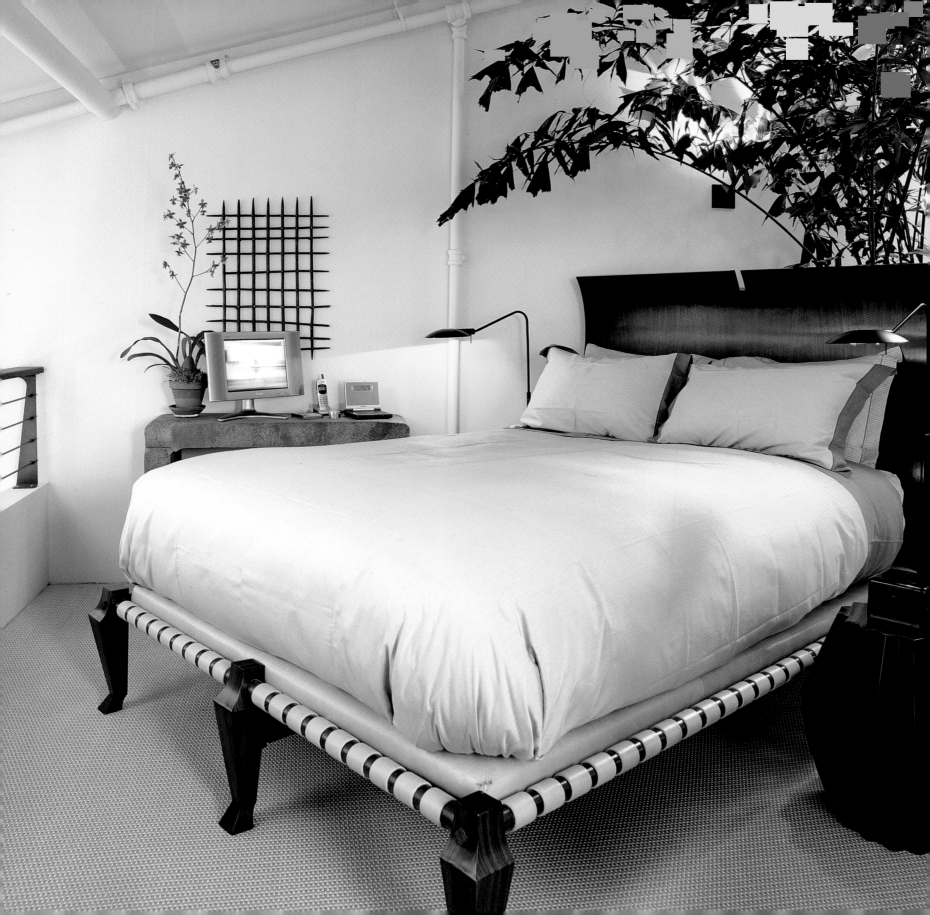

The Definition of Luxury

SHIRLEE RHINE'S APARTMENT IN PACIFIC HEIGHTS

Along the leafy streets of Pacific Heights that stretch from Lafayette Park out to the Presidio stand imposing 1920s apartment buildings with a distinctly Mediterranean air. Adorned with bold hand-wrought iron rails and lanterns, colorful handcrafted Mexican tiles, ornate iron grille front doors, and marble stairways, these stuccoed residences nevertheless have a quiet, understated air and present to the street a sunny disposition that belies their eighty-plus years.

In one of these elegant apartments, just ten minutes from downtown, lives Shirlee Rhine, a highly successful businesswoman who is the founder and owner of the 77 Maiden Lane beauty salon and spa.

Shirlee recently commissioned San Francisco interior designer Steven Volpe to redesign the spacious three-bedroom apartment in which she has lived for more than thirty years.

"Shirlee and I had been friends for years and often attended the opera or symphony together. She had been following my career, and when it came time to redecorate I was delighted she asked me to do it," said Volpe.

The project has been remarkably successful for both client and designer. The apartment, now decorated with rare Asian antiques, museum-quality French thirties and forties furniture, and a splash of contemporary paintings, possesses an air of quiet luxury and rare charm.

"It is not often that I have a client who has such great taste, who participates in the design process, and who totally gives me carte blanche," said Volpe, who is in demand for his refined decor and deep understanding of antiques.

"Shirlee's knowledge of Asian antiques and my love of French antiques came together well in this apartment," noted Volpe, who founded Steven Volpe Design in 1990. "I visualized rooms that looked like a glamorous thirties or forties Paris apartment owned by an art and antiques connoisseur."

SUBTLE SENSUALITY *(Left and opposite)* A pair of gilded forged iron chairs (one pictured), crafted by the French design company Ramsay, are fine companions to a sofa of Volpe's design covered in Henry Calvin Fabrics linen velvet. Tufted circa-1958 chairs by Ed Wormley for Dunbar (two originals, two copies) are upholstered in buff-colored boarskin. The Japanese woven and stitched Tagasode panel of silk and gold thread is early nineteenth century. The gilt-bronze and glass tables are by Ramsay, from the late 1940s. In the sunroom, a forties French iron table from Akko van Acker stands with a pair of Swedish chairs. From the window, Rhine can see the northern reaches of the San Francisco Bay.

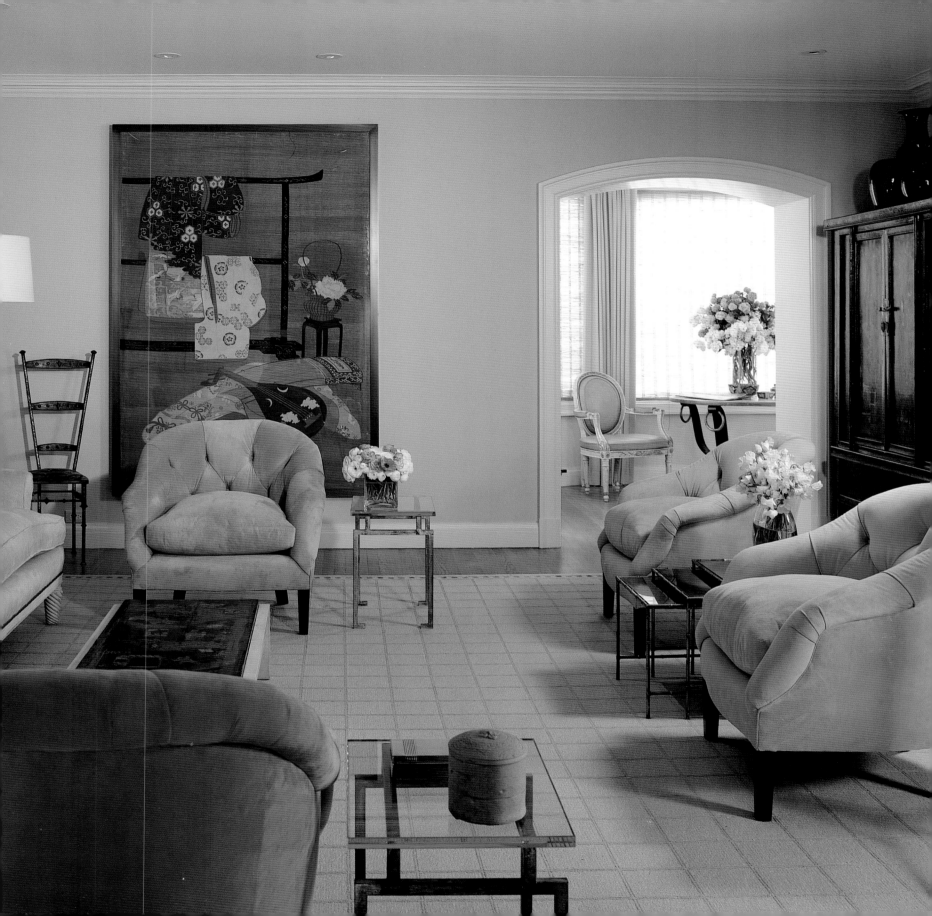

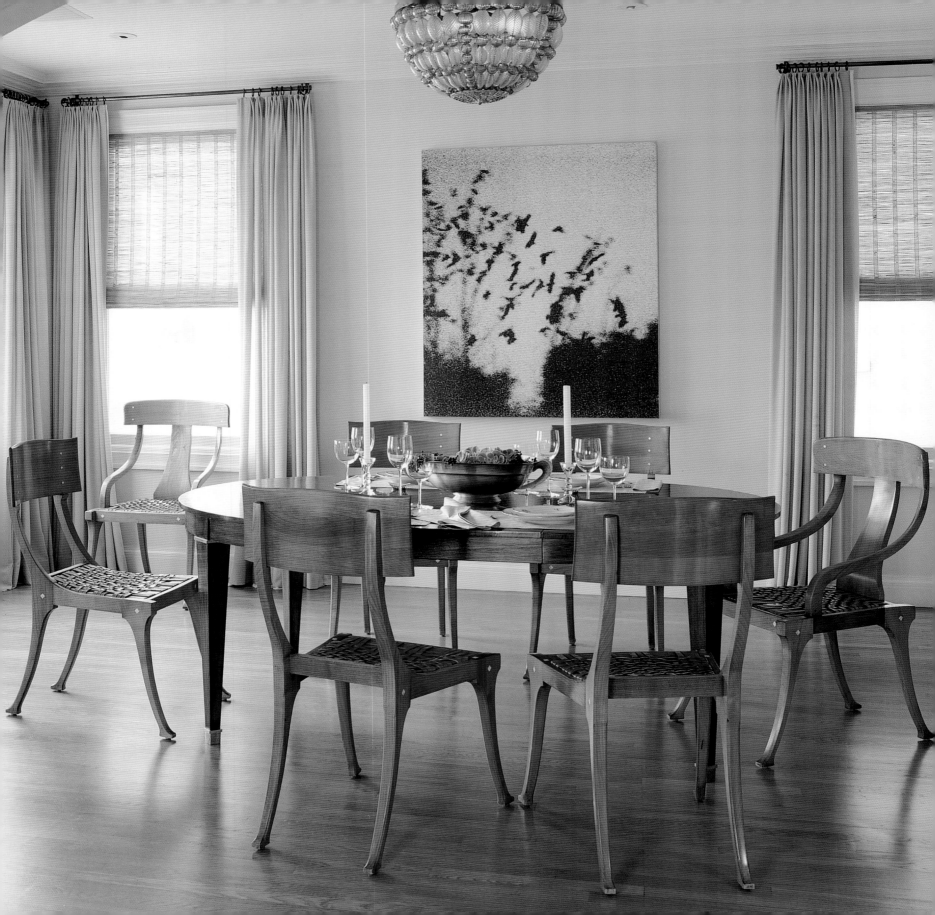

Rhine moved out for a year so that Volpe could overhaul every room.

"We didn't alter the floor plan but changed every piece of hardware, every molding, every surface, and all the lighting," noted Volpe.

The first piece the collaborators acquired was a framed eighteenth-century Japanese embroidered wall hanging depicting the accoutrements of a geisha.

"A similar silk textile is in the collection of the Metropolitan Museum of Art in New York," Volpe said. Rhine's became a starting point for the decor.

"I took most of the faded colors for the apartment—cream, ivory, caramel, buff, rust, dove gray, gold, and mustard from that hanging," said the designer. "Its colors have softened over the years, and it was a wonderful inspiration."

While Rhine cooled her heels in a nearby private hotel, Volpe went to work.

"I wanted Shirlee to have the most luxurious textiles—silks, wool challis, velvet, boarskin, silk velvet, cashmere—and the sensual textures of leather and beautiful woods," Volpe said.

A grid-patterned tonal carpet for the sitting room was crafted by V'Soske in Ireland out of silk and wool.

Volpe traveled to Paris several times and attended international antiques shows. Earlier he had passed a two-year design apprenticeship in Paris and wished to find the extraordinary furniture that would evoke the French-style rooms of his imagination.

"There was a lot of trial and error and experimentation at first," he said. "Great rooms don't happen overnight. Pieces came and went. You go through the torture of testing and searching for exactly the right pieces."

Volpe's style is the opposite of instant decorating.

"When you're creating rooms that are so simple in form and line, everything has to balance," said the designer. "The mark of a good room is that the pieces are harmonious together and no one piece vies for attention over another."

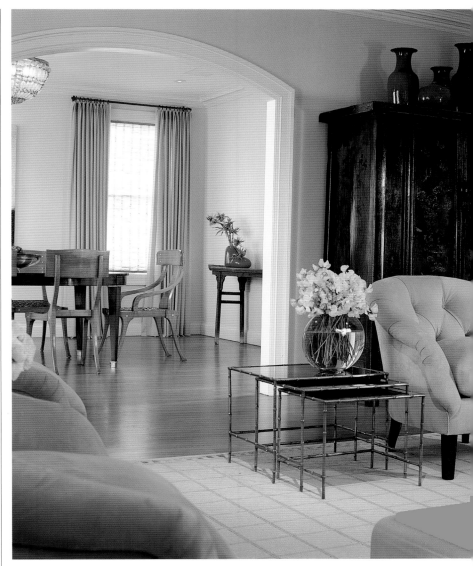

CULTURAL EXCHANGE *(Above and opposite)* Eight elmwood and ivory-inlay Klismos chairs encircle a quarter-sawn oak table with a cerused finish and brass inlay, by Steven Volpe Design. A Murano chandelier, circa 1950, in the form of a sea urchin is from Ciancimino Antiques, London. The draperies are wool challis. The rooms have views of San Francisco Bay. Volpe recently founded Hedge, with Roth Martin. The company designs and manufactures chic French forties- and thirties-inspired furniture and lighting.

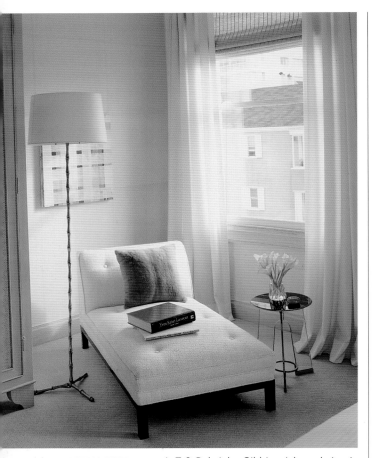

As the months passed, Volpe found a series of dramatic and quirky ivory-inlaid Klismos chairs, which were originally made in 1902 for the Villa Kerylos in Beaulieu-sur-Mer, on the Côte d'Azur. The villa was a faithful reconstruction of a Delos villa of antiquity, and the chairs followed the classic Greek Klismos silhouette.

"They were a fortunate find from Therien & Co. when the villa deaccessioned some of their furniture," Volpe noted.

Soon a Ming altar table, an imposing pair of Chinese lacquer cabinets, *sang de boeuf* porcelains, and fifties French gilded iron ladderback chairs from antiquaire Akko van Acker in Paris were juxtaposed with curvy fifties American chairs by Dunbar covered in tufted buff-colored matte-finish boarskin.

"Boarskin was used a lot in Paris in the forties," noted Volpe, an expert on that gilded and cerused design era. "It's more sumptuous than suede. I like its understated quality."

Gilded forged iron tables by Ramsay, and a pair of brass Renzo Mongiardino tables with *verre eglomisé* tops accompany the handsome (and comfortable) chairs.

The pièce de résistance of the apartment is Rhine's bedroom suite, with its subtle golden light, Paris salon furnishings, delicious fabrics, and a regal bed with a sand-colored crocodile-embossed leather headboard framed in oak. Every surface and textile here, perfect and polished under the direction of Volpe, begs to be touched. Cashmere draperies in pale ivory (protected from the sun by gauzy shades), buttery leather, silver-gilt, cerused woods, and plaster walls exude the most discreet luxury.

Beside a Robsjohn-Gibbings chaise, a 1935 Jacques Adnet black opaline glass and crystal table with brass trim shimmers like precious jewelry.

In the closets, shelves contain natural linen-covered boxes, each designated for gym apparel, T-shirts, accessories, and shoes.

"Shirlee works very hard and she deserves to be cocooned in luxury," said Volpe. "Crocodile was the ultimate choice, but it's matte and pale buff to keep it low-key and not obvious."

The improved configuration of the rooms, as well as the silken carpet and whispery cashmere, provide a sexy, silent retreat—which feels as if it could be hidden in a leafy enclave in the chic sixteenth arrondissement in Paris.

Volpe has successfully realized his dream to conjure up the French forties style. Jacques-Emile Ruhlmann would be pleased. ❧

RARE PLEASURE

A HOUSE IN KENTFIELD DESIGNED BY SUZANNE TUCKER & ARCHITECT ANDREW SKURMAN

This is a tale of a house with at least two lives. The first era began in 1932 when it was the new residence of Dr. Arthur Ritter, the Swiss-born founder of the original Ross Hospital in Marin County. Dr. Ritter acquired land for his house in Kentfield because he felt that nearby Mt. Tamalpais embodied spiritual and medicinal properties. Dr. Ritter was also a Francophile, so the house was styled after the Riviera villas dotting the shores of the Mediterranean.

Every year for more than eleven summers, the doctor headed for France and brought back antique stone fireplaces, elaborately detailed iron gates, hand-wrought metal locks and hinges, stone tiles, and rare architectural details that still adorn the house. The house became a mini–San Simeon, with its wrought-iron chandeliers, wine cellar, iron sconces, oak floors, and numerous antique artifacts.

The present life of the house began in 1999, when a woman who is an accomplished pilot, jewelry designer, and world traveler purchased the home and commissioned designer Suzanne Tucker and architect Andrew Skurman to turn it into her dream house.

"This house had such spirit, and the French influence was still apparent, but the rooms were tiny and a bit too cottage-y for true comfort and elegance," said Tucker, who worked closely with Tucker & Marks senior designer Kaidan Erwin on the project. The noble villa has a romantic turret, a terra-cotta roof, and French iron garage doors, and it's surrounded by mature redwood trees, old pines, and oaks, which frame views of Mt. Tamalpais.

"We wanted to bring the house into the twenty-first century while still retaining its character and individuality," said Tucker. But the interior was a disaster of successions of awkward remodels, odd additions, and ill-fitting cabinetry.

Tucker and Skurman's client wanted them to open up the rooms, give them a logical flow, and create entirely new decor and interior architecture.

RIVIERA REVERIE *(Opposite)* Suzanne Tucker choreographed a worldly living room, which includes a circa-1714, twelve-panel Coromandel lacquered screen from the Kang Hsi period, a Moroccan table inset with mother-of-pearl and ivory, and lamps custom designed from a pair of early-eighteenth-century Tuscan carved wood and parcel-gilt urns, found in Paris. The sofas were designed by Tucker and Marks with custom-dyed, handwoven chenille. The chair fabric is by Clarence House. The nineteenth-century Oushak carpet is from Tony Kitz Oriental Carpets, San Francisco. The grand ottoman is eighteenth-century English, with carved walnut lion's paw feet. Elisa Stancil stenciled the ceiling in an Italianate pattern.

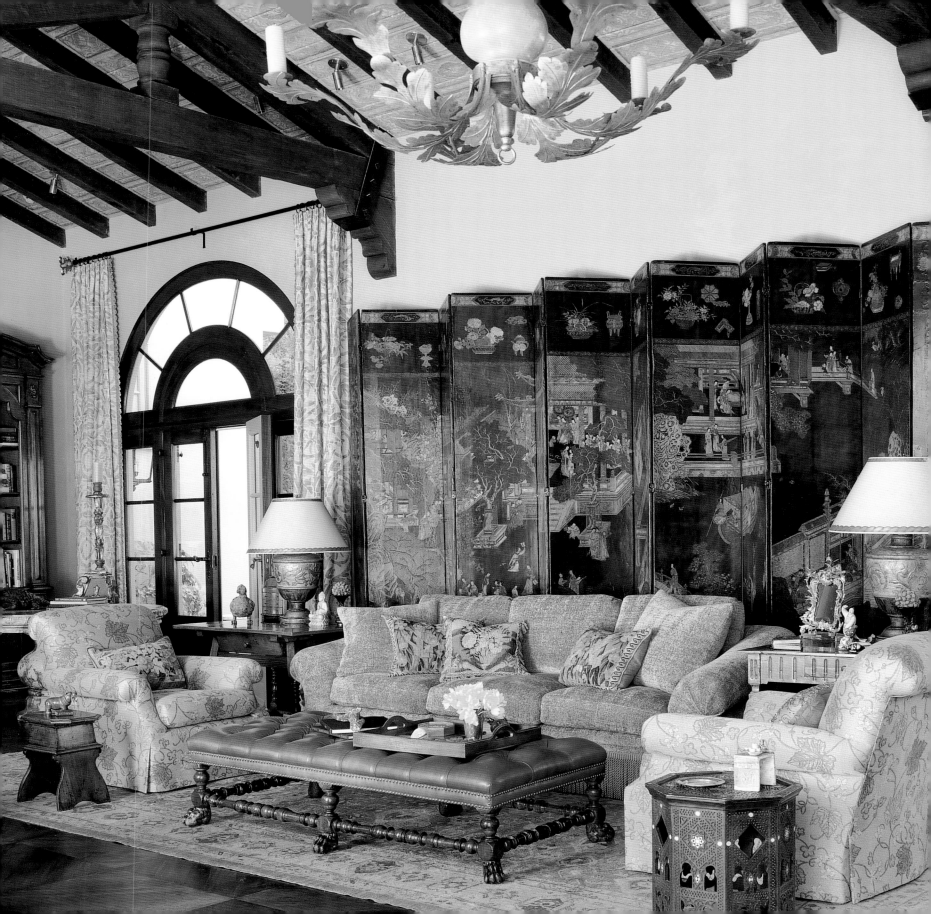

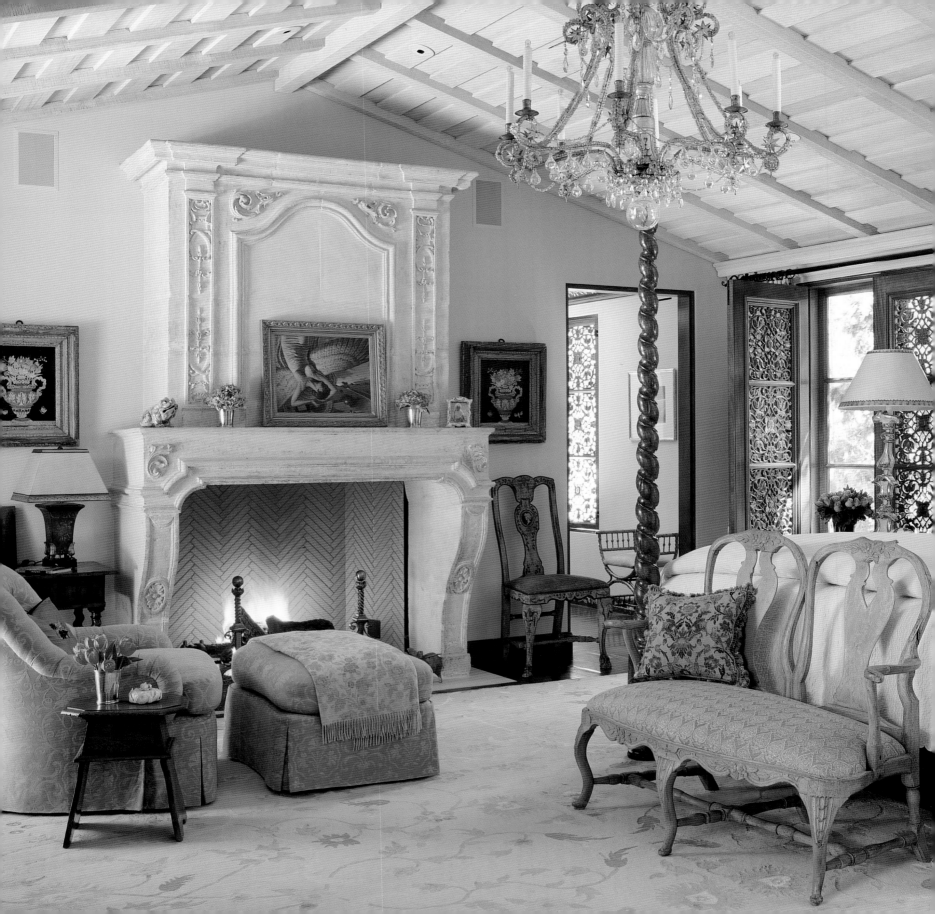

The new living room, which measures thirty-eight by twenty-five feet, was reworked with arched windows. The original beamed ceiling, which reaches to eighteen feet at the top beam, was cleaned and lightened, then stenciled by Elisa Stancil.

"I wanted to create more intimate conversation groups in this large room so that it would work for a variety of occasions," said Tucker. She designed two large sofas, set one on each side of the room, and paired them with down-filled armchairs, low tables, and a tufted leather ottoman. Significantly, Tucker did not center the seating around the stone mantel.

"I like the play of textures in the living room," said the designer, who started her design career in the office of Michael Taylor. "There's the carved stone mantel, the soft terra-cotta chenille of the sofa, antique tapestry pillows, antique carpets, and the beautiful rich colors of the Coromandel screen."

Many details catch the eye. Tucker orchestrated the room with ivory-inlaid cabinets, a bibliotheque with space for a collection of miniature volumes, Venetian gilt mirrors, and antique tables. The tones, proportions, textures, and scale are all harmonious.

Ceilings in other rooms were lightened and stenciled, a stairway was reimagined, and antique Italian carved columns were placed in a large doorway leading to the living room to give both the entry and the living room a sense of stature.

"This house is so romantic," said Tucker, who worked on the project for several years. "It was the work of many experienced, passionate people. Andrew Skurman provided superb new architecture that connects the house to the terraces, the garden, and the pool in a very attractive manner. My client contributed her wonderful collections of inlaid-wood and marquetry cabinets and tables and unstinting enthusiasm. Many fine decorative artists contributed their talents. Willem Racké faux-painted doors in the dressing room to look like fine antique marquetry. Fabrics were custom printed and custom dyed. Tile makers and stone carvers worked to perfection. Plasterers and painters crafted a glorious background. Carvers, upholsterers, metalworkers made beautiful things. This was the best kind of collaboration." ☙

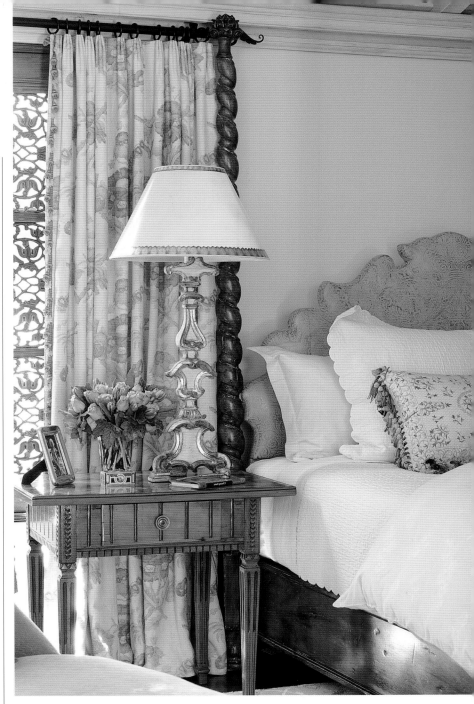

THE ROMANCE OF SUBTLE DETAILS *(Above and opposite)* After Skurman and project manager Mark Rushing had enlarged the bedroom, Suzanne Tucker planned a room of grace and grandeur that was also sexy and sensual. Bleached and limed cedar ceiling rafters and wheat-colored plaster walls serve as a canvas for a noble eighteenth-century French stone fireplace and for the wooden window screens designed by Tucker and crafted by carvers in Nepal. The custom-carved walnut four-poster bed has a gaufrage headboard. The silk and wool carpet was crafted by Himalayan Weavers. The bedroom wing, measuring one thousand square feet, includes this bedroom, a luxurious bathroom, and a dressing room. Antique textiles by Kathleeen Taylor, The Lotus Collection, San Francisco.

ARCHITECTURAL EVOLUTION

SHARON & ANDY GILLIN IN PIEDMONT

Sharon Gillin remembers first seeing the house as a child. As she roamed the sycamore-shaded, winding roads of the Piedmont hills, high above the eastern reaches of the San Francisco Bay, she entered Wildwood Gardens. High hedges obscured grand Palladio-inspired houses from view. Clipped privet and yew added their sculptural counterpoints to gnarled old oaks and a profusion of climbing roses and jasmine. Within this *Secret Garden* setting was a small pavilion with the air of a residence on the splendid grounds of Versailles.

"From the moment I first saw that house, with its neat and romantic Tommy Church garden, a terra-cotta roof, white stucco walls, tall and perfectly symmetrical windows, and an air of simple elegance, I wanted to live there," recalled Gillin, an antiques specialist and designer. The house, she discovered, had been built in 1929 in thrall of classic French pavilions and had never been updated or remodeled.

Eventually, after decades, the house came on the market. By chance the Gillins rediscovered the long-lost object of desire, and one fine day it was theirs.

As any healthy cynic might now imagine, the reality of the house, once secured, was rather different from the dream. An entranced young girl could hardly know that the object of so much longing was a house of cards, a residence so poorly fortified that one strong earthquake or storm could topple it.

Gillin called in architects Ivor Brown and Alison Keene of Slant Studio in Emeryville.

"There were two goals in the remodel," said Keene. "The first was a seismic retrofit. The house had a very unusual structural system consisting of interlocking concrete tiles that was totally unstable. To make the house structurally sound, 126 strips of the exterior face were torn off, rebar was added, and the void was filled with concrete. No remodel is simple, but this one came with complications. The walls became almost solid concrete and their additional weight necessitated rebuilding the roof to provide lateral support for the walls."

COMFORT AND EASE *(Opposite)* The living room overlooks the Tommy Church–designed garden in the front of the house. A large sofa and barrel chairs custom-made by Fitzgerald, San Francisco, anchor the decor of the living room, which has fourteen-foot-high ceilings. Custom cabinetry is by Dave Barrett Woodworking. The chandelier (see inset, this page) is original to the house. Recessed lights are by Lightolier, and Boyd sconces are by Orlando Diaz-Azcuy.

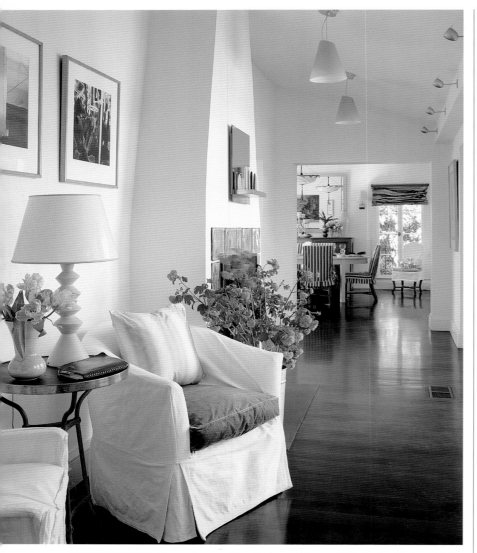

LIGHT FOR LIVING *(Above and opposite)* For Andy and Sharon Gillin in the Piedmont hills, architects Alison Keene and Ivor Brown of Slant Studio reconfigured rooms to draw in light. A hallway connecting to the dining room and facing a new terrace invites repose. The chairs and sofa are by Fitzgerald, San Francisco. The scroll lamp is from Paris.

The second goal of the remodel was to open up a labyrinthine interior filled with dark hallways and small rooms, so that each main room had exposure on two sides.

The courtyard and loggia at the back of the house, which had been sunken and inaccessible from most rooms, were raised to the level of the interior floor to facilitate flow between interior and exterior.

"The project was a collaboration between our modern and very practical take on spaces and materials, and Sharon and Andy's experience in decorating and their passion for furniture, objects, and fabrics."

The layout of the house is now a simple U-shaped plan with the kitchen and dining room along with a new office and pantry in one wing and the living room in the middle of the U. Bedrooms and bathrooms are in the other wing. Each wing looks both into the terra-cotta tiled, sunny courtyard and out to the garden, with its clipped sycamore trees *à la française*. Completing the restoration, the architects installed all new hardwood floors, hand-trowelled walls, and new plumbing and electrical fixtures throughout.

"This was a wonderful project to work on because the house had such great 'bones' and style," said Brown. "The project was a collaboration between our modern and very practical take on spaces and materials, and Sharon and Andy's experience in decorating and their passion for furniture, objects, and fabrics. Now every room gains sunshine from the central courtyard, and the house feels light all year long."

Sharon Gillin is delighted too. She loves to entertain, and the new kitchen is both decorative (with great retro style) and practical. A swoop of drapery between the kitchen and dining room is ready to be closed during a formal dinner and is left open during the week. Without adding square footage the architects have made the house feel much more spacious and welcoming.

"Now it truly is the house of my dreams," said Gillin. "It's rare in life that a childhood wish can be fulfilled so completely." ☞

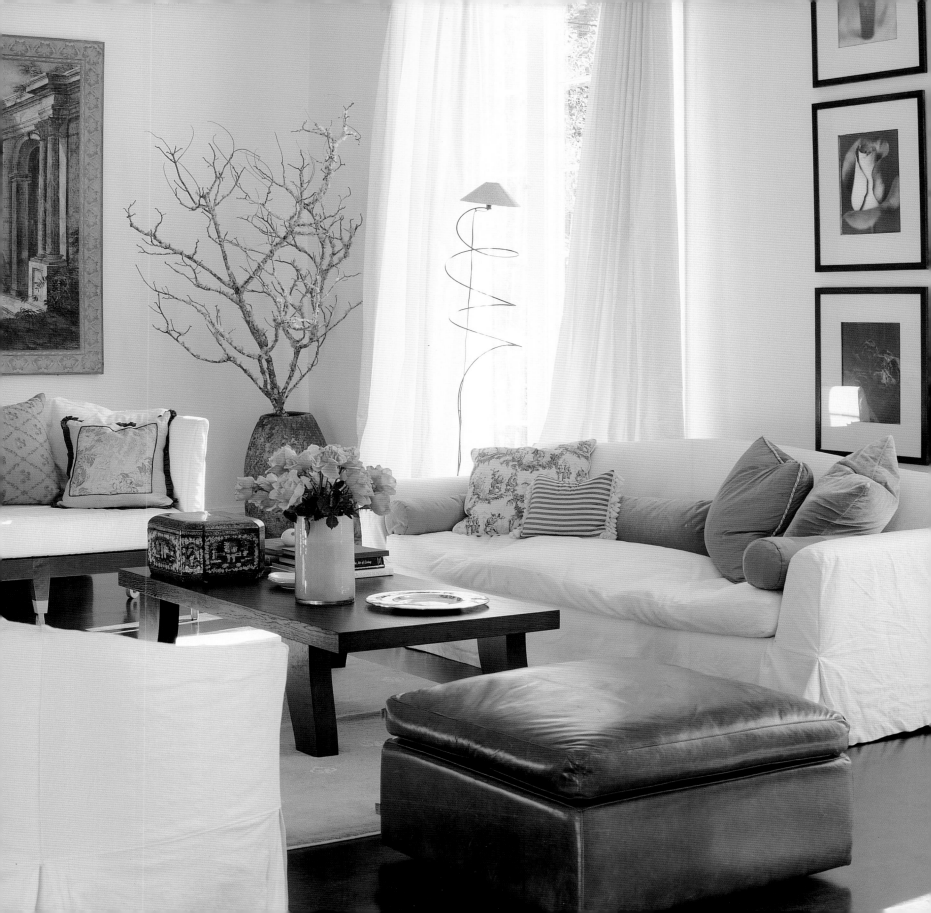

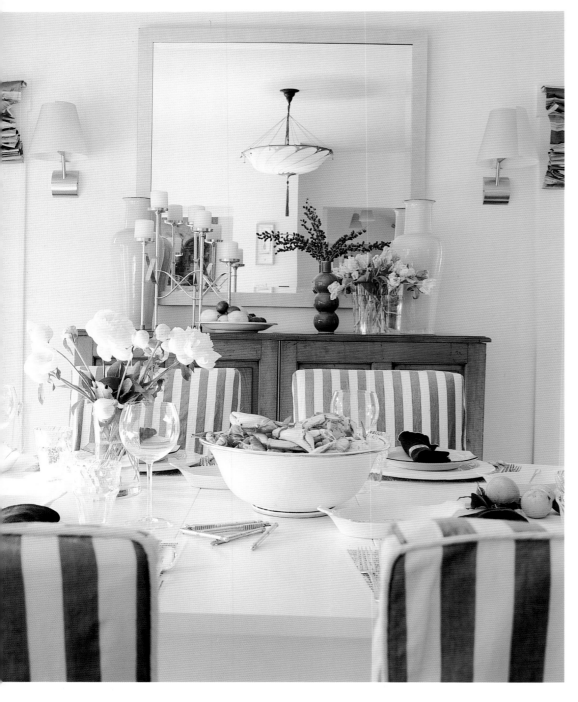

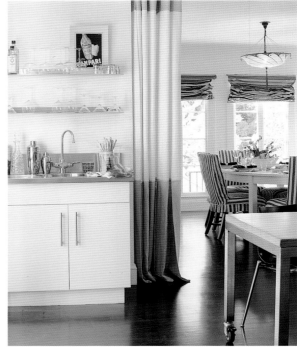

A DIFFERENT STRIPE *(Left)* Gillin gave the dining chairs slipcovers so that the room's style can waltz from season to season. The Fortuny pendant is from Sue Fisher King. Sconces are by Leucos. The dining room table was custom designed by Slant Studio and crafted by Dave Barrett Woodworking, Berkeley. Stained Brazilian mahogany hardwood floors (throughout the house) were crafted by Third Generation Floors, Pleasanton, California.

RETRO STYLE *(Above and opposite)* The kitchen was designed to work hard—and to look as if it belonged to the house when it was first built in 1929. Colors are soft pale greens and creams. Concrete counters are by ConcreteWorks, Oakland. For a classic, timeless look and practicality, the architects selected white three-inch-by-six-inch "subway" tiles by Ann Sacks. With a dishwasher by Miele, refrigerator by Sub-Zero, range and range hood by Viking, and pot filler by Chicago Faucets, the kitchen is ready to welcome dozens of guests. All the new interior architecture and design is by Slant Studio of Emeryville, California.

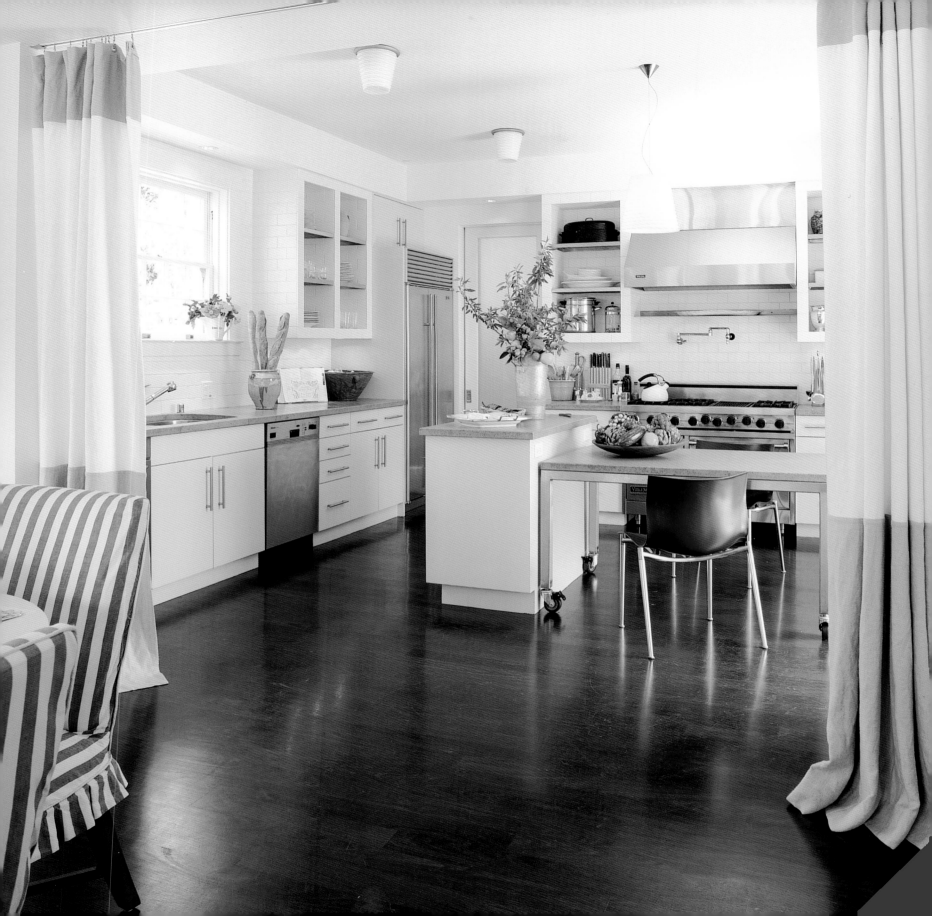

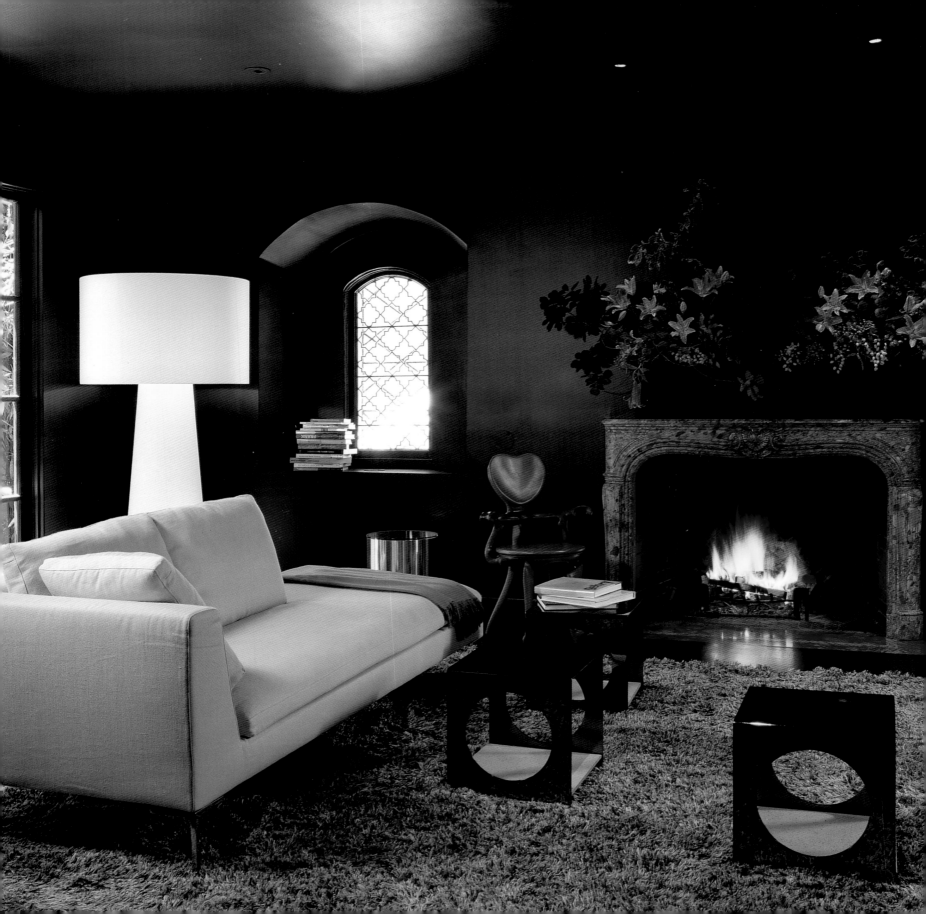

ROMANTIC MODERNISTS

ABIGAIL TURIN & JON GANS IN PACIFIC HEIGHTS

Designer Abigail Turin is a modernist at heart. A native of Berkeley, she received her master's in architecture with distinction from Harvard University, worked in the offices of British architect David Chipperfield, taught architecture at Harvard, and started her own international design practice in San Francisco at the age of thirty, with a partner in London. She is now working on residences and commercial properties around the world.

"My thesis was on the classical architecture of Palladio, but I approach my work with conviction as a modernist," said Turin. "I like to create interiors that deal with the issues of the day, that address the present in a creative manner. And I usually prefer pared down architecture."

Naturally, when Turin and her husband, Jon Gans, principal of an investment company, went looking for a house in San Francisco, their first requirement was modernist architecture. Lighthearted as well as hardworking, they spontaneously decided one day to get married at City Hall—in jeans.

For a couple whose life has a certain magic, the house hunt was not a thrill. Rigorously modernist houses are few and far between in San Francisco.

"After we had looked at about five houses, with no frisson, Jon phoned me out of the blue to tell me that he had found our house," recalled Turin. "I went running over there with him and found before me a house with a Mediterranean exterior, small dark rooms, an ornate marble fireplace, mullioned windows, wrought iron. We wanted a view, and this house had none. We did not want a garden, and this house has a great garden by Topher Delaney. But I fell in love with the possibilities of this charming house, and suddenly we were the owners."

After they had moved in, she started drawing up plans, sketching, trying to make the interior work, and attempting to give the house a logical modernist spin while maintaining the integrity of the original architecture.

SUBVERTING MODERNISM *(Opposite)* Designer Abby Turin painted the living room walls deep aubergine-brown-black, which pumps up the volume and drama of the antique stone fireplace, original to the house. She set a pair of linen and cotton Antonio Citterio sofas and three steel cube tables on a linen-cotton shag rug by Kasthall. Against this retro-modern beat, she added an overscale linen-covered floor lamp by Marcel Wanders for Cappellini and a playful Calvet chair by Antoní Gaudí that seems ready to tango. The mullioned windows are original to the house. Flowers are by Kelly Kornegay at Rayon Vert.

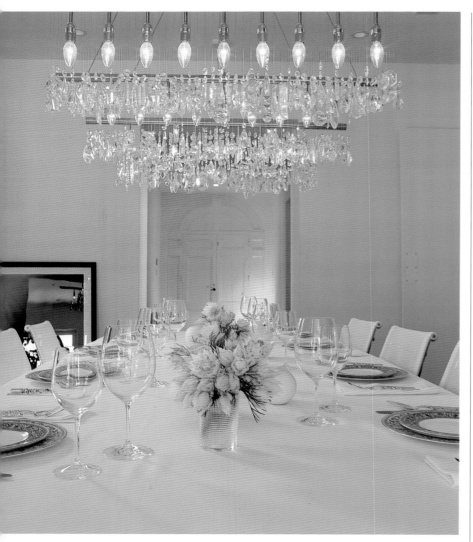

GLITTERING PRIZE *(Above and opposite)* In the black-and-white box of the dining room, Abby Turin created a subtle play of minimal lighting and rhythmic rows of Eames chairs, and then amped up the glamour with the wildly gorgeous Cellula chandelier by Nunzia Carbone and Tiziano Vudafieri for Anthologie Quartett, Germany. Swarovski cut crystals, made to adorn traditional chandeliers, are here strung on three steel bars and lit with rows of bulbs. The flowers are by Kelly Kornegay at Rayon Vert. The laminated rainbow chair by Patrick Norguet, a plastic rod sculpture by Abby Turin, and a nude photograph of a Mark Morris dancer by Annie Liebowitz play a game of contrasts.

"For encouragement, I looked to see what John Pawson had done within traditional architecture, and I checked out contemporary Milanese architecture, which is always done in the context of venerable old architecture," said Turin.

The exterior, with its arched doors and graceful iron balcony, was painted but left intact. The back of the house was taken down to the studs, and Turin gave it a clean sweep. All old moldings and extraneous detail were stripped. Doors were realigned, halls were widened, and the kitchen was remodeled to make it sleek and simple. Turin inserted a crisp, clean, white modernist interior into the traditional envelope.

White walls and black floors would be her canvas for a collection of contemporary classic furniture by Cappellini and B&B Italia, and the living room and dining room would be a gallery for large-scale photography, sculpture, and modern lighting designs.

"I didn't want the finished decor to be too austere or chilly, so I started looking for some quirky furniture and lighting, pieces with an attitude," said Turin. She searched at Milan furniture fairs, in London showrooms, at Los Angeles vintage stores, and in Paris.

"When I studied the Italian Renaissance, I learned of the importance of rhythm in architecture, and creating complexity, so I applied that same concept of provocative juxtapositions to the decor," she said.

Most dramatically, Turin decided to contrast the all-white interiors with a black-walled living room.

"The black walls and ceiling are actually a deep aubergine-brown that reads black," she said. "I tried pure black first. There was a lot of experimentation with this color. Plain black looked so dead, so ashen. So I tinted the black with deepest purple and brown pigments, and it works. The room is warm, inviting, mysterious, and has a great mood."

Another masterstroke was the dining room chandelier, a most modern take on glamorous lighting. Italian designers Nunzia Carbone and Tiziano Vudafieri dreamed up a lighting system of three steel bars from which are hung sparkling clusters of Swarovski crystals, each

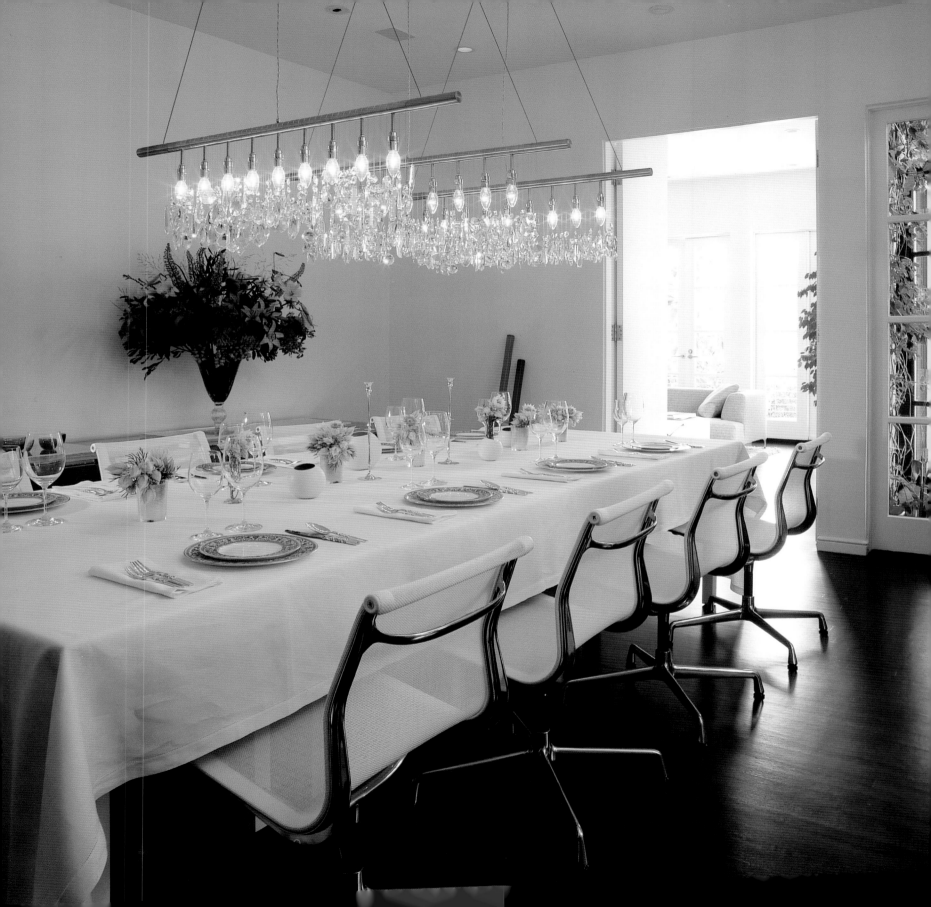

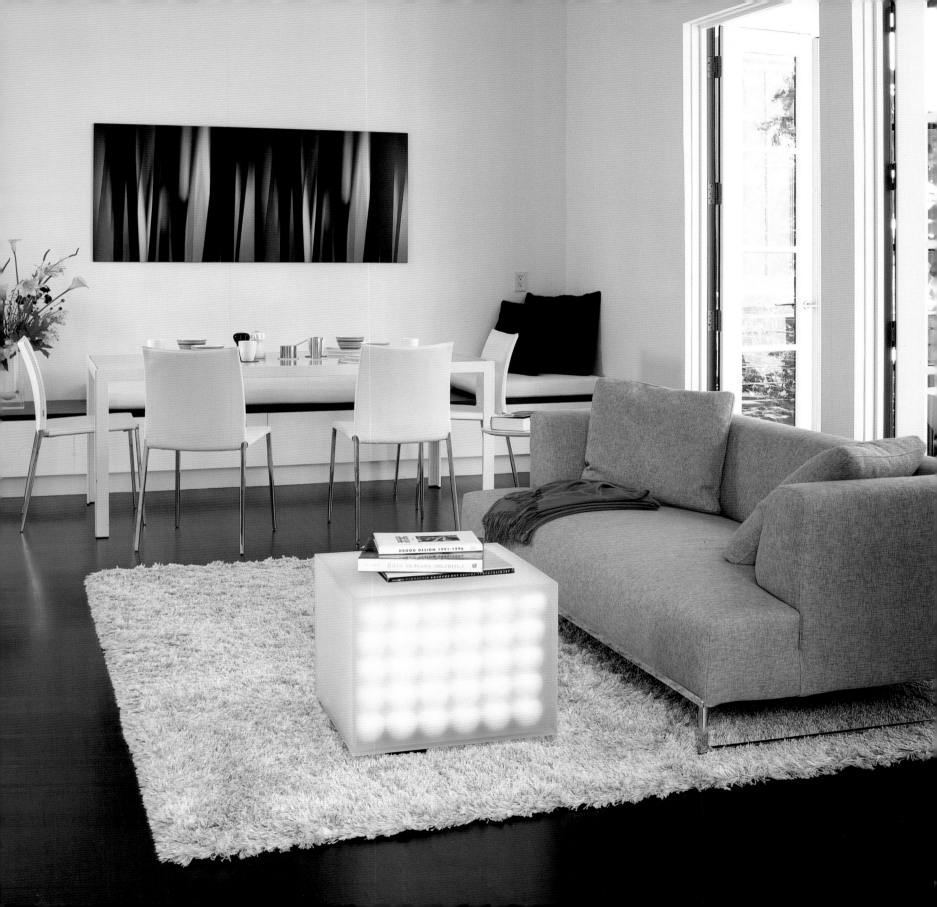

one different. The effect, day and night, of the hard-edged steel rods and the delicate crystals is dazzling and witty. The cut crystals move and sparkle in the breeze. There is nothing ponderous or old-Europe about this design.

"It's a very practical design."

The couple's traditional friends love the interiors, and their modernist chums adore them.

"There's danger in trying to be too provocative, which can veer into uncomfortable and unworkable. And I didn't want to do the usual modernist thing, which ends up looking as slick as a showroom with no eccentricity or charm. I definitely wanted to avoid being too tasteful," noted Turin. "We are a young couple. This design can evolve. Many of the chairs and tables can move from room to room. It's a very practical design."

The traditional archaeology of the house benefits from the dash of chrome yellow silicon-covered stools, Italian cool, architect-designed wedding presents, and remote-operated lighting. The steel and glass table in the kitchen and steel and lava rock tables in the living room are lifted by their association with hand-carved marble and graceful wrought iron.

In the end, Turin and Gans love their house.

"It started out as the opposite of what we thought we wanted," noted Turin. "But we've made it over for our own life and needs. After a few parties, with friends gathered and family around us, this house truly feels like home." ☞

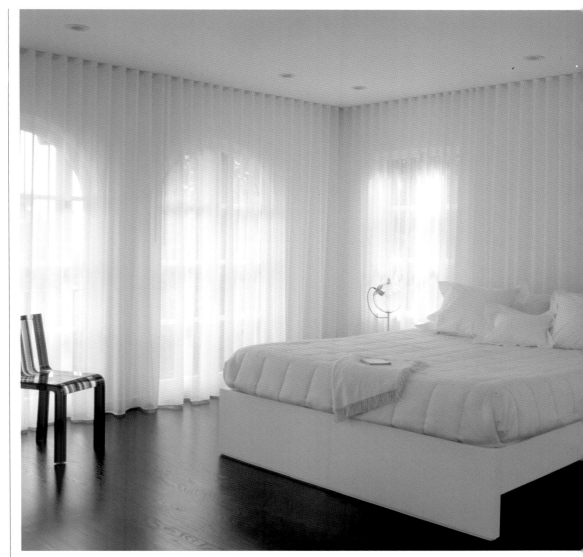

DREAMING IN WHITE *(Above)* Designer Abigail Turin designed the bed, with Frette linens. Gauze curtains hang from a concealed track system.

A MODERNIST BREAKFAST *(Opposite)* Abigail Turin freshened the breakfast and media room with white paint, a black floor, and a splash of acid green. The glass-topped table by Monica Armani has a quartet of Lia chairs by Zanotta. The Solo sofa is by B&B Italia.

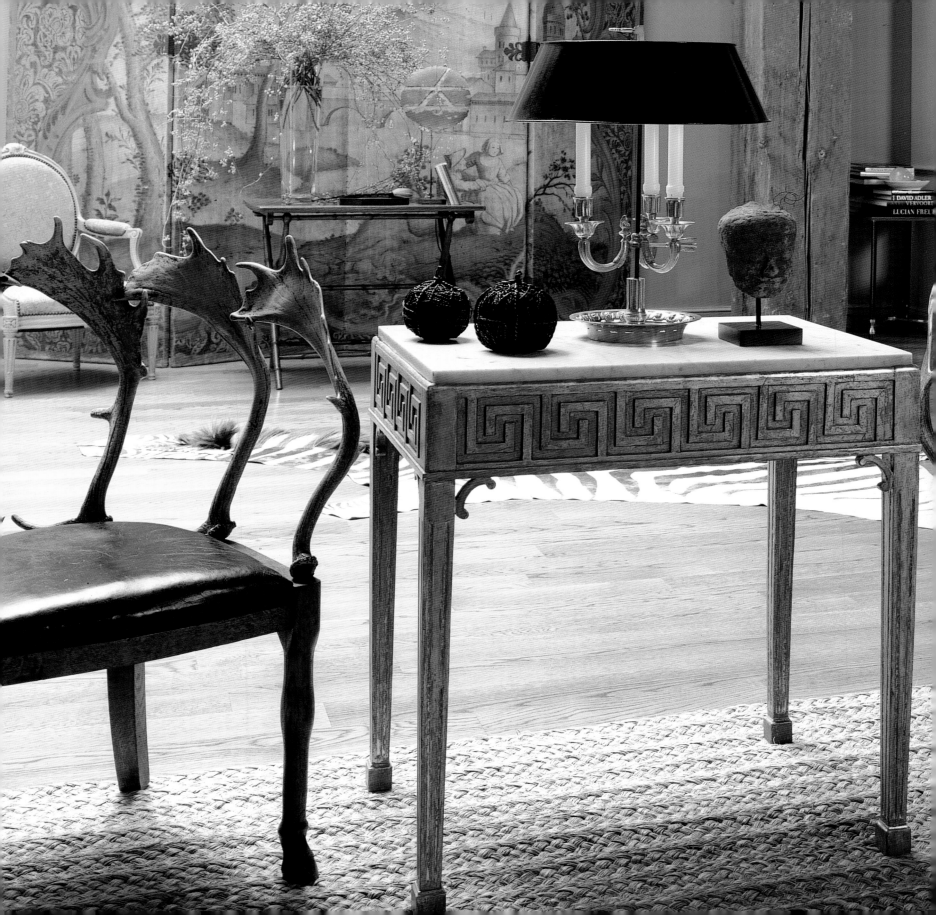

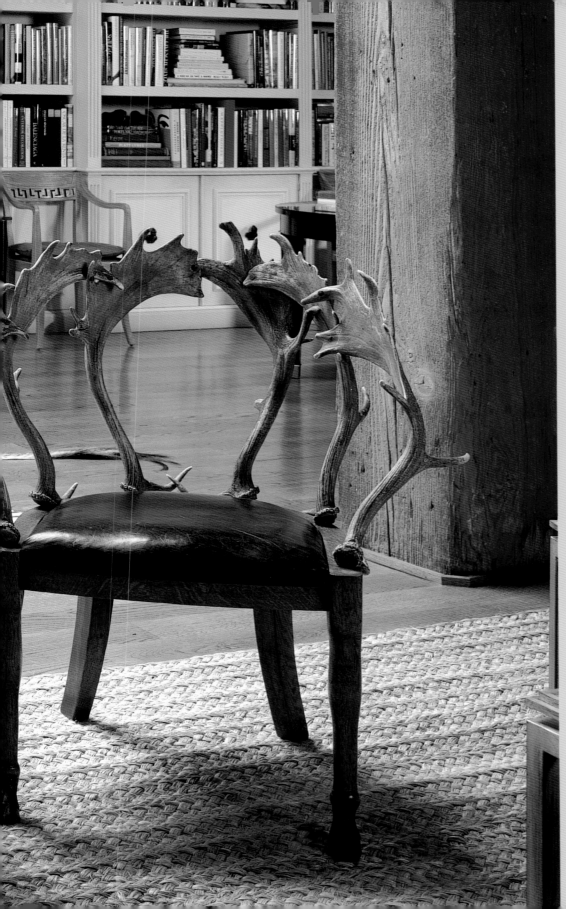

DESIGNERS

Une jolie habitation ne rend-elle pas l'hiver plus poétique,
et l'hiver n'augmente-t-il la poésie de l'habitation?

ISN'T IT TRUE THAT A PLEASANT HOUSE
MAKES WINTER MORE POETIC, AND DOESN'T WINTER
ADD TO THE POETRY OF A HOUSE?

Charles Baudelaire
Les Paradis artificiels

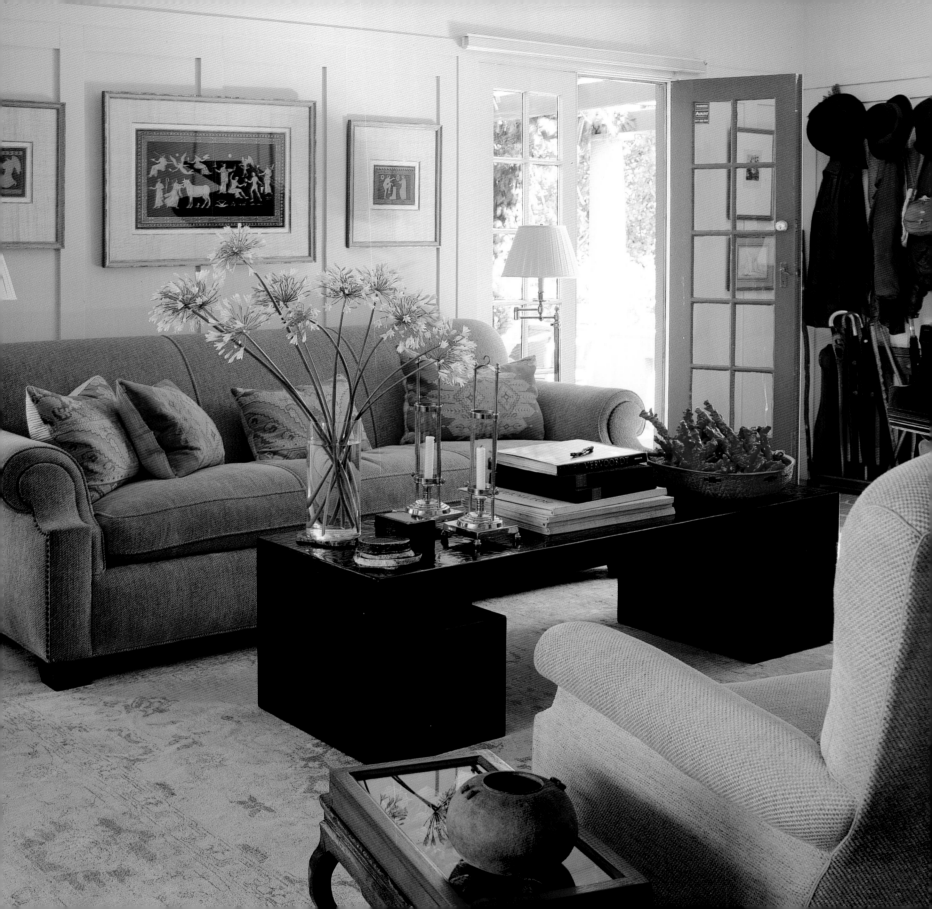

SOUL AND SOLITUDE

PAUL WISEMAN & RICHARD SNYDER IN BELVEDERE

For the past thirteen years, the Wiseman Group has been considered the paradigm of discreet residential design firms in San Francisco. Obsessed with detail, the company's designers polish and perfect rooms of lasting beauty.

After a day or a week of creating opulence and grandeur, Paul Wiseman retreats to a historic turn-of-the-century Belvedere cottage hidden among allées of white and purple acanthus, waving white agapanthus, and orderly parterres of hollyhocks.

"I like the pure escapism of this place," said Wiseman, walking onto his wisteria-draped loggia. Far below, a scoop of Belvedere Cove and the whitewater of Raccoon Straits are visible through a veil of old oak trees.

"When it's foggy in the summer in the city and in Berkeley, it's warm and sunny here," said Wiseman. "We're sheltered from the high winds that scream through the Golden Gate. It feels like nineteenth-century Lake Bellagio or Lake Garda here. I can watch the regattas, take breakfast on the portico, potter about the garden, listen to the wind in the trees, watch the birds."

Wiseman's one-bedroom pink stucco house, which also affords views of both the Golden Gate Bridge and Angel Island, was originally built in 1912 as a weekend cottage for Dr. Florence Nightingale Ward, one of the first female surgeons in the United States. According to Belvedere library records, she would take the ferry to Tiburon from the city every Saturday morning.

"Dr. Ward was a close friend of Julia Morgan, and the house definitely shows Morgan's cosmopolitan sensibility and Italian-influenced eye," noted Wiseman. The superbly proportioned loggia, with its finely tapered Doric columns, and a vine-entwined belvedere, hint at Morgan's hand in the initial planning of the house.

SCOTTISH RIFF *(Pages 56–57)* In his redwood-columned loft, designer Steven Volpe chose a pair of hoof-footed chairs with seasonally cast-off antlers. Iron "ball of string" boxes are Japanese.

GOLDEN AFTERNOON *(Opposite)* Wiseman likes the undecorated, relaxed feeling of the living room, with hooks for raincoats and umbrellas and doors that open to the terrace. The *craquelure* lacquered coffee table in the living room was designed by Douglas Durkin, based on a historic Chinese model. On the paneled wall hang a trio of Grand Tour portfolios of details from Greek vases. The chenille-upholstered chair in the foreground is a Rose Tarlow design.

ODE ON A GRECIAN BRONZE *(Right)* Perched on the eighteenth-century walnut table, the brass head is an eighteenth-century Grand Tour Greek-inspired model. The antique ivory and bronze temples are also eighteenth-century Grand Tour artifacts.

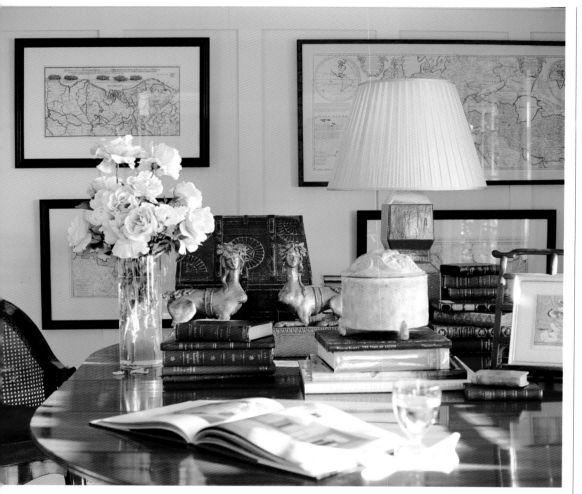

COLLECTOR'S DELIGHT *(Above and opposite)* Wiseman arranged a tablescape of Venetian paintings, Roman and Florentine bronzes, crystal, and Balinese lacquer pieces on his dining table. "I travel a lot and always bring back some treasures," he said. "I put them on the dining table so that I can enjoy them every day."

The house today looks much the same as it did when it was first built—one of its great draws to Wiseman and his partner, Richard Snyder, an attorney.

"I love the fact that it has never been 'modernized' or fancied up," said Wiseman. "No one had ruined it. I glazed the walls a rich, warm ocher color, but I have not done any renovation or restoration. I like the old terra-cotta tiled floors, the original doors and windows. I didn't want it to be a big design statement."

"Dr. Ward was a close friend of Julia Morgan, and the house definitely shows Morgan's cosmopolitan sensibility and Italian-influenced eye."

Wiseman's three rules of good design, he said, are "appropriateness, appropriateness, appropriateness." Furnishings should be right for the location, the architectural style, the purpose, and the people and their lives.

"This is a weekend cottage, so the most appropriate furnishings here are comfortable and show the soft patina of time and use," Wiseman said. "I love 'old-shoe' furniture and antiques that have elegant lines but are not too formal. We've brought some favorites from a previous residence, dragged out prints and paintings and bronzes that had been in storage. Colors are soft, fabrics are smooth to the touch. I come here to live a low-key life." ▣

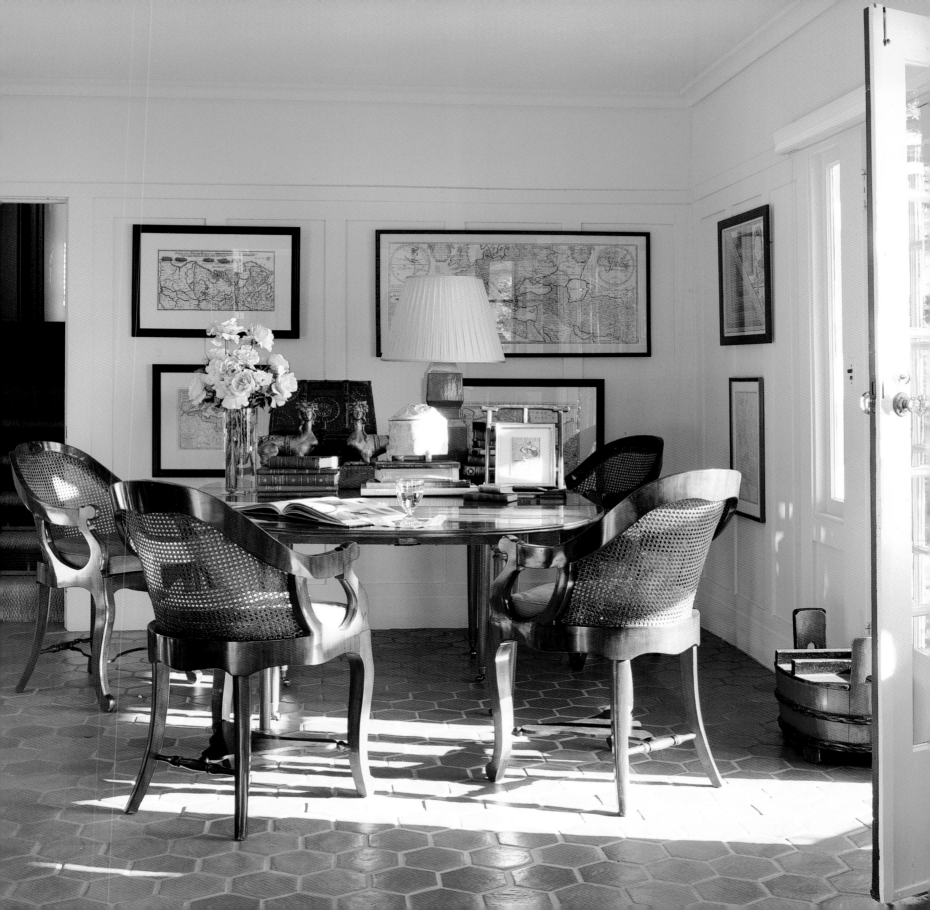

Dreaming of Paris

MYRA HOEFER IN HEALDSBURG

The Ivy House is one of the prettiest residences in California. Hidden behind festoons of ivy and clouds of white Iceberg roses and obscured behind a tall stucco wall, the Ivy House is home to Myra Hoefer, a leading interior designer who is also a partner in 21st Arrondissement. The chic Healdsburg shop imports and sells French antiques, contemporary sculpture, tableware, pottery, tables, iron daybeds, and a revolving door of Provençal props and rare Parisian decor.

For Hoefer, the Ivy House is a retreat and a refuge from an extraordinarily busy life. From her office, just behind the house, she runs Myra Hoefer Design, a high-profile decorating firm. She also has an atelier in the Marais, in Paris. From her antiques-filled studio on rue des Tournelles, she acquires antiques for her clients and finds unique merchandise for her shop.

"I thrive on travel, and I am energized both by my life in Paris and my work in Healdsburg," said Hoefer. "Every day in Paris feeds my hungry design eye. A trip to the mad scramble of the Saint-Paul fabrics market can inspire color schemes and make me want to experiment with new textures and colors. Paris is a constant education. I love it."

Hoefer has such a love of French design and style that she spends much of the year in Paris, driving from fabric house to flea market to florist in her trademark black Volkswagen Beetle. Evenings, she entertains in her courtyard apartment, a former hayloft.

The designer first started spending serious time in France when she was commissioned to design apartments for Chez Vous, a Sausalito-Paris apartment rental company.

Chez Vous had been a well-kept secret among travel insiders for many years. Francophile guests as diverse as Chicago attorneys, Hollywood scriptwriters, Berkeley chefs, poets, and high-tech executives have made themselves at home in the Chez Vous Portfolio Collection apartments, which are situated in the most interesting and convenient Paris arrondissements.

LE MARAIS IN HEALDSBURG *(Opposite)* Myra Hoefer's love for Paris and the 4th Arrondissement are graphically apparent in her breakfast room. Louis XVI gilt chairs, a French provincial table, a map of Paris, and the iron fleur-de-lys evoke the French taste.

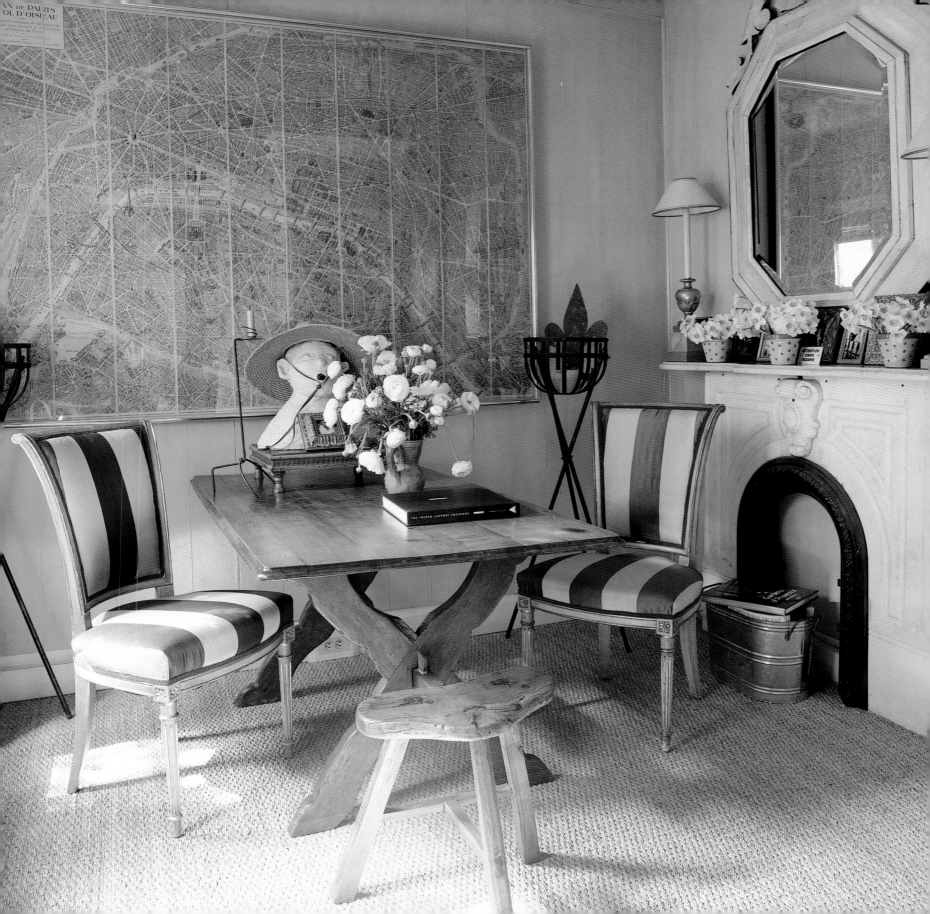

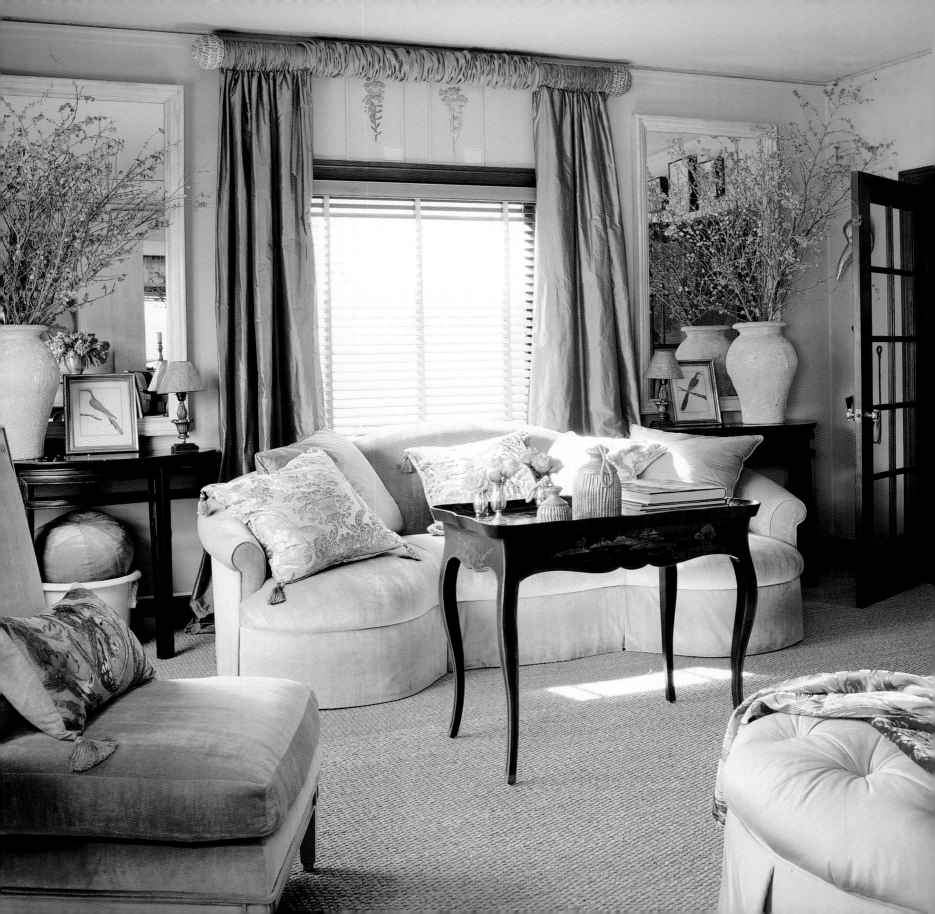

TEXTURE AND TONE *(Opposite and right)* Myra Hoefer's living room is an album of her favorite things. A Syrie Maugham-style sofa, by Michael Taylor Designs, curves around a Michael Taylor Designs table. The sofa is given a little oomph with silk pillows. Rustic pottery urns and pewter-colored silk draperies play a game of contrasts. Jack Russells (four lively, silk velvet–loving terriers) leap onto classic, cushy armchairs. The plaster table is a classic design by John Dickinson. The painting is by Wade Hoefer. The lacquered table is by Michael Taylor Designs.

Myra Hoefer lavished the Chez Vous apartments with California comfort and inventive French style. The Left Bank rooms are graced with French antiques (some from the Paris flea market), silk taffeta draperies, large Belgian linen-soothed sofas, and gilt-framed mirrors. For a two-bedroom apartment on the rue Dauphine, Hoefer combined voluptuous caramel-colored silk taffeta draperies and Louis XVI-style walnut chairs with iron chandeliers to achieve Parisian panache. On the rue Jacob, Hoefer planned dove-gray walls to frame antique carved mahogany Dutch armoires and gilded Louis XVI-style chairs. Most of the apartments are classic French with tall windows, parquet floors, and luscious "patisserie" plaster moldings. Hoefer lifts them from any possibility of formality with her quick-pick, early-morning Porte de Clignancourt flea market treasures.

Hoefer's Healdsburg house neatly balances pristine white linens and pewter silk with seagrass matting and dog-friendly silken velvet slipper chairs with provincial French farm tables and pine cabinets.

It's an art to balance a frequent-flier life between Paris and Healdsburg, and Hoefer has found her balance. In the same way, she has perfect pitch for setting up rooms that are exquisite in detail— but not so precious that her grandchildren are afraid to enter.

"This is a house for yappy dogs and lively kids," notes Hoefer with pleasure. "It also reminds me of Paris. France is never far from my thoughts." ▣

LOUIS LOUIS *(Above and opposite)* A pair of slipper chairs in the style of Jean-Michel Frank, with richly detailed cut velvet pillows, are set on each side of an intricate Louis XV–style console table found in Paris. On the two gilt wall sconces are unframed landscape paintings by Wade Hoefer. The pewter-colored silk taffeta draperies, as elegant as a Balenciaga ball gown, make a perfect retreat for Hoefer's tribe of Jack Russell terriers.

STYLE DE VIVRE *(Left)* In a corner of the living room, decorator Myra Hoefer has set a pine cabinet and topped it with a plaster sculpture, a French antique lamp, and French flea market objects. The paintings of flowers are by Wade Hoefer.

CALME ET LUXE *(Above and opposite)* A ceiling-height broad-framed mirror enlarges the apparent size of the living room, which has pale wheat-colored walls. A Portuguese-style table from Michael Taylor Designs is surrounded by eighteenth-century neoclassical French chairs covered with striped silk. The paintings are by Wade Hoefer. On the floor: seagrass matting.

A LOFT IN THE CITY

STEVEN VOLPE & HIS SOUTH OF MARKET LOFT

San Francisco interior designer Steven Volpe is a classicist who is passionate about Paris forties and thirties furniture designs. He studied classical design as an apprentice in Paris for two years and travels to the ends of the earth to study classical architecture.

No wonder his friends were surprised when Volpe turned the tables on himself and acquired his redwood-columned loft in an almost-funky part of town eleven years ago.

"My interior design tends to be classic, and I love rare antiques with a touch of glamour, so I was not even thinking about purchasing a raw loft," he recalled. The designer's real estate agent phoned him raving about the newly converted Bryant Street loft, in a 1916 former printing factory. It had the generous space, character, and privacy he craved. He had been searching in vain around Pacific Heights for an apartment of quality that was affordable.

"The moment I walked through the entrance and into this airy loft, I knew I had to have it," Volpe said. "The ceilings are eighteen feet high, with eight eighteen-inch square raw, heart redwood support columns reaching from floor to ceiling. The timber had been milled from massive redwood trees at the turn of the century. You simply would never see noble timber like that today."

Volpe trained in design as an assistant to legendary San Francisco decorator Anthony Hail. He founded his own design firm, Steven Volpe Design, in 1987 and now has eight staff members in his South of Market atelier, a ten-minute walk from his loft.

One corner of the 2,100-square-foot loft has been opened up with a conservatory window. There is grandeur to the space, an elegance to the proportions, that belie the industrial origins of the building.

"The walls were bare brick, and the floor was concrete," Volpe said. "It was a blank canvas, so it gave me the opportunity to experiment. I wanted to juxtapose sandblasted redwood and rough brick with highly detailed, handcrafted, refined antiques. This would be an unexpected loft, the antithesis of industrial decor."

ANGLE OF REPOSE *(Opposite)* Volpe pulled together a conversational group with a Steven Volpe Design sofa covered with Gretchen Bellinger chocolate velvet, a pair of Maison Jansen forties bergères covered in Rose Tarlow leather, and gilt bronze forties tables found in Paris. The paintings are by Nilus de Matran.

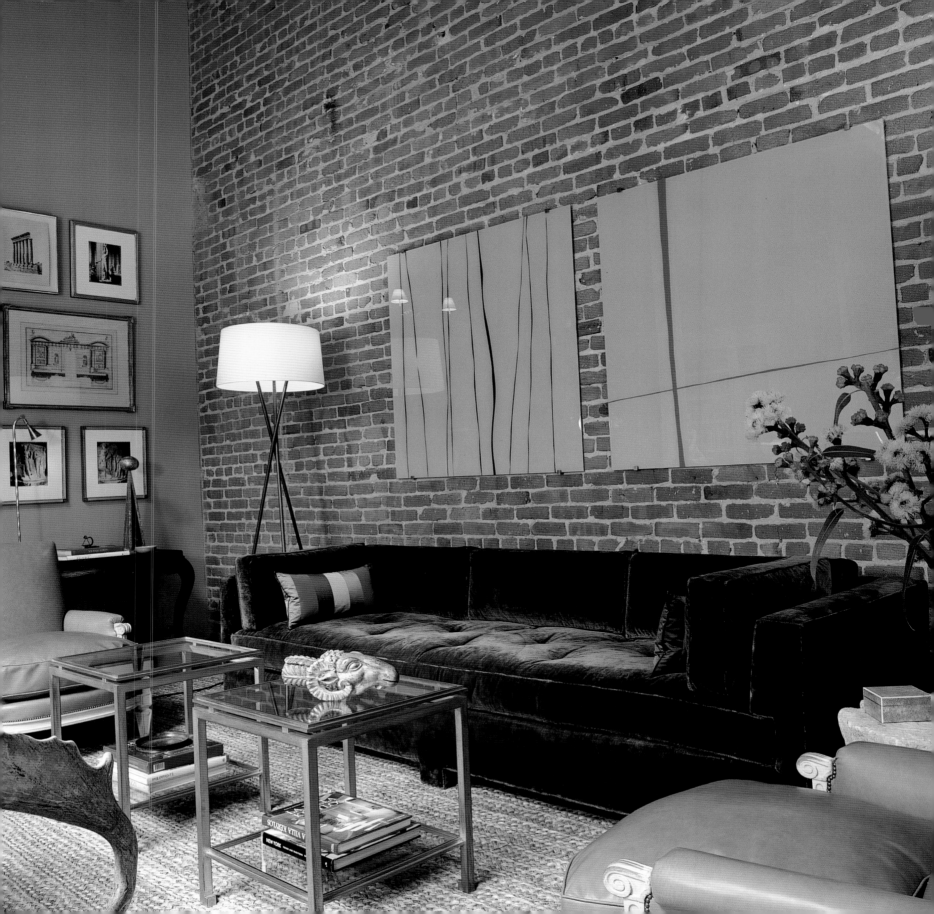

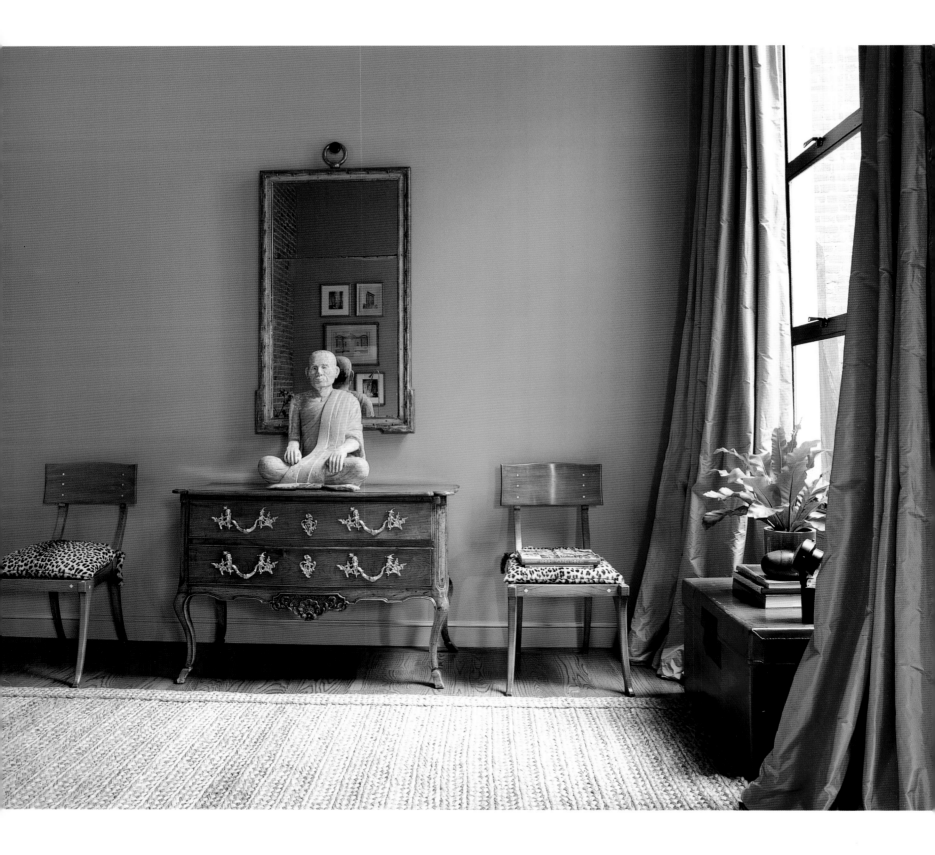

Volpe was undeterred when friends noted the lack of a city or bay view.

"I can create my own inner roomscape," he noted. "I wanted this to be an apartment which could be in any great city in the world."

The first order of business was to install white oak plank floors and to paint the plaster walls in Farrow & Ball's muted Sage and Ginger.

"I moved in with just a few pieces of furniture I loved," said the designer. "I was stopped from making quick additions by the tyranny of the high cost of ownership."

He would rather be in a room with one great chair than a lot of mediocre furniture, he said.

"I decided to take my time and purchase only pieces I loved and wanted to live with for the rest of my life," recalled Volpe. "I didn't want 'filler furniture,' only things that I couldn't let go."

One of his first acquisitions was a stunning nineteenth-century Régence commode, its cast bronze handles depicting quirky French mythological characters, discovered at Louis Fenton Antiques in Jackson Square (which is now closed).

"The proportions are graceful, yet unexpected," said Volpe. "The nicks and smooth sheen give it soul. It pleases me every time I look at it."

Some of Volpe's antiques are virtuoso pieces, while others are rustic and raw. A pair of turn-of-the-century Klismos chairs deaccessioned from the legendary Villa Kerylos near Nice are a significant tribute to design history. His signed Georges Jacob fauteuil, covered in the original tapestry, is a standout. An eighteenth-century Danish gilded table with a marble top (and royal Danish stamp) stands on rush matting in the sitting area. A seventeenth-century carved, seated Burmese monk, found at Quatrain in Los Angeles, is another piece that gives Volpe daily jolts of joy. These objets contrast with mid-century industrially produced lighting and contemporary photography.

Three years ago, Volpe designed a grand ten-foot-tall Adam-style bookcase to house his growing collection of rare and out-of-print reference books on design, architecture, fashion, photography, art, and travel. Among the designer's newest obsessions, indicative of new

EAST MEETS ZEST *(Above and opposite)* Volpe's most treasured piece of furniture is his extraordinary Régence commode with handcast bronze hardware, each depicting varied whimsical and magical figures. It was his first serious acquisition. The gilded eighteenth-century French mirror was purchased from Ed Hardy San Francisco. Volpe's sinuous chairs, originally crafted in 1902 for Villa Kerylos in Beaulieu-sur-Mer, are from Therien & Co. The Japanese lacquer chest is a fine foil for the richly colored silk draperies.

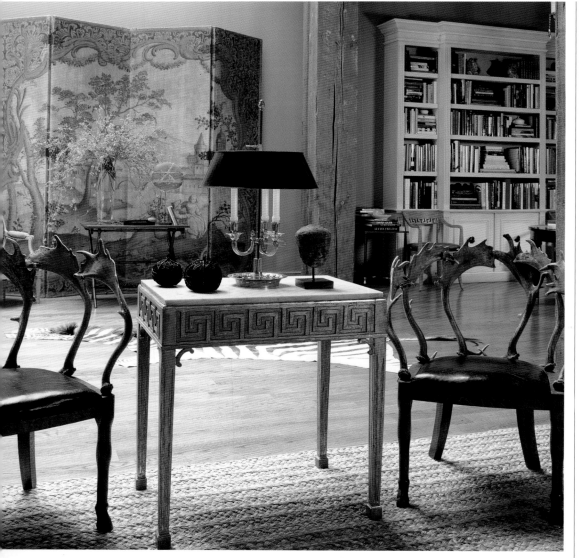

GILDED GRANDEUR *(Above and opposite)* An ebonized table, designed by Steven Volpe, is encircled by a pair of chic eighteenth-century benches from a French convent covered in Brunschwig & Fils silk velvet. The Adam-inspired bookcase was designed by Volpe. The six-foot-tall gilded anchor chandelier is from the Glenn Smith Collection. A pair of chairs with gilded Greek key carving was designed by Volpe for Michael Taylor Designs. The gilded Greek Key table, from a Danish country mansion, stands in elegant contrast to a pair of antique Scottish chairs.

directions in his decor, are first-edition volumes on mid-century French master designers such as André Arbus, Maxime Old, Jacques Quinet, Andre Groult, and Suë et Mare.

> **"I decided to take my time and purchase only pieces I loved and wanted to live with for the rest of my life," recalled Volpe. "I didn't want 'filler furniture,' only things that I couldn't let go."**

"When I am making my rounds through the antiques shops and flea markets in Paris now, I am more and more drawn to the thirties and forties and the work of designers like Jacques Quinet or Maxime Old," noted Volpe. "Their chairs and tables and desks have vestiges of classic proportions and shapes, but they're brisk and modern and energetic. Parisian dealers now are also offering fifties, sixties, and seventies designers as the hottest thing. I love the newness of it. It's refreshing. Design can't stand still."

To his eighteenth-century collections, Volpe adds forties mahogany and steel tables by the legendary Parisian design firm Maison Jansen, and a pair of forties gilded bronze tables by the Parisian design house Ramsay.

"Now I'm looking for seventies French light fixtures in New York and London," said the designer. "In Paris, I want to discover design and craftsmanship before everyone else jumps on it. I like to stay ahead, find resources before design editors latch on to them. As a designer, I want to keep growing. I never want to know it all. I want to keep learning and exploring." ◾

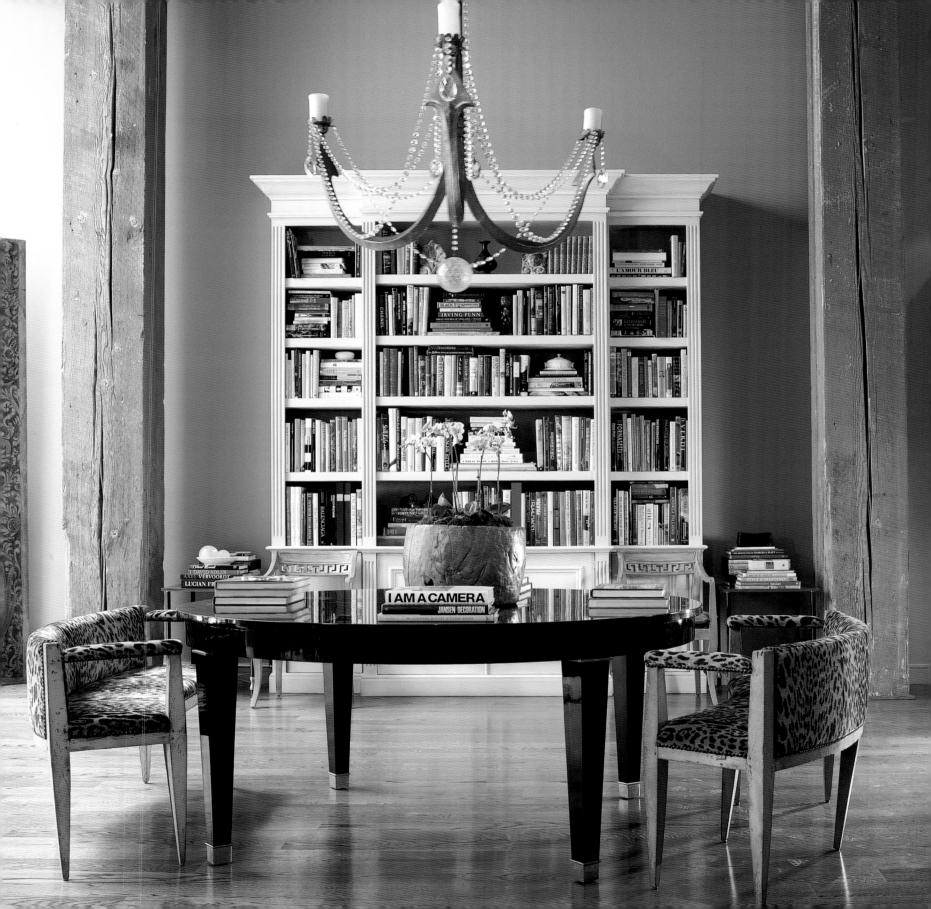

ART-FILLED AERIE

MARTHA ANGUS & CHRISTOPHER FLACH ON NOB HILL

Interior designer Martha Angus and her husband, Christopher Flach, a fine art photographer, trip the light fantastic in their new Nob Hill apartment. They live in one of those legendary views-for-days San Francisco apartments that everyone dreams of finding.

Situated on the crest of Nob Hill, the eleventh-floor apartment affords lyrical vistas of the city and the bay with only an occasional clang of the California Street cable car to break the silence. Rooms are gracious and full of light.

Viewed from the couple's living room windows, the Golden Gate Bridge looks like a delicate loop of red thread, stitching together Fort Point and the Marin Headlands. Lafayette Park's Cézanne-green crown, and the scribble of streets criss-crossing Pacific Heights, are revealed from the window beside a neoclassical banquette in the dining room.

"I never used to think a view was tremendously important, but now I've changed my mind," said Angus, whose client list includes notable art collectors. "I focused on the interior architecture and decor of these rooms, but the views draw you to the windows."

Grace Cathedral comes into view from almost every room, and its massive silhouette is as compelling as any Parisian scene. The late-winter-afternoon sunsets turn the living room pink or gold.

Angus, whose decorating touch is light and confident, designed simple ecru silk curtains to frame their cityscapes. Colors in the rooms are deliberately calm and subtle. Angus paired the light-as-air draperies with ivory-painted walls for a seamless, floating feeling. The oak plank floor was bleached and hand waxed.

Each room gains drama and humor from the couple's growing art collection.

In the living room hangs an in-your-face self-portrait etching by Chuck Close. A Christo *Wrapped Trees, Project for the Avenue des Champs-Elysees, Paris, 1987* is propped on the floor beside the sofa.

LEFT-BANK DREAMS *(Opposite)* An ebonized and cerused oak coffee table in the style of Ruhlmann is juxtaposed with a pair of neo-classical Piedmontese *chauffeuses* upholstered in vintage Fortuny fabric. The Paris thirties-style sofa is upholstered in practical faux suede. Pizza-eating is allowed.

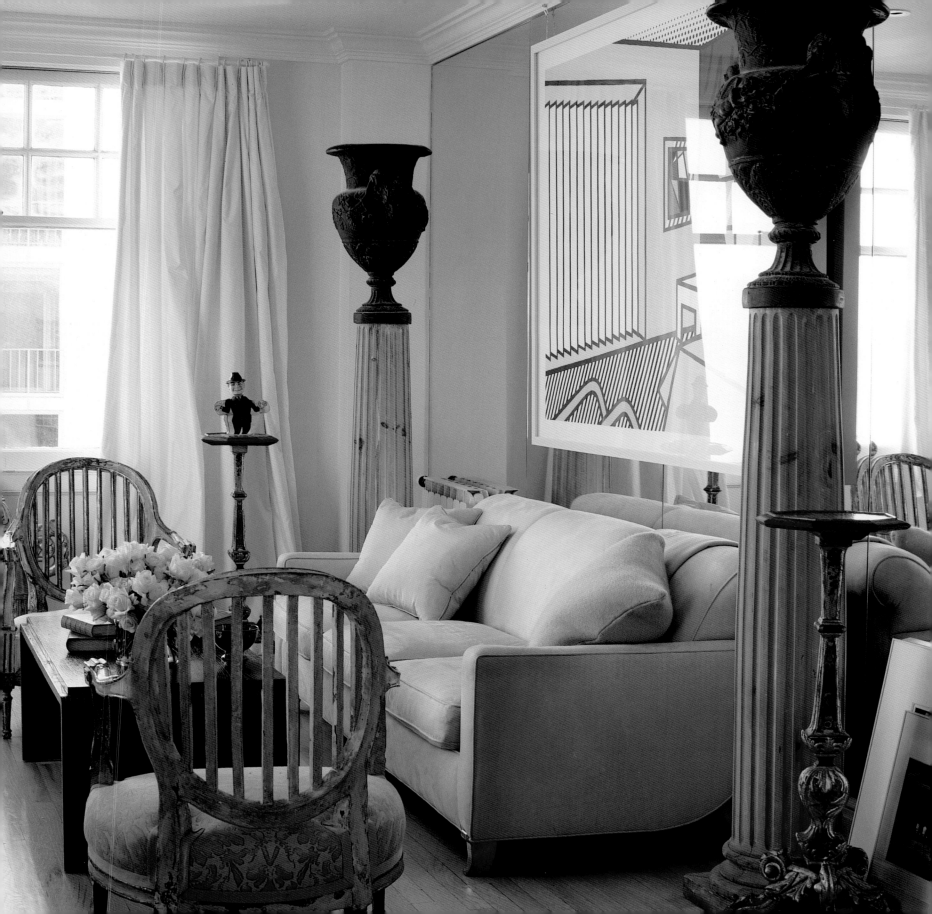

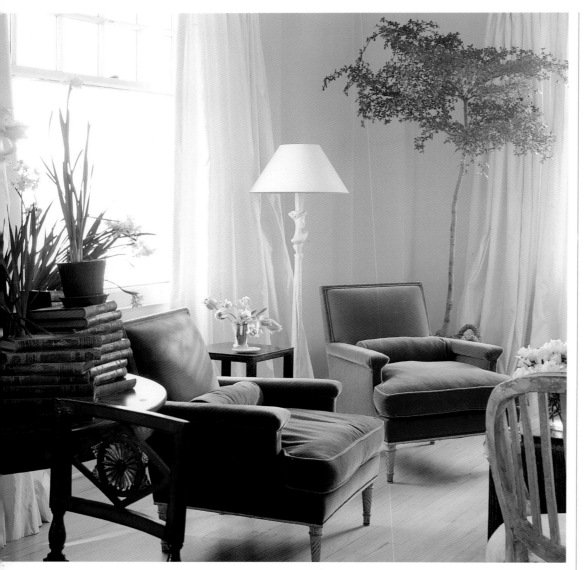

FRENCH LESSONS (*Above*) A pair of sixties Maison Jansen chairs found in Paris was upholstered in mushroom-colored mohair.

HEAVEN IS IN THE DETAILS (*Opposite*) Martha Angus offers close-up delights: white roses in a simple glass vase on a cerused oak table; an antique Swedish clock, which still indicates the correct time; the cerused tabletop created from an inspiration by Jacques-Emile Ruhlmann; and the scroll of a Gustavian bench.

Angus and Flach have a fondness for American mid- and late-twentieth-century artists. Pieces by James Rosenquist, Andy Warhol (his iconic Mao Tse-tung silk screen), David Salle, and Roy Lichtenstein, as well as an ink drawing by Henri Matisse, are displayed throughout the apartment.

"I have always loved this elegant building, with its Art Deco-ish trappings," noted Angus.

"Art is always the most important aspect of the interior, for me," said the designer. "The draperies and furniture back up the art. I have a degree in painting, so I care about the placement and lighting of the art, beyond belief."

Their Chuck Close etching, simply framed, hangs on the ivory-painted wall of the living room above a white plaster sphinx with the body of a lion. The mythical creature has the neatly coiffed eighteenth-century-style head and voluptuous *poitrine* of Madame de Pompadour. The original sphinx stands in the garden of the Ritz hotel in Paris. A witty silk screen of Jayne Mansfield in a bikini looms nearby.

"I like artworks on paper because there's often more spirit and immediacy," noted Angus. "I collect etchings, lithographs, and silk-screen pieces for their graphic quality, the lightness and freshness."

In the dining room, Angus has juxtaposed a pair of Louis XVI-style carved giltwood fauteuils from Therien & Co. and a fanciful giltwood tole chandelier with framed black-and-white photographs by Flach of the gardens of Versailles.

In the living room, an elongated buff-colored twenties-style sofa and a pair of Maison Jansen chairs form a conversational group with a curvy

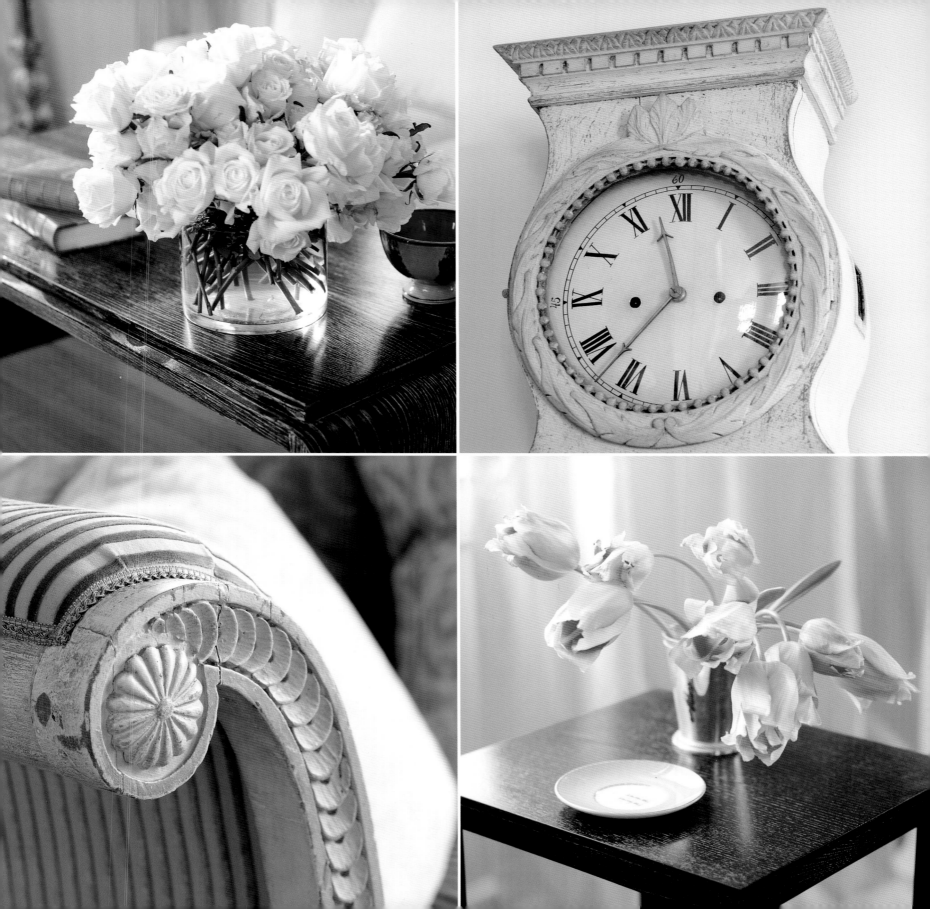

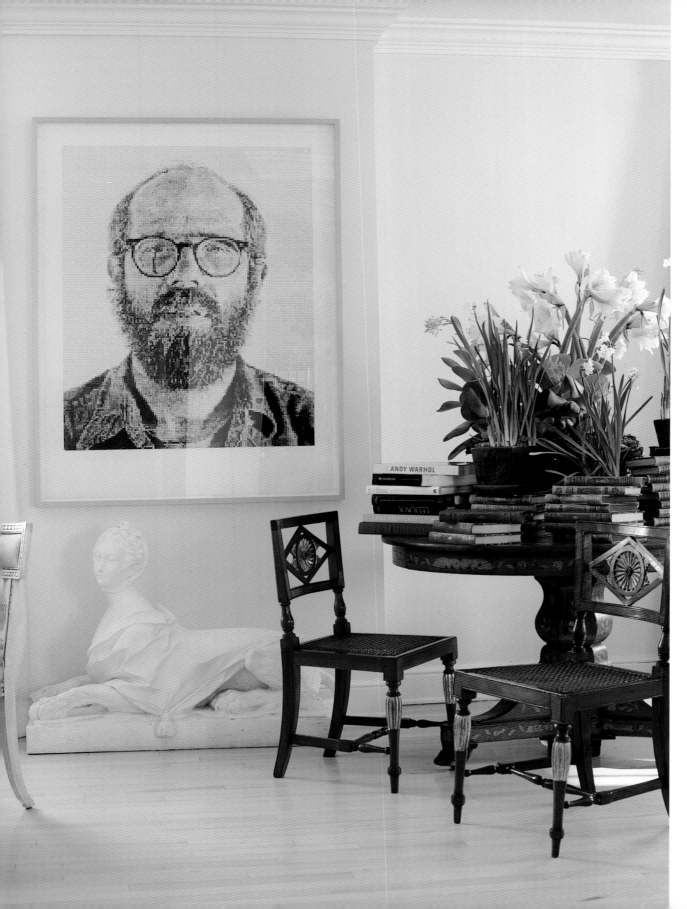

CLOSE UP-CLOSE *(Left)* A 1977 self-portrait on paper by Chuck Close, from the John Berggruen Gallery, gazes and draws the eye above a plaster sphinx in the French style with the face of Madame de Pompadour. The eighteenth-century Swedish neoclassical chairs are from Therien & Co.

INTERNATIONAL TRADE *(Opposite)* A granite-topped iron table from Therien Studio works with a painted Directoire bench covered on Nobilis striped velvet. Swedish antique chairs are all from Therien & Co.

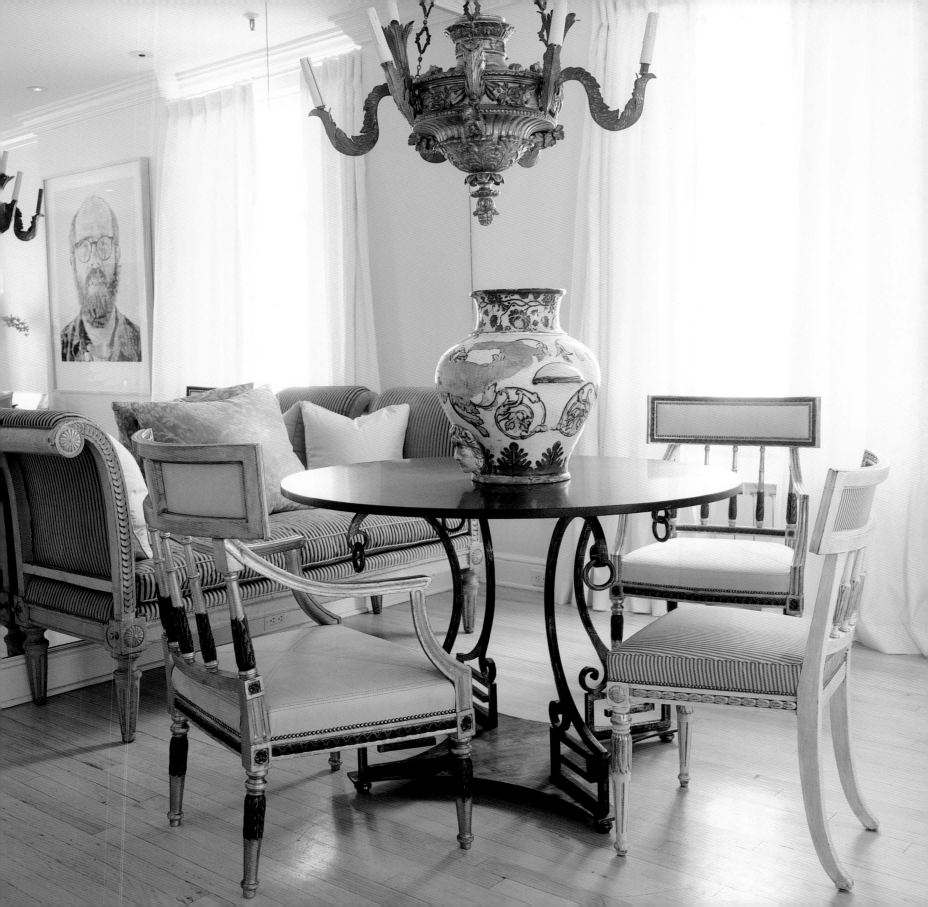

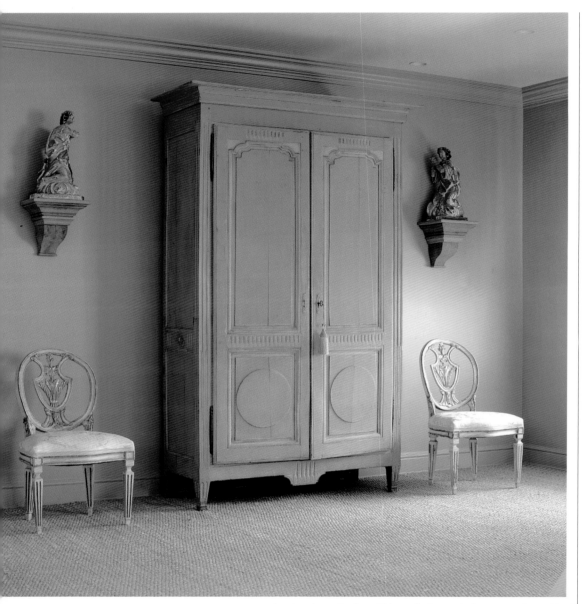

SHADE OF PALE *(Above)* A painted armoire from L'Isle-sur-le-Sorgue in Provence is framed by a pair of Italian neoclassical oval-back chairs, acquired in Montecito.

GRACE NOTES *(Opposite)* The flourishes of Martha Angus's bedroom decor include flowers in a silver vase on a French neoclassical *commode* beside her bed.

pair of Italian neoclassical *chauffeuses* with gilt-trimmed and scroll-carved arms and Fortuny seats.

"I've been in and out of art and antiques auctions my whole life," Angus said. "I was bitten by the antiques bug, thanks to my grandmother, when I was ten years old."

Angus is a perfectionist who avoids anything that smacks of a fad.

"I've seen design trends come and go, and I avoid trendy colors and styles," said the designer. "They're captivating for a second or two, but they are not a good investment. I prefer top-quality antiques and art that you love and want to live with forever."

Angus dressed her bedroom with plaster *bas relief* busts in graphic mahogany frames, along with a French Empire mahogany marble-topped commode and a nineteenth-century gilt-bronze mount portico clock underscored with an Aubusson carpet. The gray-ivory paint color of her bedroom walls was computer generated to match the Henry Calvin linen Roman shades and headboard.

A James Rosenquist lithograph and a charming Henri Matisse pen-and-ink drawing hover above an early-twentieth-century patinated bronze athlete figure mounted on a polished black slate plinth.

"I love pop art and black-and-white photography, combined with antiques and tailored upholstery," noted Angus, whose Bush Street atelier is decorated with black-and-white blowups of eighteenth-century French gardens by Flach, as well as a collection of antiques from Therien & Co. "Contrasting fine antiques with contemporary art and photography gives them all an edge." ◼

La Petite Maison

STEPHEN SHUBEL & WOODY BIGGS IN SAUSALITO

San Francisco interior designer Stephen Shubel, his partner, artist and prints purveyor Woody Biggs, and their dog, Rosie, share a one-thousand-square-foot Sausalito captain's cottage that feels as if it was washed up on this sunny hillside overlooking San Francisco Bay. Their charming shingled bungalow was built soon after the 1906 earthquake.

When the duo acquired their retreat, after living in Berkeley for a decade, it had great potential but lacked a foundation. The roof leaked, and the interiors were dark and post-hippie sixties funky.

Shubel can see past downtrodden decor, and these drawbacks did not deter him. He is known for lyrical and worldly rooms that effortlessly combine crisp, clean architecture with poetic colors. He quickly brought in painters and gave the house buckets of white and cream paint.

"Color sets the mood and can even 'rearrange' the visual space of a room," said Shubel, who chose pale cream dashed with lots of white and a splash of orange for the furnishing of his own Sausalito house. "Using different color combinations is tricky, but when done right, you know it. As the French fabric designer Manuel Canovas said, 'There are no bad colors, just bad color combinations.' I am particularly fond of rich cream or apple green with white. They look fresh and work well with black and with all woods, with silver and all the things I collect in France."

Shubel seldom uses bright patterns, seldom prints.

"If you want a neutral palette, nobody does it better than Mother Nature, so I look outside at the fog, or the clouds, or my garden for ideas for clients and myself," he said.

"I think the worst decorating mistake you can make is to design rooms that look too 'done,' too serious, too 'decorated,'" said Shubel. "It's never wise to be too trendy, either, or too much of the moment. Furniture has to last."

THE ART OF RELAXATION *(Opposite)* Stephen Shubel has covered the floor of his living room with seagrass and painted the walls and fireplace a chalky white with a dash of cream. His dog sleeps on the sofa and chairs, so Shubel selected washable denim and hard-wearing mohair for sofas and chairs. He collected many of his antiques, objets d'art, paintings, and decorative objects in Paris and Angers. The clock and collage are by Woody Biggs. Table lamp from the Stephen Shubel Collection at Shears and Window.

Shubel detests paint-by-numbers traditional rooms and design that is stiff and intimidating, preferring decor with charm, wit, and comfort.

"Rooms often benefit from something a little subversive," he said. "I like acid colors for contrast, some gilded objects from the flea market juxtaposed with precious antiques. Contrast makes a room come to life."

And there's a flip side to their California life. Five years ago Shubel and Biggs acquired a five-hundred-year-old limestone town house near Angers in historic northeastern France. The classic architecture, all original, is extraordinarily handsome and intact.

Now Shubel works from his French house several times a year, finding antiques for his San Francisco clients and decorating Paris residences.

"My clients in California and in France want rooms with style that are comfortable and easy to live with," said Shubel. "I work closely with an architect to get proportions and floor plans right. As with my own house, I always aim for freshness and elegance without making rooms look bourgeois."

Shubel creates fresh schemes for Brion and for Sausalito.

"I want my new designs to be inspiring, highly individual, and full of new ideas," Shubel said. "I love bringing back all my collections from France—paintings, sculptures, old tables, rare etchings and engravings, decorative porcelains, an old bed, country linens."

He loves Sausalito, said Shubel, but he's thrilled by visits to France.

"Paris has some of the world's most beautiful architecture, and walking along the street is an adventure," he said. "Each time I travel to Paris it's as if it's my first time. The city mixes new design and contemporary art with its centuries of history and blends the past with the present. For a designer, it's fantastic inspiration, whether I'm taking coffee at the Café Marly or wandering, lost, around some obscure corner of the Left Bank. The Loire Valley is invigorating and inspiring, too, with all the chateaux. I drive to explore the region from my house near Angers, and this constant flow through the history of France always impresses me. Then I bring it all home to Sausalito." ▨

SOUL OF THE SEA *(Right)* Shubel believes that it is generally a mistake to whomp up a small house or to give tiny rooms airs. Instead, he brings in generous furniture for extreme comfort, a judicious gleam of gilt for a jolt of glamour, casual collections, and a sly reference to the origins of the house. The stair handrail is a thick jute rope, just to keep everything shipshape. The easygoing chair is covered in orange velvet.

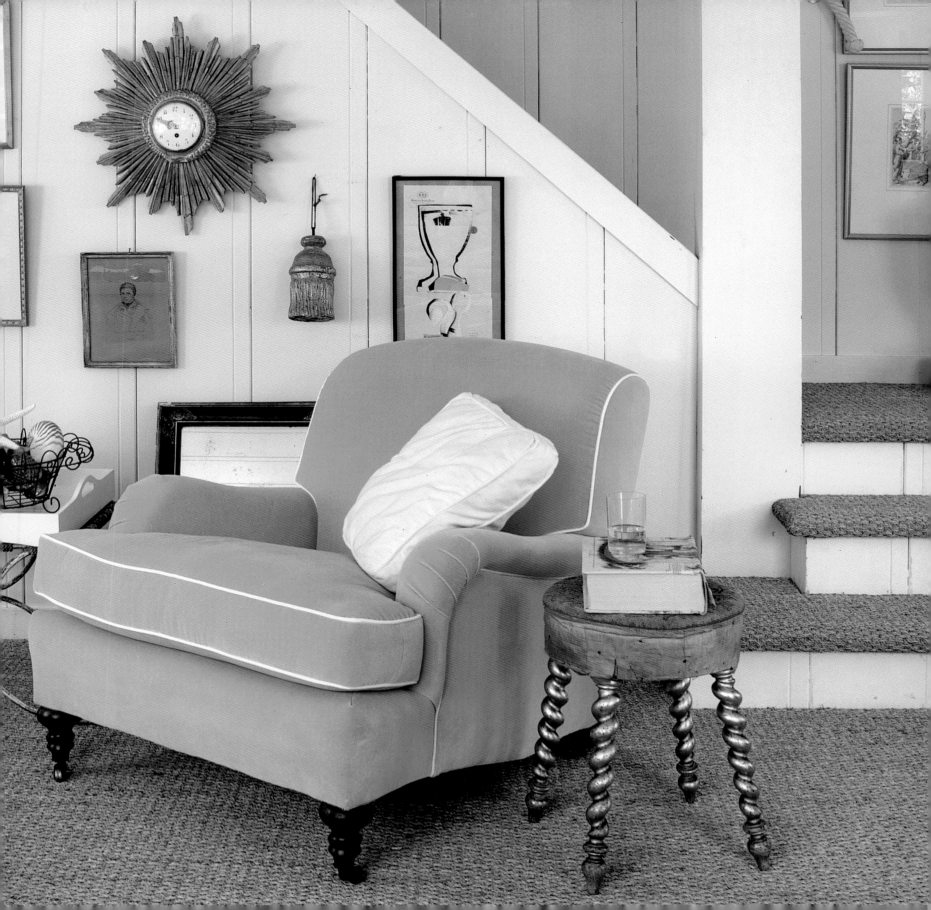

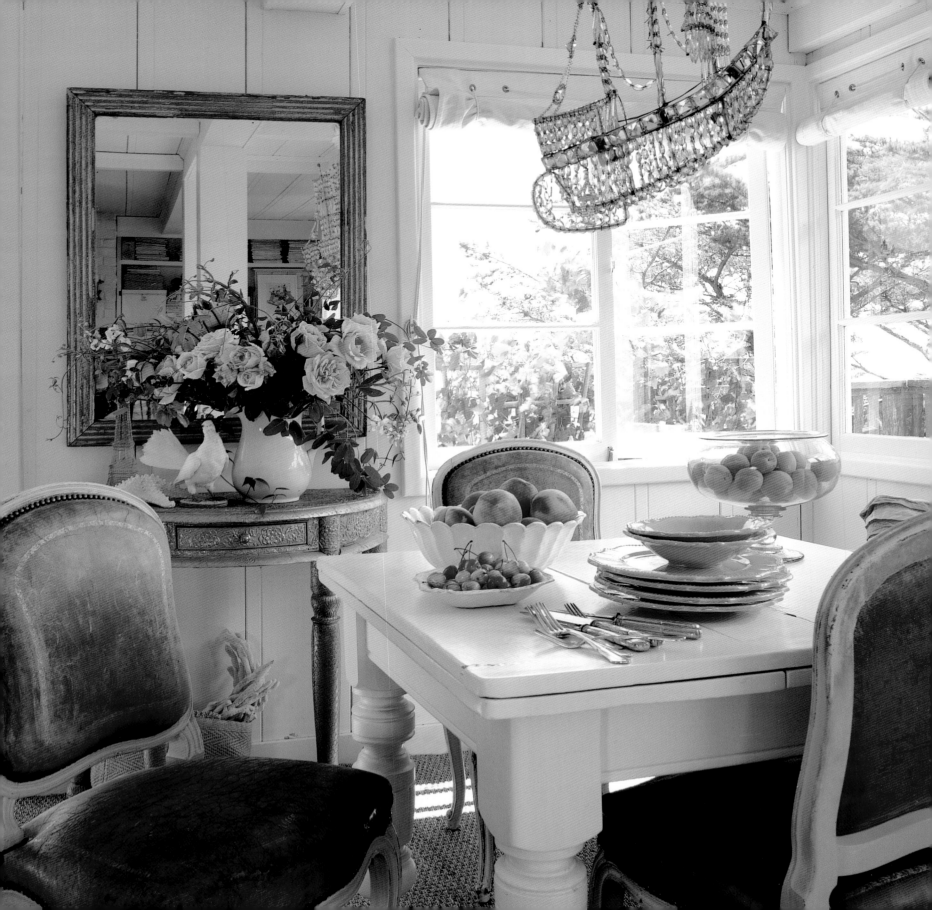

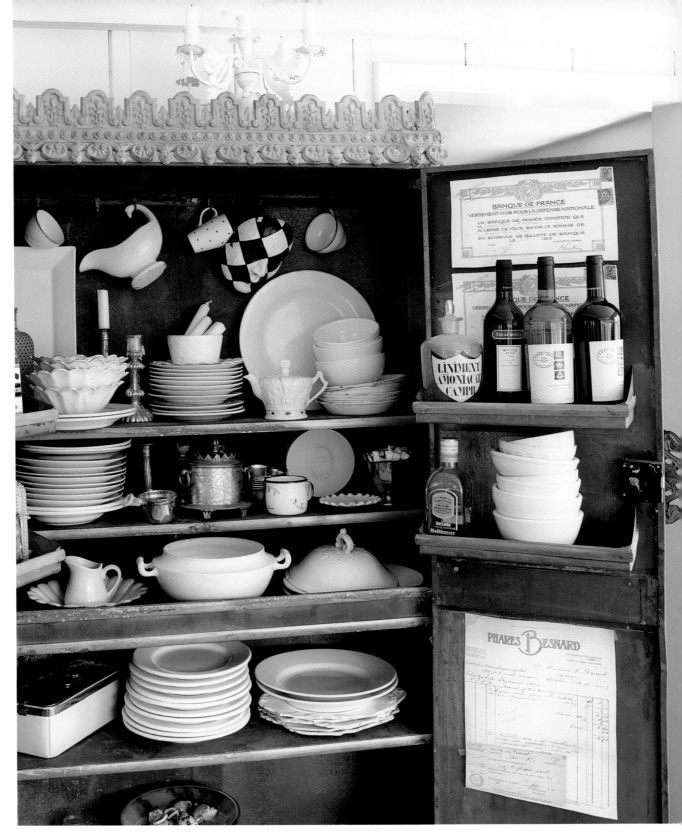

OPEN HOSPITALITY *(Opposite)* Shubel and Biggs delight in entertaining and make a habit of collecting French pottery and table decor (Shubel loves Astier de Villatte collections, from Sue Fisher King), French antique silver, and Venetian and French glasses. The silver *demi-lune* table, left, is an Indian antique. The crystal galleon and the leather-upholstered chairs were Paris flea market finds. Armfuls of roses from the garden complete the setting.

FRENCH STYLE *(Right)* Shubel has just three rules for the ironstone, porcelain, and pottery he collects in France, San Francisco, London, and New York: it must be old, it must be white, and it must not be too cleaned up or prissy. On each visit to Paris, he finds old silver and prefers to leave it tarnished and mysteriously beautiful.

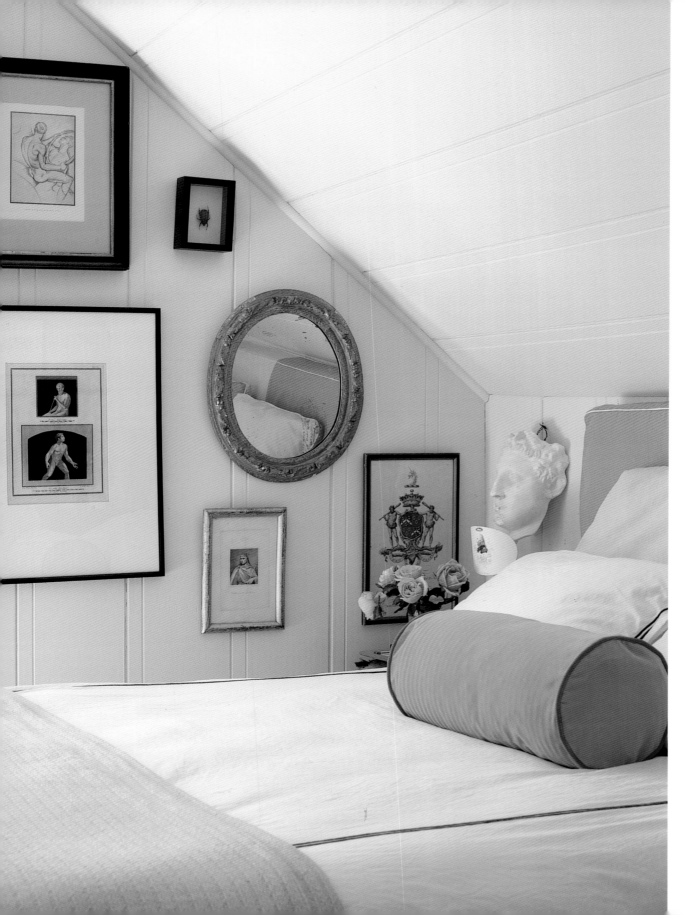

A ROOM OF ONE'S OWN *(Left and opposite)* The house was originally built for a seafarer and has a maritime air. Shubel seized on the sea concept and designed a built-in ship's bed for Biggs's bedroom. Shubel sleeps under the eaves in the tailored bed, with French prints found in the Loire Valley. An inveterate, lifelong collector, Biggs stacks his parchment covered books on the floor, along with old prints, a gilt footstool, and quirky objects found at French countryside fairs.

GOING FOR BAROQUE

ANDREW FISHER & JEFFRY WEISMAN ON NOB HILL

San Francisco artist Andrew Fisher creates rococo decor with shells, coral, paint, gilt, and his own free-floating imagination. He has never encountered a chair or table he could not improve with lavish embellishment of sea creatures. Fisher's chosen decorative technique is to apply a collage of limpets, pearlescent oyster shells, gleaming shards of abalone, chips of mirror, found objects, and treasure chests of crystals, glass beads, and branches of coral—real and wonderfully faux—to tables, chairs, candlesticks, picture frames, and chandeliers.

Call him Fabergé with a glue gun.

On a glass-topped table in his living room stands a pair of candlesticks with gilded stems shimmering with crystals and volutes, a theatrical chinoiserie temple roof and gold lotus leaves. They look like rare finds from a forgotten antique shop in Malacca or Kota Kinabalu, but were made by the fervent Fisher for his own amusement in his own atelier.

The happy results of Fisher's more-is-more baroque artistry are glamorous and eccentric tables encrusted with layers of sun-bleached black and white mollusks and mussels, as well as loopy and glamorous chandeliers dripping with tiny scallops, convoluted limpets, nacreous oyster shells, and chunks of branch coral. In his living room prance a series of ballroom chairs with backs transfigured by faux coral splats painted rich coral red. Chippendale would approve.

"I love ornamentation and baroque design," says Fisher, a partner with Jeffry Weisman in the seven-year-old San Francisco design and decoration firm, Fisher Weisman. Fisher's designs are custom ordered through Fisher Studio.

"I have busy hands, and I like to turn plain furniture and accessories into something richer, more theatrical," noted Fisher. "I use shells by the ton to cover even the smallest table. Once I start on a piece, it's no holds barred."

FANTASY AND FROLIC (*Left*) Andrew Fisher does not merely embellish: he lavishly embellishes the embellishments. His new coral trees in gilded urns are set on coral and shell-studded columns.

MIRRORED WIT (*Opposite*) The eighteenth-century Portuguese mirror above the French marble mantel in the living room was a gift from Tony Duquette. Paintings are by Andrew Fisher. This cosmopolitan mix includes an eighteenth-century table from Lucca, on the right side of the fireplace, and eighteenth-century fauteuils from Foster Gwin.

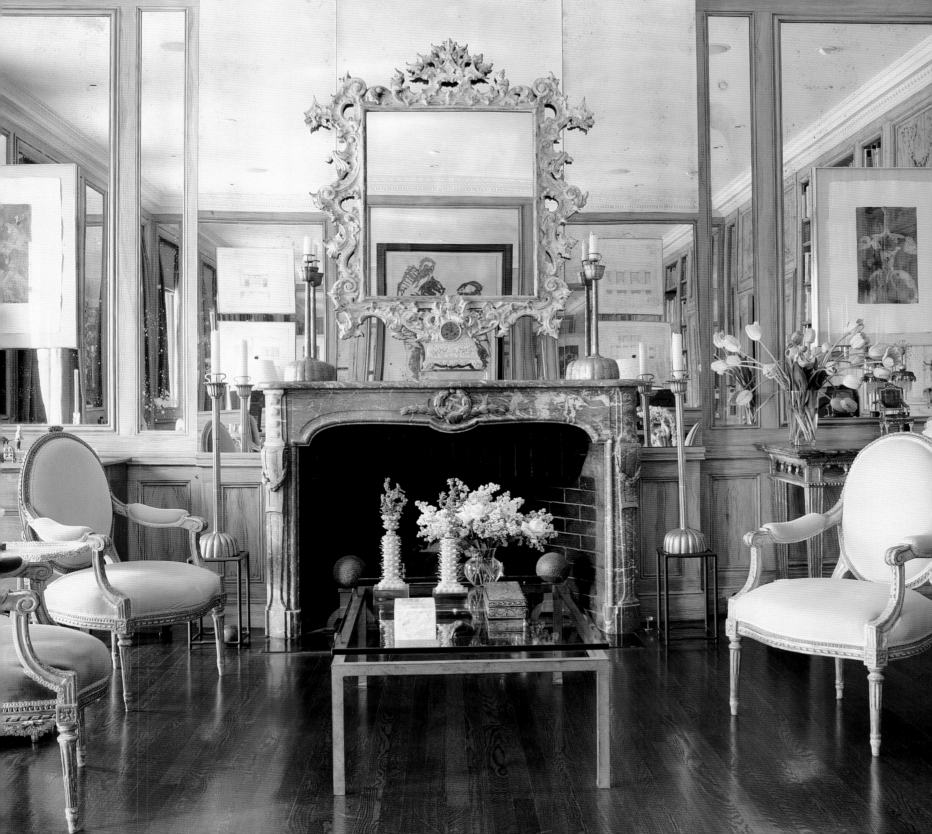

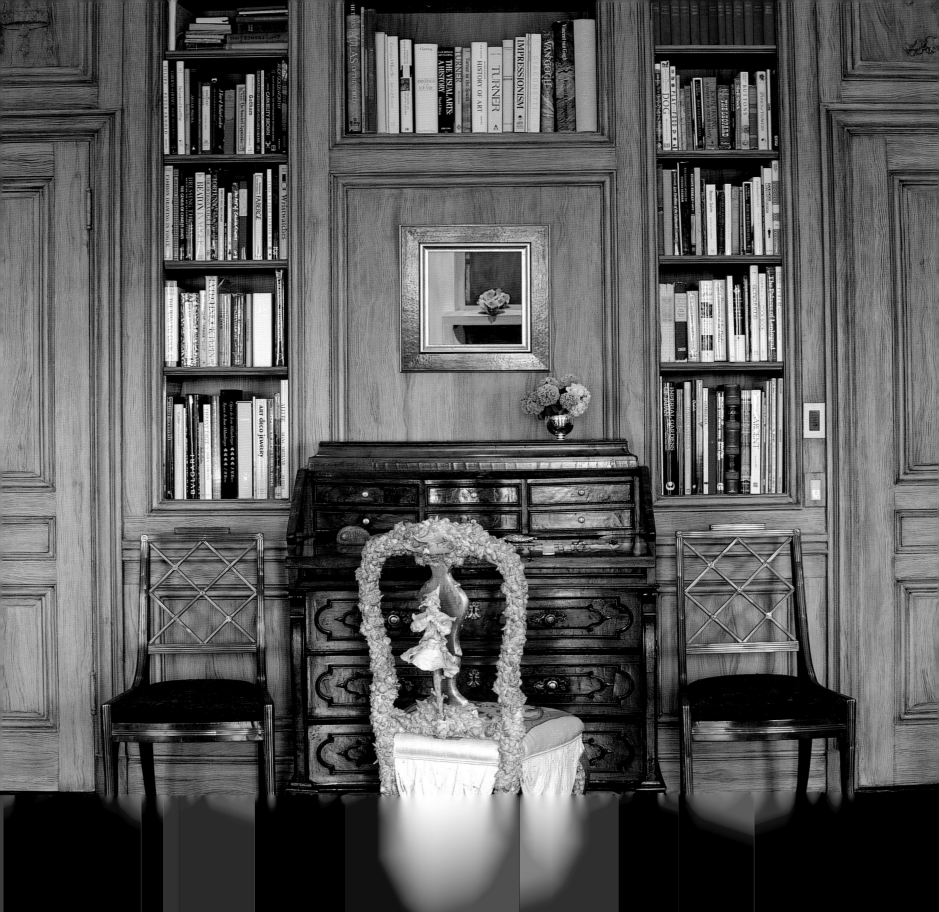

Fortunately his Nob Hill apartment, an elegant pied-à-terre that he shares with Weisman, can accommodate Fisher's over-the-top creations. He recently installed an eight-foot-tall chandelier in the dining room, its elongated skeleton covered in tiny white mollusks.

Mirrors in his atelier are decorated with rococo flourishes of oysters and bleached lobster shells as if they were precious gems, to conjure wacky grandeur and a touch of Jean Cocteau surrealism.

In his dining room at night, candles balanced on the shell-shocked chandelier flicker in a series of antiqued wall mirrors. The mercurial surfaces shimmer like ice crystals, catching and refracting the poetic winter light from downtown San Francisco.

"Guests at our house love this theatrical style," said Fisher, who also works on projects in his Sonoma County retreat and for private commissions.

Completing his labor-intensive designs is like meditation, noted Fisher, who formerly worked as an assistant to Los Angeles design legend Tony Duquette.

"It nourishes my soul to create these rich designs," he said. "It's the process that's thrilling for me."

Fisher studied sculpture, painting, and jewelry-making at the California College of Arts and Crafts in Oakland and still finds time to design and craft fine necklaces, brooches, and bracelets. He recently embarked on a series of large-scale self-portraits on canvas.

Fisher also masterminds smaller tabletop decor including candelabra, small picture frames, lamps, obelisks, coral trees in silver urns, and shell-covered boxes. He is currently designing a trio of eight-foot-high chandeliers with translucent oyster shell lamp shades, brass rods, and shell swags for an atelier.

Fisher works on his designs at night and on weekends for clients impatiently awaiting their bravura mirrors and tables ornamented with *coquillage* and bedecked with gold. He is making them as fast as he can. ▓

HE SHELLS *(Above)* Fisher's new chair is ornamented with a fantasy Oriental figure.

SWAGS OF STYLE *(Opposite)* In Weisman and Fisher's library, a new swagged chair by Fisher contrasts with the eighteenth-century Lombardy drop-front desk and a pair of nineteenth-century Russian occasional chairs upholstered in woven peacock-feather fabric by Christopher Hyland. The *faux bois* paneling is by Karin Wikström.

MATERIAL GOODS *(Above)* Fisher is a virtuoso in many media, including gilding and fine eggshell work. His new occasional table has an eggshell and lacquer top and a shell-encrusted base.

BRANCHING OUT *(Left)* A custom console by Fisher Weisman has a gilded steel base and sandblasted solid walnut top. The silk pillows are Scalamandré silk, and the green cashmere throw is by Frette.

CANDLELIGHT SERENATA *(Opposite)* Andrew Fisher created his new shell chandelier in a fantasy lantern silhouette. The black lacquer dining chairs by Michael Taylor Designs are upholstered in black calfskin (Randolph & Hein). Rock crystal votives are by Tony Duquette.

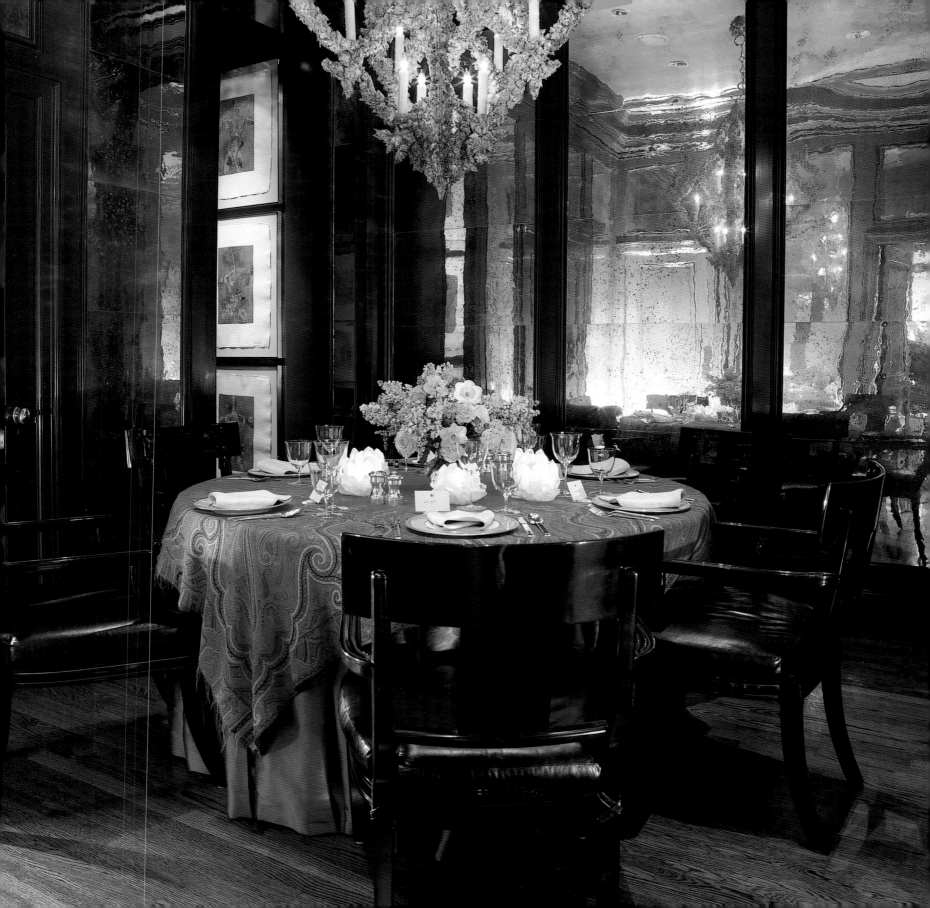

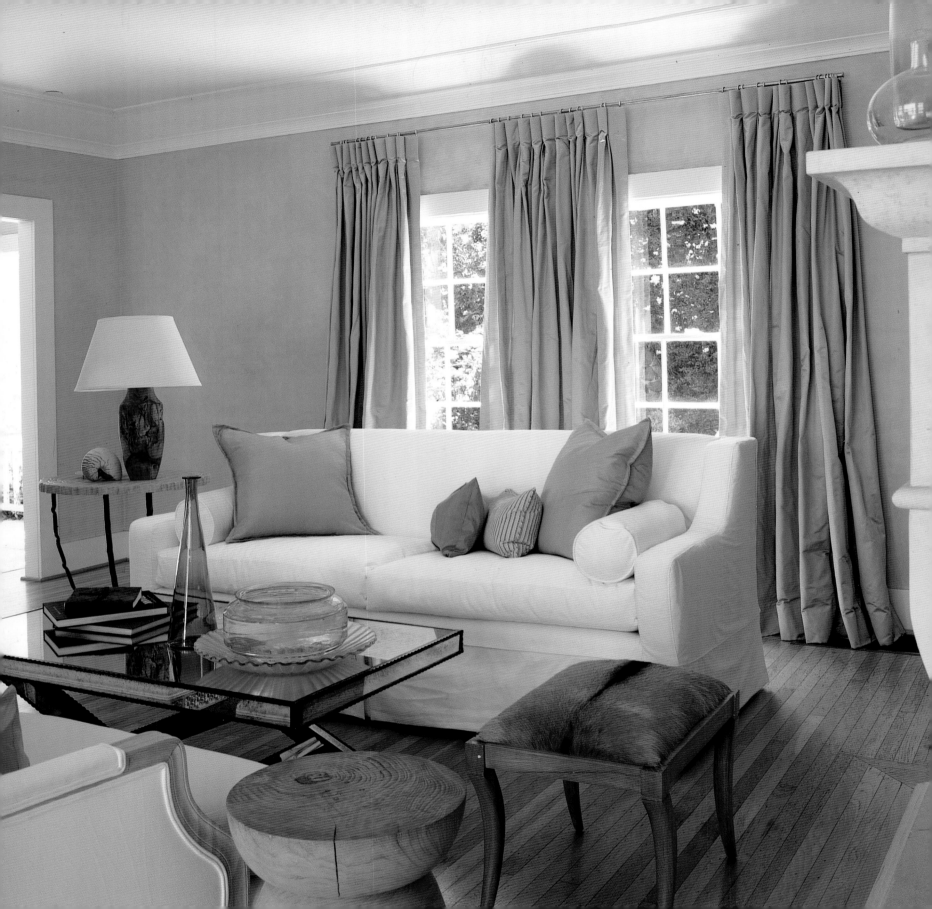

The LIGHT of Day

KATE MCINTYRE IN SAUSALITO

In Kate McIntyre's garden in the green hills high above Sausalito, Sally Holmes roses float like pale pink fairy floss among lavender, shell-pink penstemon, and fragrant mauve verbena. It's a romantic scene, perfect for the Botticelli blonde McIntyre and her young daughter, Olivia.

Kate, a furniture and interiors designer and co-owner and co-founder of Ironies, with Brad Huntzinger, planted roses and palm trees as soon as she found the house six years ago. She wanted the garden to flourish even before she started working on the house.

"When we acquired the house, the interiors had been pushed in a Craftsman-style direction, and the interior was very dark and woodsy," recalled Kate.

It was the location that drew her, not the dated decor.

"We gave the walls coats of integral plaster in a golden wheat color and left it a little rough for a relaxed, rustic feeling," Kate said. "The plaster instantly made the rooms feel lighthearted and sunny and gave the house the toned-down Mediterranean feeling we wanted."

Floors were sanded and bleached. The house feels cheerful, like living in a summer house year round.

French doors and decks were added to take in views of Mt. Tamalpais, Belvedere, and the bay. A dreamy, airy, and very private setting, it feels more like Bellagio than Sausalito.

Kate's route to Sausalito and to design stardom was a circuitous one. After studying English literature in upstate New York, she met her future business partner, Brad Huntzinger, on a job site in Marin County, where he was performing artistic paint magic.

"We started Art of the Muse together in 1988 and specialized in decorative painting and furniture. Soon after, we founded Ironies to design and sell handcrafted iron furniture," said Kate. The Ironies collections, which are shown in twelve design showrooms around the country, now include forged-iron beds simulating bamboo, inlaid stone-topped tables, wood headboards handcarved for a wave effect, *verre eglomisé* beds, carved coral

MIRRORED GRACE *(Opposite)* Kate McIntyre's ongoing experimentation with contrast, juxtaposition, and distillation of shapes is evident in her Sausalito living room. Oly and Ironies chairs, tables, and lamps live happily with beach finds and curtains by the Silk Trading Company.

mirrors and chests, cut obsidian chandeliers, silver-leafed carved coral-decorated wood cabinets, faceted mirrors, *verre eglomisé* frames, and limestone fireplaces. They also founded Oly, a design company that produces French-inspired furniture, as well as ceramics made in Vietnam, rustic accessories handmade in Indonesia, and a variety of chic and inventive mirrors and adornments for interiors.

Working closely with small ateliers in Indonesia, Huntzinger and McIntyre have developed and encouraged skilled carvers, silver-leaf artists, mirror artisans, and wood finishers. In between intense weeks in these studios, the duo travels to beaches and into the jungle.

"Our greatest inspiration is nature," Kate said, as she picked roses for her entry foyer. "Trees, shells, coral, leaves, bamboo, twigs, colored stones, and flowers all have been important sources for imagery, color, and silhouette ideas. We like to keep products fresh and interesting because we get bored easily and are always experimenting, exploring, and traveling to find the next wonderful thing."

And they have the daily pleasure of living at home with their creations. Some of Kate's furniture pieces and accessories are one-of-a-kind prototypes, some are discontinued objects, and others are classic Ironies.

"As the sun rises, the interior of our house glows," Kate said. "It's very quiet and peaceful here because we are surrounded by hedges, English laurel, and camphor trees. It's perfect for privacy, shelter, and escape." ⌗

NATURE'S TREASURES *(Above)* "Brad and I are enthusiastic collectors of ceramics, shells, glass, leaves, branches, ferns, and seedpods," said Kate. "We are drawn to the organic shapes of shells, or a handblown glass, with the feeling that each is one-of-a-kind and precious. We appreciate artists' dedication to their craft." The celadon vases and vessels are made for Oly in Vietnam.

MUTED TONES *(Opposite)* "Ironies is not exactly a traditional collection, but we sometimes go in a rather traditional direction," noted Kate. "Then we'll give it a twist, a tweak or two. For my own chairs, I had daisy chains carved around the frame. I wanted this house to be girly and feminine for Olivia and me." Hand-embroidered butterfly pillows by Oly also dress a tailored sofa covered in tailored denim slipcovers.

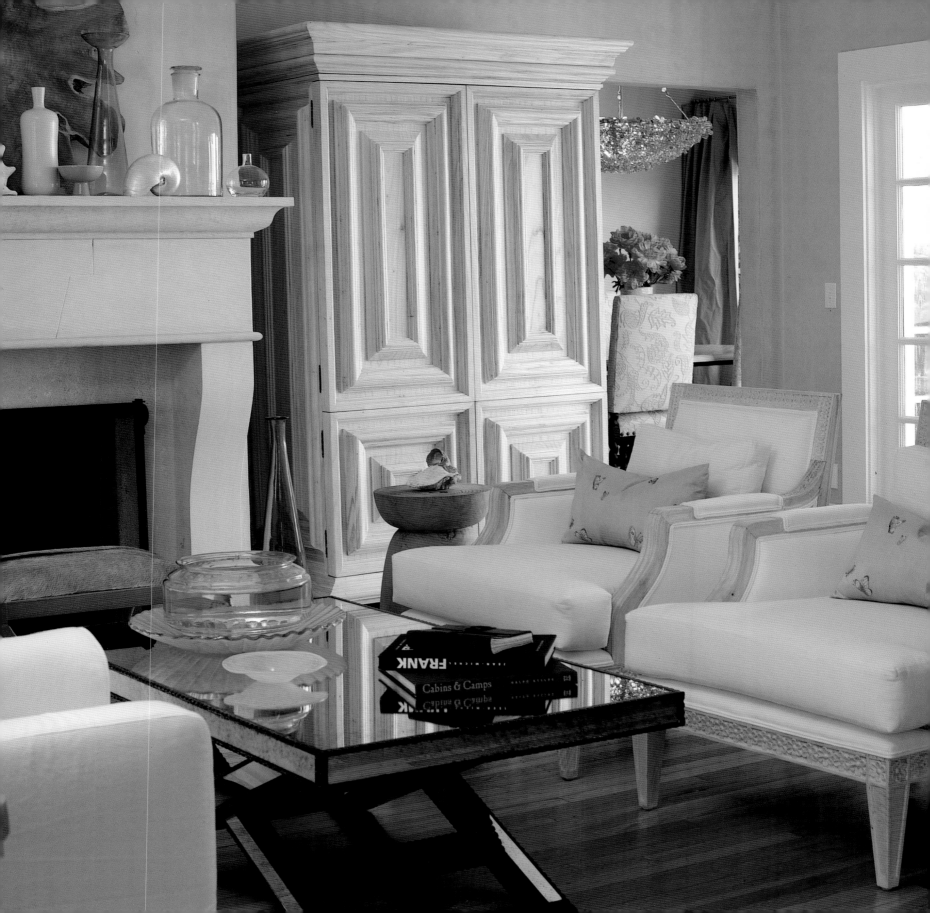

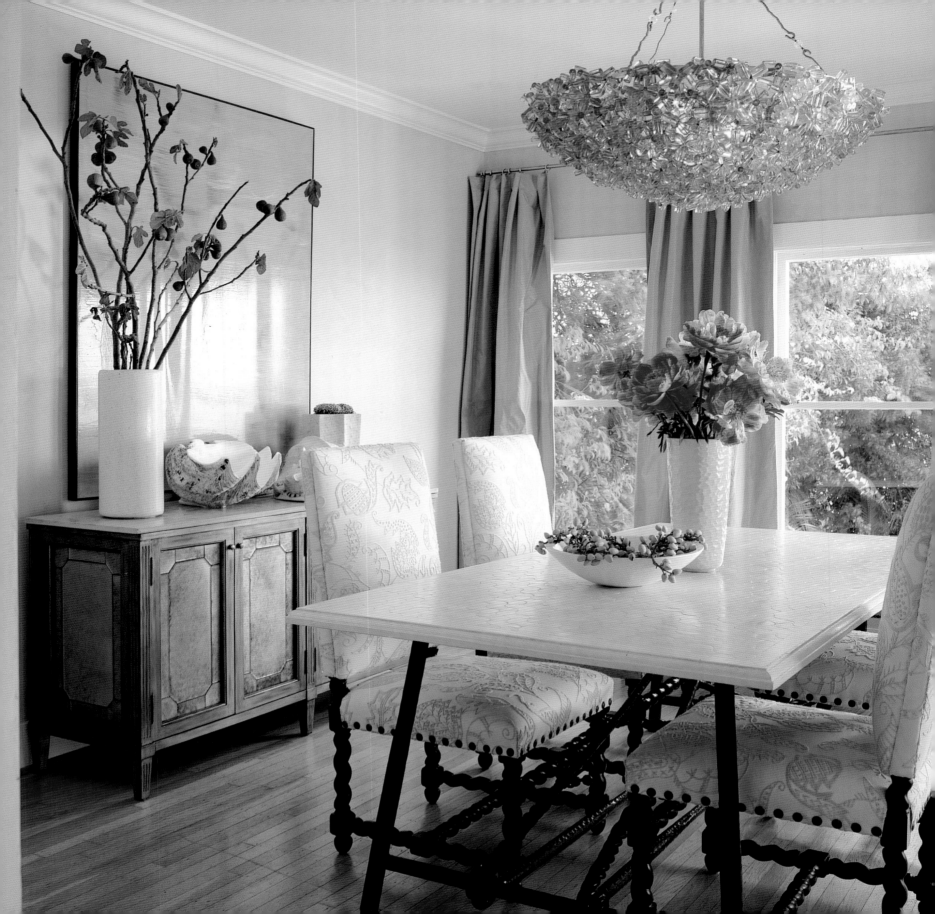

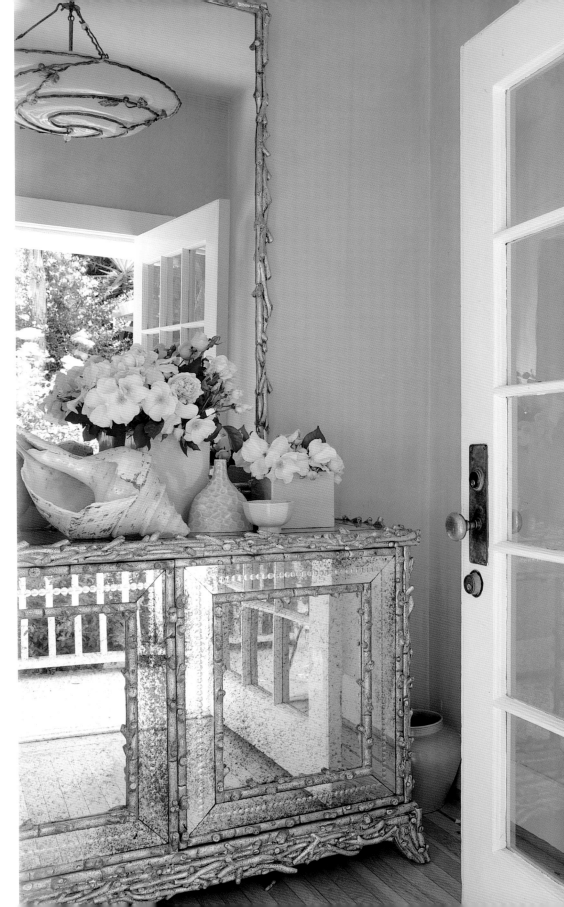

DELICIOUS DECOR *(Opposite)* In the dining room, the Siren table, with an inlaid top, is circled by the Ironies Bianca chairs with Travers crewel fabric seats. The chandelier, of Plexiglas beads, is a new Ironies prototype, not yet in production. It is to be made in glass, a complex operation.

SUNLIT REFLECTIONS *(Right)* In the entrance, armfuls of Sally Holmes roses are arranged on the Trove cabinet. It's crafted from individually carved coral-shaped wood twigs, which are silver-leafed and individually attached to the wooden frame. The doors are antiqued mirror glass.

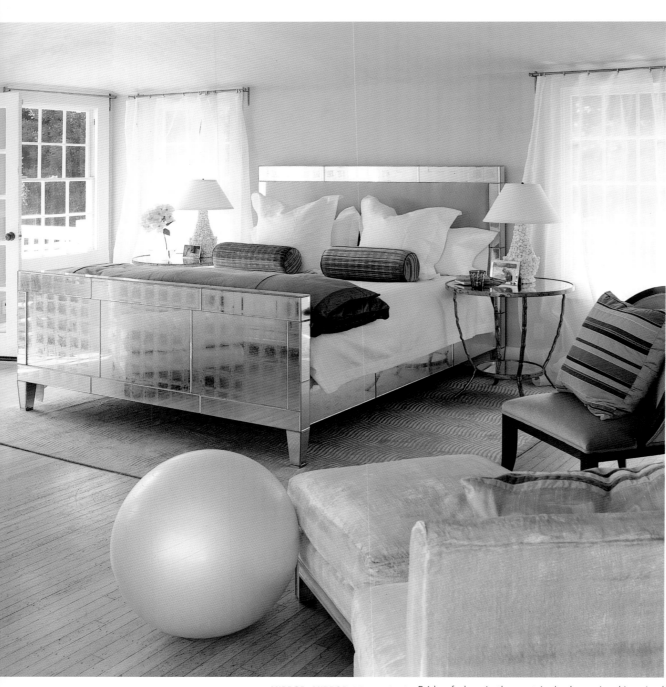

MIRROR, MIRROR *(Above and right)* Pride of place in the upstairs bedroom is a king-sized Ironies bed crafted of *verre eglomisé* panels. Each panel of glass is silver-leafed by hand to create an antique mirror effect. The Pearla chairs and shell lamps are by Ironies. The Ironies slipper chair is covered in silk velvet. New Ironies Gallen cabinets have honed mirrored glass doors and a birchbark finish. Tables and the mantel serve as platforms for Kate's personal expression; each vase, flower, leaf, shell, and lamp is positioned as carefully and reverentially as an offering.

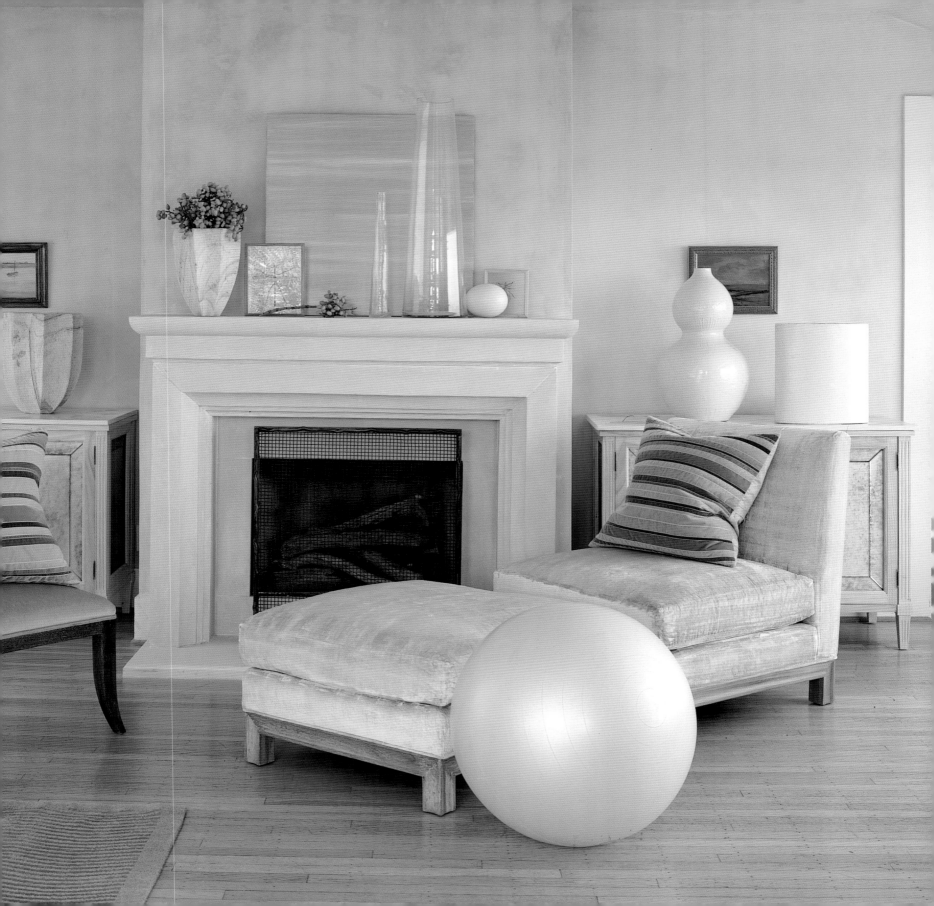

House of FUN

CHARLES DE LISLE ON POTRERO HILL

San Francisco interior designer Charles de Lisle plumps his pillows and plays his tiny rented Potrero Hill cottage for comfort as well as for smiles. His house is perhaps the smallest rental this side of the Golden Gate Bridge, measuring less than seven hundred square feet. With just three miniscule rooms, it offers no space for a dining table and is definitely not big enough to swing a sofa.

Charles insists that his San Francisco cottage is the sweetest deal in town and recently finished decorating it with a dynamic mix of vintage pieces, sidewalk sale discoveries, and cutting-edge Italian design.

"I've got peace and privacy, a sunny deck covered with jasmine, and views for days," said de Lisle, a partner with Your Space, Inc., a design firm with offices in San Francisco and Honolulu.

His new pad, built in the forties, stands on a quiet hillside shaded by grand pines and fragrant mimosa trees. It's ten minutes from downtown, and even more important to the vintage-loving designer, it is a mere five minutes from the popular Alemany flea market that de Lisle frequents on Sundays. Many of his lucky finds—his fifties lighting, a pair of seventies dressers, paintings, and a folding leather stool—were early-bird weekend loot.

Undeterred by sparse space, de Lisle decorated his domain with garage-sale, flea-market, and tag-sale finds, along with breezy collections of seascapes, glossy white Ikea closets, and a mix of practical industrial shelving and chic mid-century furniture. His cottage is home to smart splurges like his leather upholstery as well as inventive penny-saving DIY projects. A former lighting designer, he rigs dramatic lamps from vintage parts. Gauzy bedroom drapery trimmed with citrine ribbon is hung from steel airline cable, walls are covered in $9-a-yard raffia cloth.

Chairs are big and inviting (to fill in for the sofas he lacks), vintage dressers are capacious (there's no space for big-time storage), and his queen-size bed is an oasis of down-filled linen pillows.

THINK BIG (*Opposite*) "The living room is where I spend time with friends when it's too cold to sit on the terrace," said de Lisle, who stores his color-coded Oxford-cloth shirts and shoes in the basket-equipped Ikea cabinets. "Small rooms require discipline," he said of the eight-by-ten living room. "The flea-market bookcase is functional, not overdesigned, and the fifties dresser is very straightforward. The room's pale, no-color palette (linen-white painted walls, white cabinet doors) makes a neutral canvas for the graphic cowhide rug, which the designer found at a farm in Sonoma County.

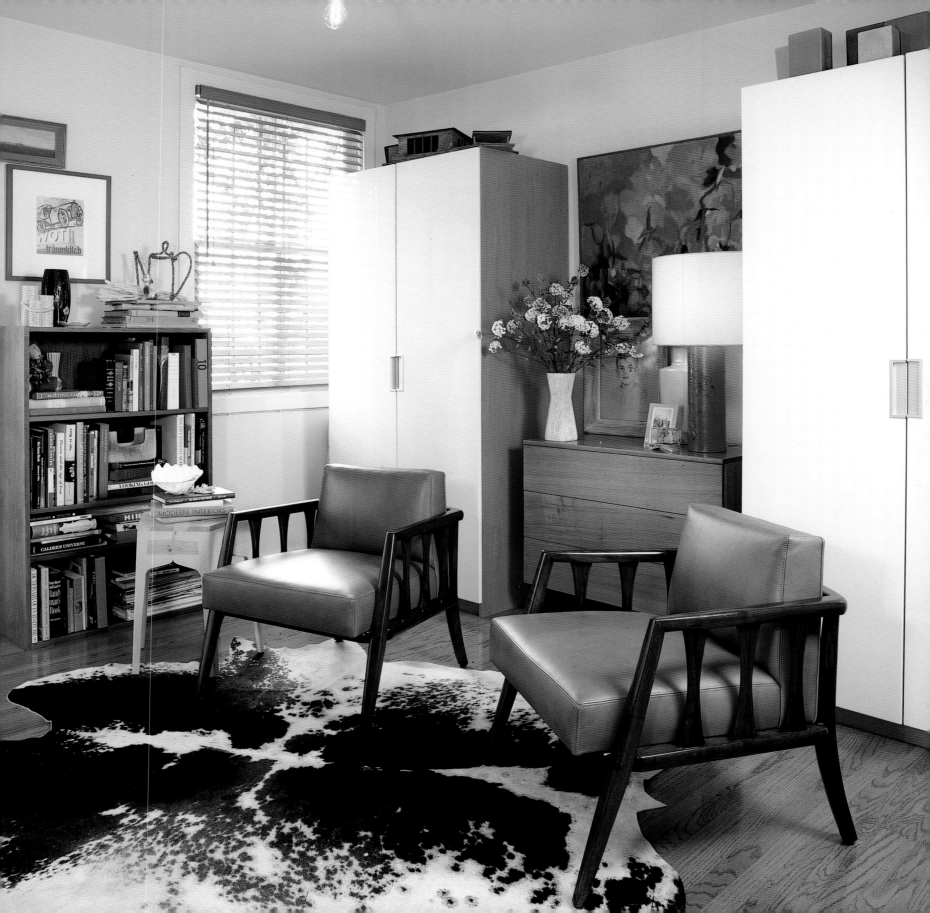

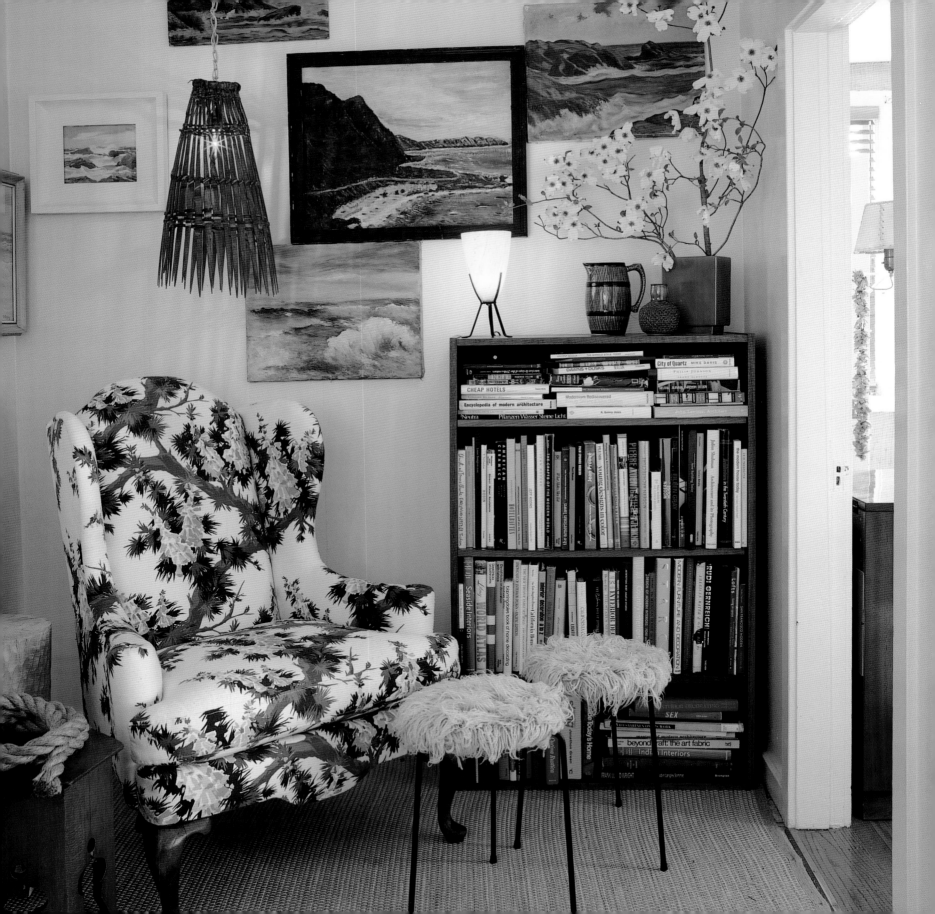

"It's the biggest decorating misunderstanding to think that a small cottage demands dollhouse furniture or lacks luxury," noted the designer, who works on hip hotels and spas for his clients and knows that a small budget does not mean that comfort must fly out the window. "Larger-scale furniture, like my queen-size bed, give these rooms a sense of comfort and the architecture they lack. Seascape paintings and big chairs entertain the eye, they anchor rooms. Bold scale gives small rooms a feeling of importance."

Undeterred by sparse space, de Lisle decorated his domain with garage-sale, flea-market, and tag-sale finds, along with breezy collections of seascapes, glossy white Ikea closets, and a mix of practical industrial shelving and chic mid-century furniture.

De Lisle also focused on adding a sense of opulence, surprise, and delight.

"My mantra for decorating is 'add detail, add richness,'" said de Lisle. "The bedroom is ten by eight feet, so the bed takes up most of the floor space. I added texture with a handwoven rug and cotton bedcover and layered a knitted wool throw to give a warm, calm feeling. I hung paintings and collages I made in art school. The window is shaded with traditional wooden blinds. This is not the place for shock design."

De Lisle didn't fight the cottage aesthetic or kitsch it up—also key to making his decor work.

"There are not a lot of rooms to tidy up," said De Lisle, who grew up in Massachusetts and came to San Francisco eight years ago. "I kept the decorating relaxed, like a country hideaway. My friends love to visit on weekends and hang out on the deck."

He was inspired to cluster his framed oil paintings off-kilter by a visit to the classic Los Angeles house of Richard Neutra.

"I think of the whole wall as a composition, and off-center pictures give the room a spark. Three pictures placed in the absolute center of the wall, directly above the bed, would be so boring."

The king-sized headboard, a fifties piece attributed to Paul Laszlo ($500 in a Los Angeles store) is slung sideways to save space and to make the shelves more accessible. The Marlboro Man collage, a de Lisle original, was made from Hawaiian cocktail napkins, pink nail polish, electrical wire, and plywood.

"My professional life is hectic and demanding," said de Lisle. "Coming home to this cottage is like arriving at a beach shack. It's instantly relaxing." ⌧

COOL COMFORT *(Above and opposite)* The sitting nook is inches from the stove—but de Lisle's wing chair and bookshelves set this room apart. "I love wingback chairs because they're comfortable for reading, and the back surrounds you." He found the thirties chair in funky condition at San Francisco's weekend Alemany flea market ($200) and had it reupholstered with five yards of forties Waverly cotton ($10 per yard) printed with surreal bonsai branches. "Large-scale patterns energize the room and give an animated feeling to this very traditional chair," said de Lisle. Each room unfolds into the next. A large-scale lamp by Marcel Wanders and his own art school collage add jolts of color in the adjacent bedroom.

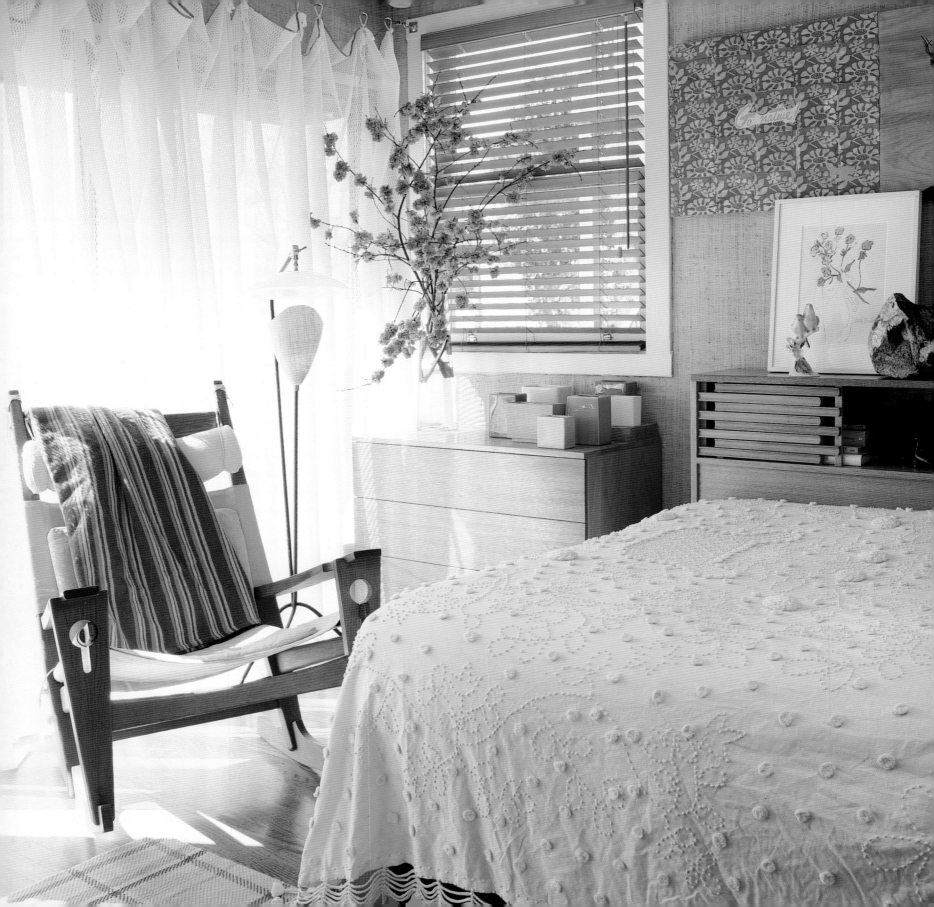

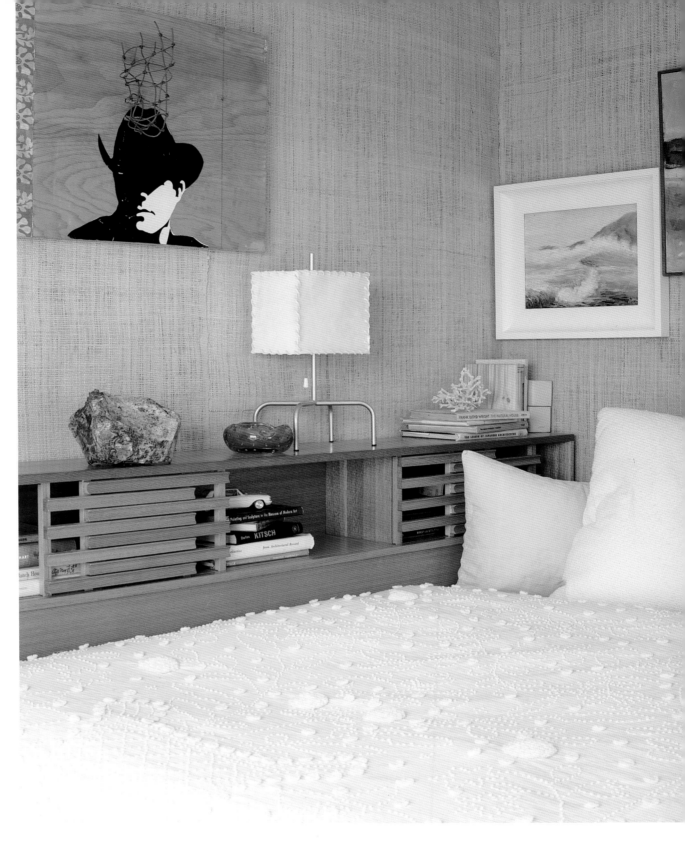

DAYDREAM BELIEVER *(Opposite and right)* Charles de Lisle banished bland paint by covering his bedroom walls with natural raffia cloth, which he bought at the San Francisco Flower Market. He stapled it directly onto the wall and left the top edges frayed. "Every room deserves one splurge, one big, bold statement to give it a kick in the pants," said de Lisle. "And I love my vintage finds, but it's important to celebrate the icons of today's design, too. A mix of styles is more modern and flexible —and more fun to live with."

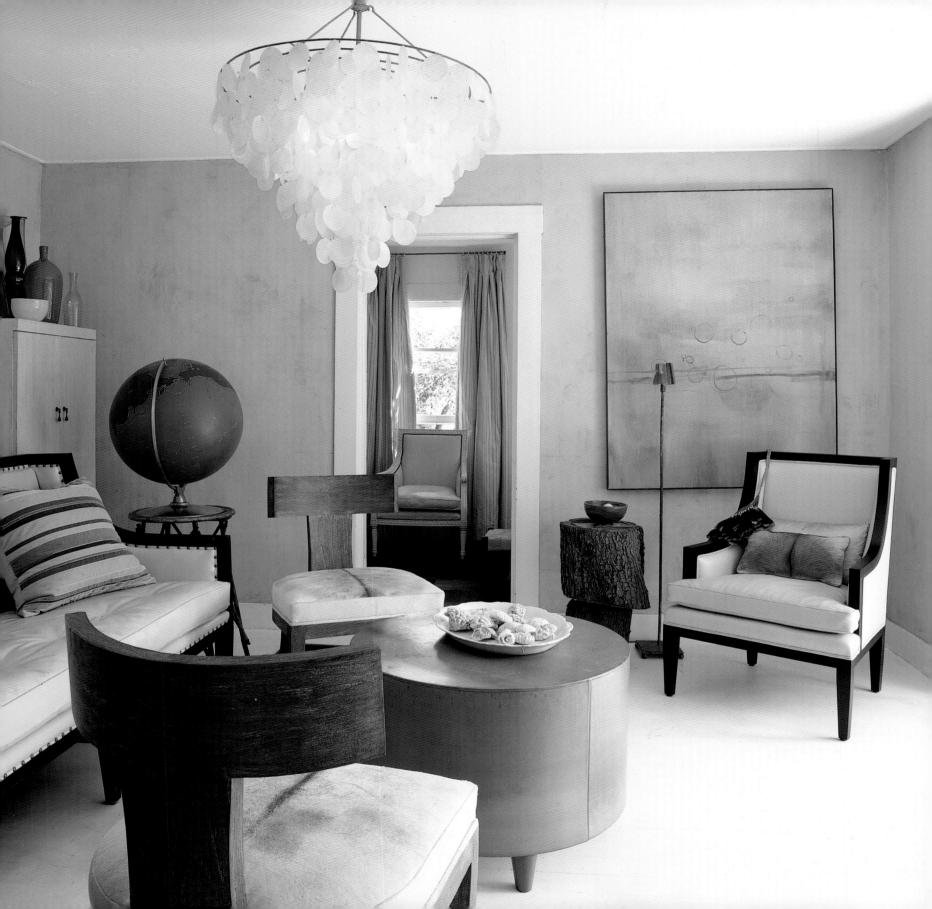

Objects of Affection

BRAD HUNTZINGER IN THE OAKLAND HILLS

Furniture designer and artist Brad Huntzinger co-founded Ironies, a furniture and decorative accessories company, in Berkeley sixteen years ago. He and his partner, Kate McIntyre, both had studied art and earlier had owned Art of the Muse, a company that specialized in esoteric painted finishes. Now the partners are designing two lines of furniture to the design trade, producing accessories and furniture in Asia for wholesale, and creating some of the most elegant and creative designs to be seen in national showrooms. New products leap from their imaginations like sparks from a fire.

If McIntyre and Huntzinger had been living during the Renaissance they would have been snapped up by a potentate or prince to paint a palace or family portraits. Once ensconced in the palazzo, they would have found it hard to resist decorating the walls and then designing new furniture and chandeliers of coral or tree branches. Soon, the prince would have dispatched Kate and Brad to distant exotic lands—India and China and Japan— to find craftspeople to make glorious new designs for their archduke or *principessa*.

This being the twenty-first century, and potentates a bit thin on the ground, Huntzinger and McIntyre have boldly leapt into manufacturing and have been very successful designing and selling meticulously handcrafted and singular Oly and Ironies designs ever since. For the last few years they have been traveling to Asia, in particular to Bali and Indonesia, to design and commission breathtakingly original, complex, and elegant designs. In Java they have found silver-leaf artists and carvers, and in Vietnam they've nurtured and encouraged teams of ceramic artists who make celadon vases for their new Oly collections.

With prototypes flying back and forth across the Pacific Ocean, it is natural for Huntzinger to treat his Oakland Hills cottage as a kind of laboratory for testing and examining many of the new Ironies and Oly designs. There, high above San Francisco Bay, he lives with the new carved beds and zinc tables and faceted mirrors that become part of the permanent Ironies offerings, and his life-long collections.

SOFT CURVES *(Opposite)* In the living room, a chair, right, and a pair of Ceres chairs covered in cowhide surround a table in zinc, all by Oly. The oil painting is by Brad Huntzinger, and the chandelier was crafted from capiz shells.

ART OF GLASS *(Right)* Huntzinger's collections of student art glass, flea market finds from around the world, and Aero Studio glass are arranged topographically on a chest crafted with a crackled linen/plaster finish, one of the designer's first decorative finish experiments.

BEACH MEANDERING *(Top)* Brain coral beach-combed from Tulum, Mexico, and from beaches in Bali, Java, and Vietnam are arranged in a white ironstone platter from the 26th Street flea market in New York.

THE COLLECTOR'S EYE *(Above)* Brad Huntzinger arranged a Balinese red bamboo vase, a Robin Mix glass vase, an orange glass vase found at a Berkeley flea market, and natural stone and crystal bowls hand-crafted in Java. They are artful placements on an Oly glass-topped table, with a painting by Huntzinger as a foil.

NATURAL SPIRIT *(Left)* The Brancusi-esque ziggurat, which stands in one corner of the living room near the front door, was made from the raw timber of a neighbor's fallen tree. The Robert antiqued mirror electronics cabinet is by Oly.

COLOR HARMONY *(Opposite)* Huntzinger and McIntyre add texture to the Ironies Jacob sofa and Ceres chair with calfskin, hand-woven textiles, and linen. The raku-fired ceramic vessel is by Brad Nebeker.

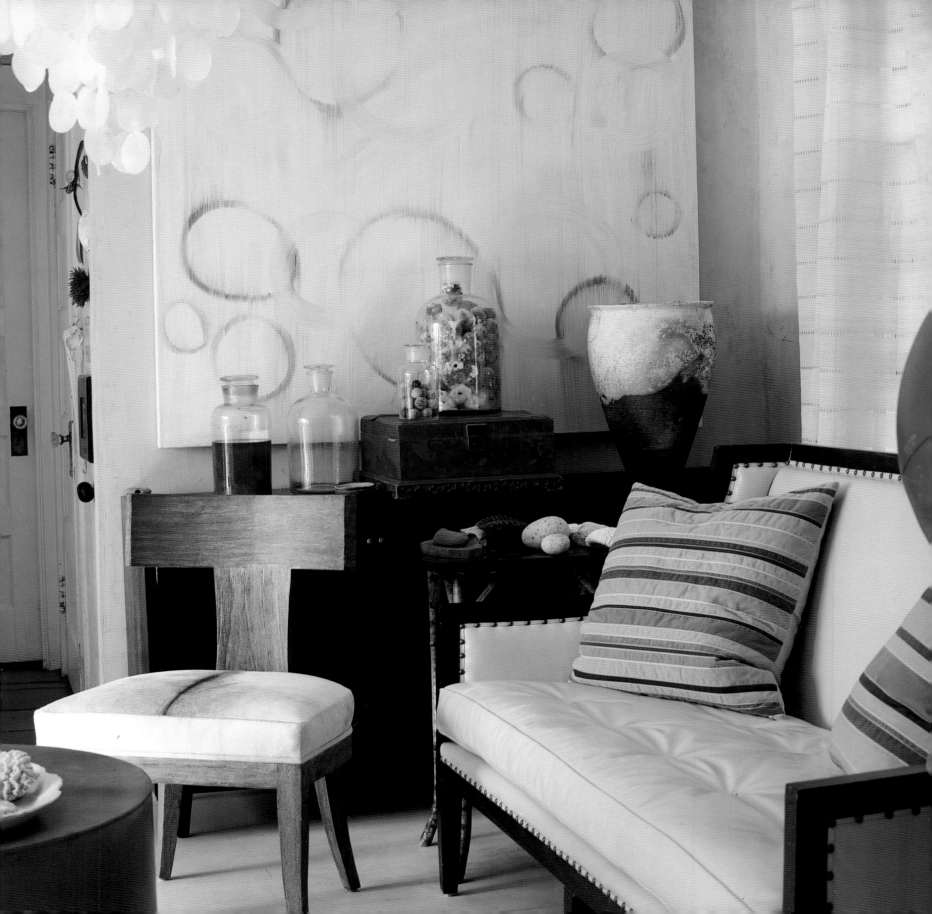

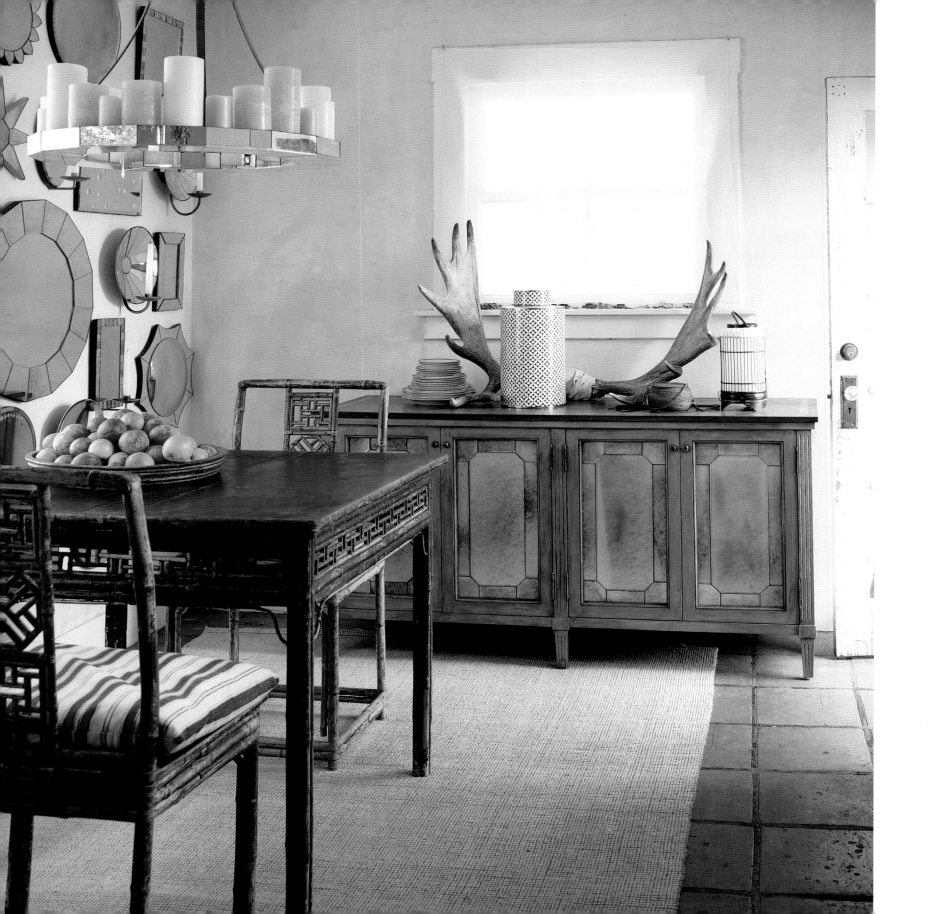

"We bought the house in 1990," said Huntzinger. "It was originally built as a weekend getaway for a San Francisco family. The Oakland hills at that time were a summer retreat, and weekenders would come over from the city on the ferry."

> "We repaired the walls and added integral-color plaster in a wheat color. Eventually we remodeled the kitchen and bathroom and then called it a day. I wanted to keep it relaxed, escapist, very cottage-y."

The house is full of light and feels sunny all day.

"It was completely falling apart when I found it, and most people would have torn it down," said Huntzinger. "We repaired the walls and added integral-color plaster in a wheat color. Eventually we remodeled the kitchen and bathroom and then called it a day. I wanted to keep it relaxed, escapist, very cottage-y."

Huntzinger said the floors are often covered with coral, beads, crab shells, stone, and wood.

"I am always making prototypes, painting, and starting new projects there," he said. "It's very quiet. I listen to the wind in the Monterey pines and hear raccoons, possums, squirrels, and skunks out in the garden."

Huntzinger is now bracing himself for the major remodel he has resisted for a decade.

"I am finally going to add another bedroom and a painting studio," he said. "I'd like a little more room." ▣

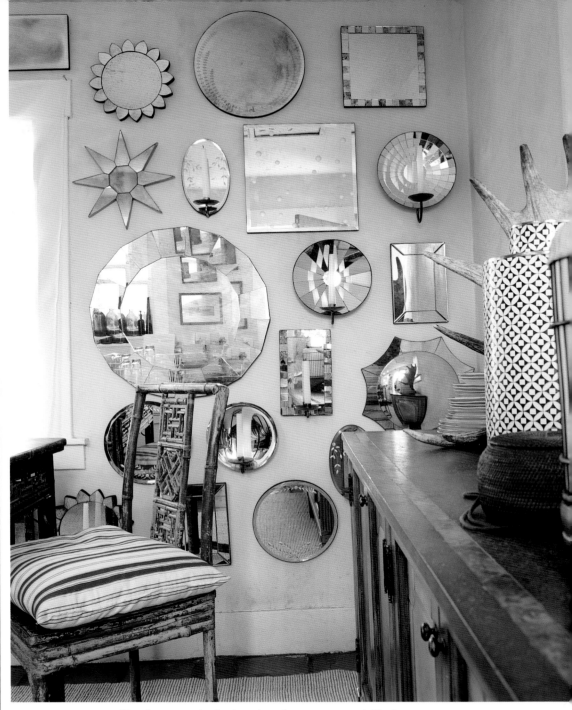

REFLECTED GLORY *(Above)* Huntzinger started collecting mirrors four years ago, and this glorious cluster includes models and prototypes from the Ironies and Oly collections, along with antiques and flea market finds.

ARTFUL FARE *(Opposite)* The original kitchen was rather a meager offering. Huntzinger had the walls plastered and furnished the room with an Ironies buffet with antiqued and honed mirror doors, dressed with moose antlers (naturally shed) and a French cloisonné canister. The antique Chinese table and chairs are crowned with a mirrored Oly chandelier and beeswax candles.

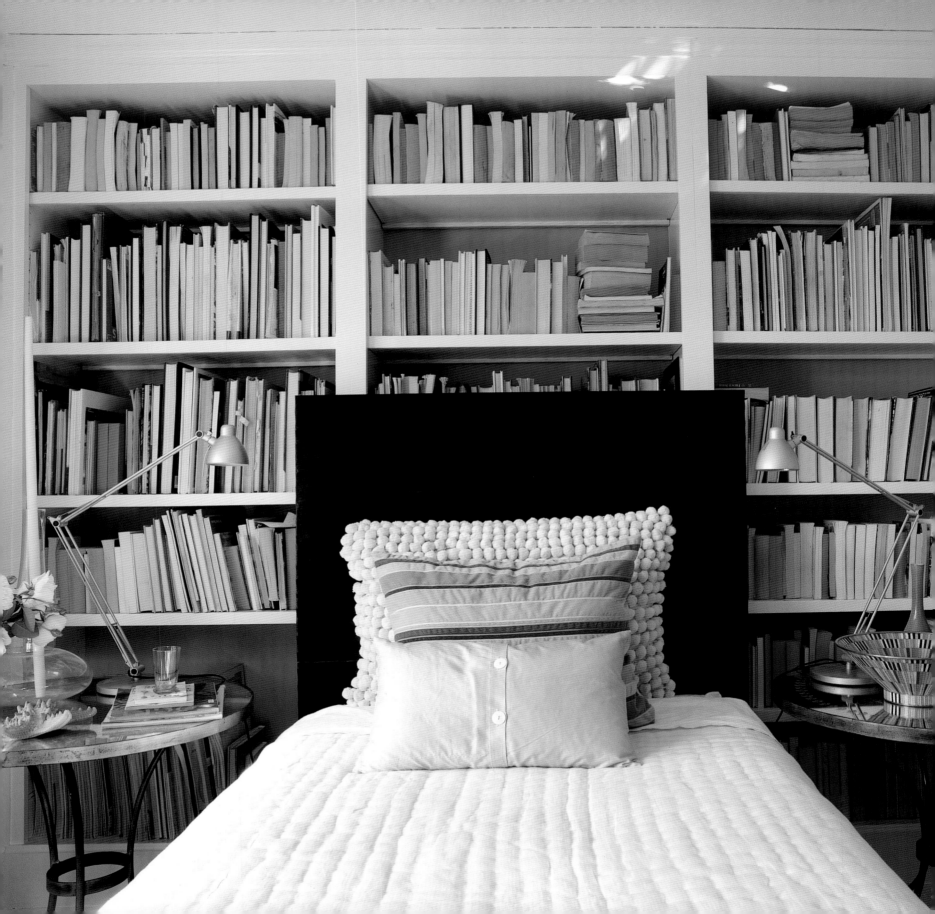

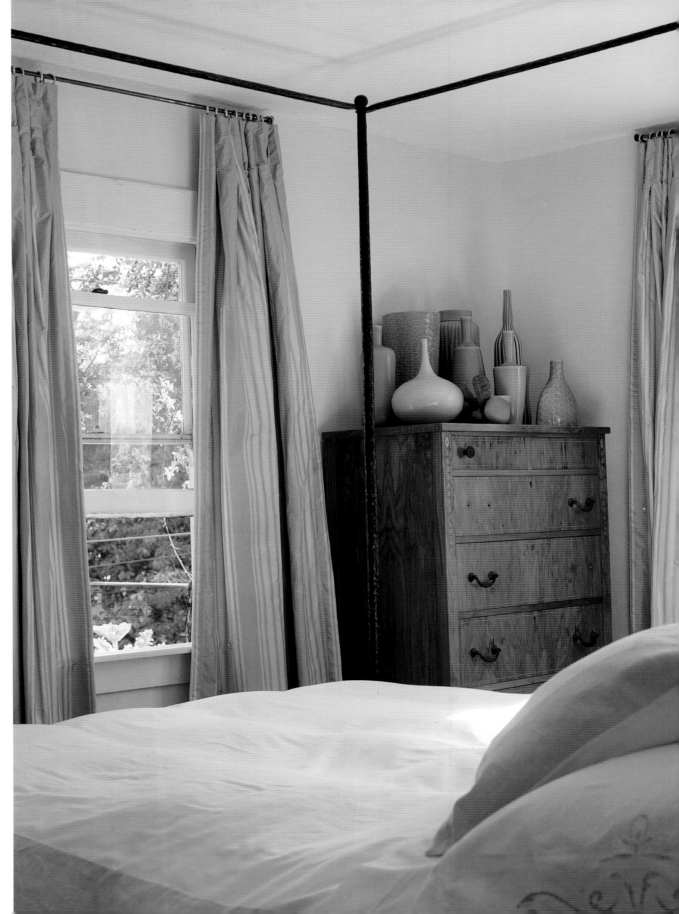

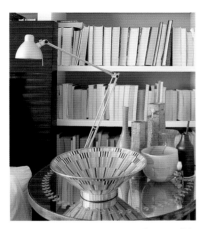

THE ARTIST'S HAND *(Above)* On an Oly mirror–topped table, Huntzinger presents his own homage to international creativity: a student-made glass bowl from the California College of Art end-of-year sale, a contemporary French cloisonné bowl, and ceramics from Indonesia and Japan.

BOOKS MAKE A ROOM *(Opposite)* A former small bedroom has been turned into a library/ guest room. An Ironies Water headboard handcrafted in Indonesia makes a graphic contrast to a quilted linen Oly bedcover. The pair of tables are also by Oly.

DREAM A LITTLE DREAM *(Right)* The bedroom is small—with barely enough space for the Ironies four-poster. Huntzinger has lavished it with silk draperies, a Biedermeier dresser (missing a few drawer handles), PaperWhite hand-embroidered bed linens, and a collection of art glass for eye candy. On the antique Biedermeier chest of drawers, a collection of vintage and Oly ceramics pleases the senses.

MODERN TIMES

INTERIORS DESIGNED BY KELLY LASSER

Her design inspirations range from Constantin Brancusi and Jun'ichiro Tanizaki to Andrée Putman, Tadao Ando, Karl Lagerfeld, the rock band Counting Crows, and Isamu Noguchi. Her career has taken off since she arrived in San Francisco from Detroit just a handful of years ago. Call Kelly Lasser a designer meteor.

Lasser founded her own design company, ShelterDesign, Inc., specializing in residential interiors with a modernist edge. In her portfolio are multiple Marina and Pacific Heights mansions for executive couples as well as edgy South of Market lofts and Berkeley bungalows. She has also gathered a coterie of rock-star clients and been named one of the most creative American designers by *Metropolitan Home*.

"It was inevitable that I would become an interior designer, even though I followed a circuitous route," Lasser mused. "I am passionate about design and architecture. I'm obsessed with design."

Lasser grew up in the suburbs of Detroit.

"It's very gray there for much of the year, and flat, so you crave color and texture," she recalled. "I was surrounded by the auto industry, which focuses on evolving design, innovation, newness, modern living. I was inspired by the constant creativity."

She attended Michigan's Cranbrook Academy of Art to study theater.

"I learned about make-believe, the art of performance, and presentation," she said. "I studied the role of the imagination and learned the craft of creating a vivid scene, and how to animate a space, all useful tools for an interior designer."

After a chance meeting, David Bryson, guitarist for the multiplatinum rock band Counting Crows, hired Lasser to design the interiors of his Craftsman-style house in the Berkeley Hills and became her first client.

"Everyone expects rockers to have outrageously wild houses, but in reality they love the comfort of the familiar and appreciate craftsmanship and fine art," noted Lasser.

MEDITERRANEAN UPDATED *(Opposite)* For the Pacific Heights house of Jason Phillips and Sheila Schroeder, Kelly Lasser brought in modern masters. Phillips is the president of McGuire, the venerable San Francisco furniture company, and Schroeder is an investment banker. Beside the Mies van der Rohe daybed, Lasser hovers a David Weeks lamp. The taupe curtain fabric is by Glant. The painting is by San Francisco artist Peter Boyer.

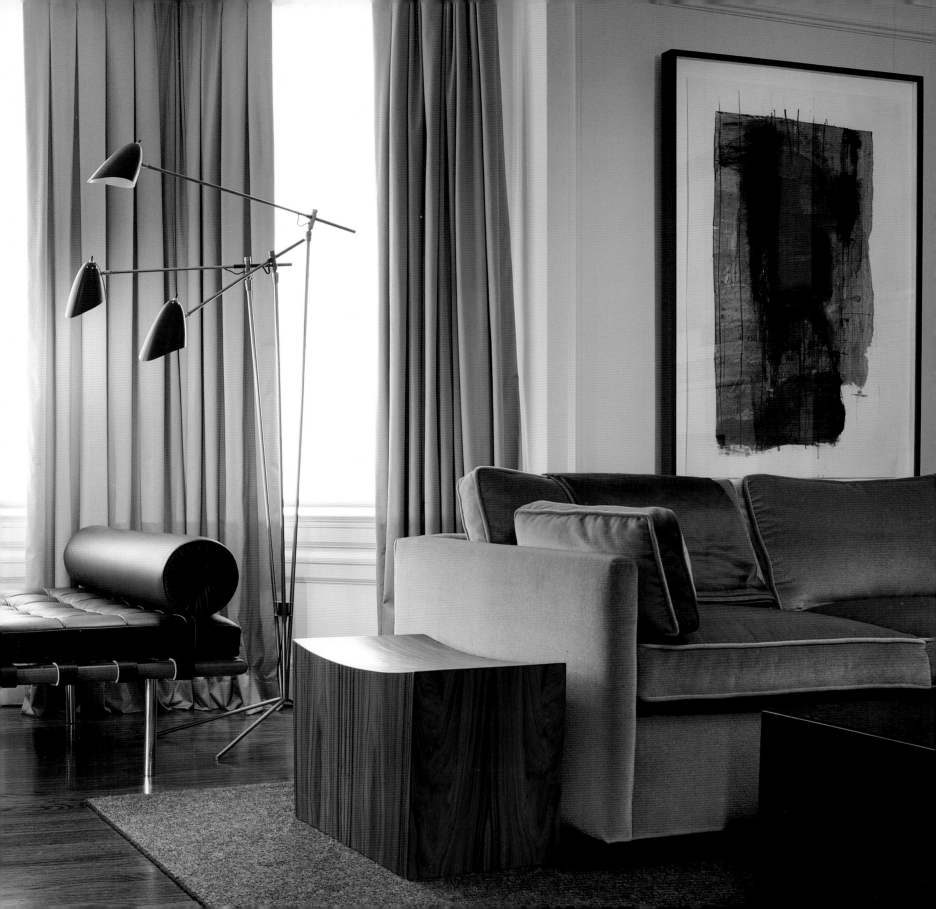

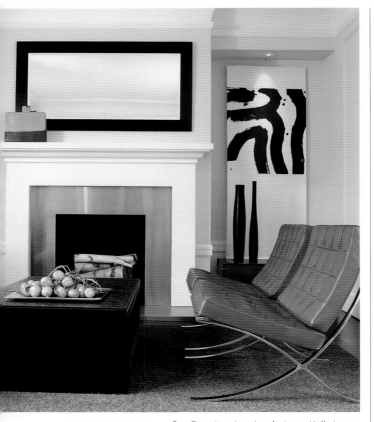

DESIGN ENERGY *(Above)* San Francisco interior designer Kelly Lasser deftly balanced a vintage pair of Mies van der Rohe chairs (found on eBay) with a Japanese wall scroll, Venini vases from de Vera, and a table of ebonized walnut and hot-rolled steel made by Paul Smith. "The chairs give an almost kinetic vibe to the room," said Lasser. "Straight lines need that contrast of curves to make rooms come alive."

"Craftsman houses are grounded in idealism and showcase fine, honest woods and careful handcrafting. The emphasis for David was on unpretentious vernacular building traditions and plain, solid furniture."

Lasser said that she is always moving forward with her design, experimenting, rebelling against the obvious design solutions. Modernist rigor may be enriched by sumptuous linen velvets, smooth leather, silken carpets, paintings by emerging artists. She tunes in to the client's needs, dreams, aspirations, and design aesthetic and creates rooms that are fresh, beautifully appointed, providing a smooth background for helter-skelter days.

"I am drawn to creating modern, clean-lined interiors, but I am always subliminally working in a spiritual way, creating inner comfort, reducing distraction, and offering a place for my clients to live quietly and at peace," Lasser said. "My designs create a counterpoint to chaos and offer a contained, streamlined life. I want to instill a sense of composure and make a thoughtful, refined interior with objects of beauty."

Lasser said the best interiors are an investment in quality, in fine materials, and design with integrity.

"Good design is not necessarily a big design statement," she said. "It's a reflection of your history and life, a place where you can be yourself."

Lasser's newest project is the design of a loft in a South of Market building by Stanley Saitowitz.

"The hard edges of the interior architecture need handcrafted details, finely engineered furniture, and the richness of sumptuous materials," she said.

"I want to include Paris antiques as well as modern furniture by Christophe Delcort, a French designer I just discovered," Lasser said. "I'm also using a daybed by Poul Kjaerholm and original fifties pieces by Jean Prouvé, if I can find them."

Lasser travels to Paris and New York to find design inspiration.

"I go for style infusions," she said. "I return with my mind full of ideas and pour them all into my design. I roam the Brancusi Atelier, drop into Chelsea galleries, dine in a Richard Meier restaurant, go to DIA Beacon to encounter true creativity, go to a dance performance, or see a fashion show. A silhouette, a color, a painting, a new book or an old volume, choreography, it all feeds design." ☒

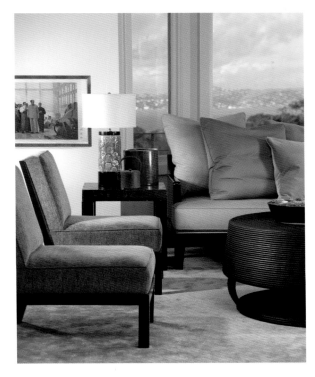

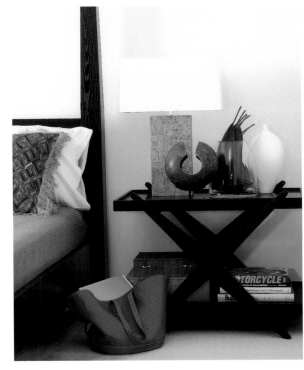

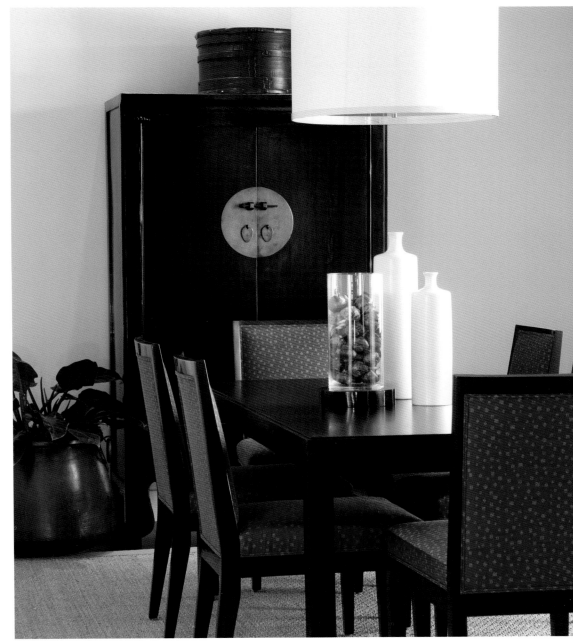

GAZING EAST *(Above)* A handsome lacquer cabinet topped with a lacquer box forms a bold background for an ebonized oak dining table by Checotti and A. Rudin chairs with ruby red Donghia fabric. The pendant lamp is by Boyd.

THE CONFIDENCE TO EDIT *(Upper left)* A Christian Liaigre daybed with mohair, silk, and linen pillows and a pair of Todd Hase slipper chairs, form a frame for a round Christian Astuguevieille table wrapped in jute twine. The rather sedate seating by Kelly Lasser, for a Pacific Heights house, is given a jolt—an international incident—with a vintage Mao Tse Tung propaganda poster from Big Pagoda, San Francisco.

EVERYTHING IN ITS PLACE *(Left)* An ebonized oak four-poster bed by Gerard from Kneedler Fauchere, is dressed in a cashmere herringbone tweed blanket from Sue Fisher King, and a Kuba cloth pillow. A lamp with a cork base from Sloan Miyasato stands on an Eric Brand table. All interior design by Kelly Lasser.

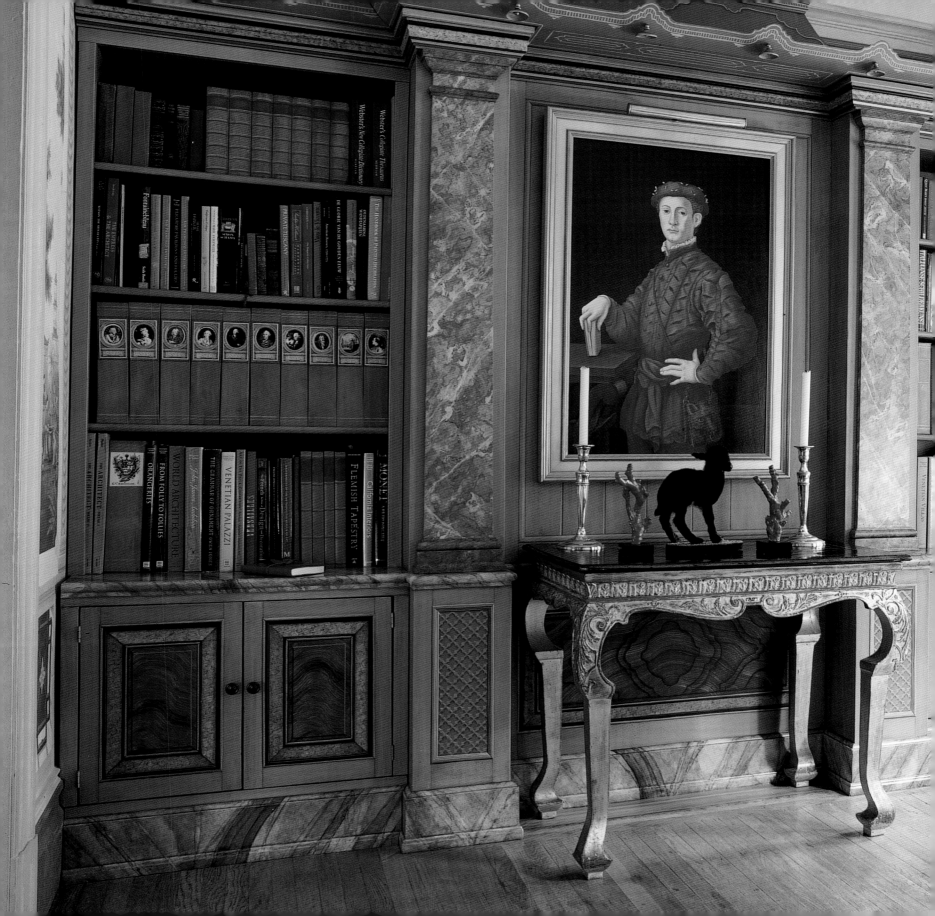

ARTS

IN MAKING FOR OURSELVES A PLACE TO LIVE,
WE FIRST SPREAD A PARASOL TO THROW A SHADOW ON
THE EARTH, AND IN THE PALE LIGHT OF THE SHADOW
WE PUT TOGETHER A HOUSE.

Jun'ichiro Tanizaki
In Praise of Shadows

PORTRAIT OF THE ARTIST

IRA YEAGER'S BARN IN THE HILLS NEAR CALISTOGA

I t is said among his most devoted friends that artist Ira Yeager loves to collect houses. He is not truly happy unless he is building or decorating one of his cottages and pavilions and barns that dot the romantic and verdant landscape near Calistoga.

In these wild green hills at the northernmost point of the Napa Valley, Yeager has built his latest creation, a pleasure barn for art, entertaining, musicals, lazy lunches, and summer frolic. Inspired by a friend's country house in the south of France, it is called La Bastide de Saint-Sénoc.

"It's very rustic among the redwoods," said Ira, whose romantic paintings are collected around the world. His subjects range from Greek peasants to French aristocrats, animals, teapots, landscapes, and flowers.

Yeager keeps a studio in a rough-and-tumble neighborhood in San Francisco but spends most of his time at the end of a gravel road and among the walnut groves. He wanted his new barn to be straightforward and unpretentious and to include one large room on the ground floor, with bedrooms upstairs.

To realize Yeager's dream, his friend Calistoga architect Richard Horwath limned a charming board-and-batten structure with a soaring ceiling and stripped pine columns to support the portico. Tall windows offer all-day light.

"Richard understands light, simplicity, proportions, pillars, and unpretentious materials," said Yeager, who grew up in Bellingham, Washington. "I wanted one large space, and I did not care about kitchens or bedrooms. It's a studio really. I love to cook for my friends, but I don't care for elaborate equipment. Keep it simple is my motto."

Yeager is a style improviser and has the wit to throw together disparate objects, precious and not-so, old and not-too, and make them appear as if Pauline de Rothschild just left the building.

SLIPPING INTO THE PAST *(Pages 124–125)* Artist Michael Duté worked for almost a decade to conjure an aesthete's study. The chair is from Therien & Co., San Francisco.

COUNTRY IDYLL *(Opposite)* A French grain storage chest offers a stage for antique porcelains and the artist's brushes and props and an eighteenth-century neoclassical fireplace mantel. The map of Lombardy, Mantua, and Brescia, dated 1825, forms a monochromatic backdrop for a Capodimonte vase, a bronze sabot.

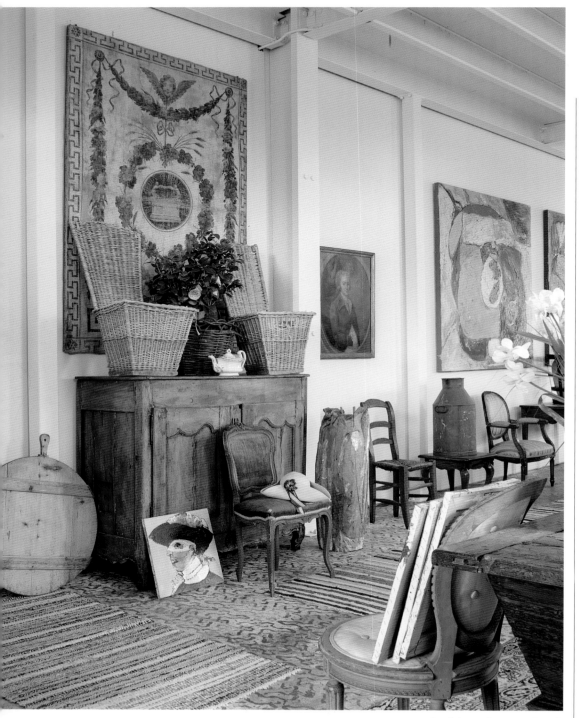

THE ART OF ARRANGEMENT *(Above)* An eighteenth-century French buffet and a nineteenth-century *chauffeuse* are posed beneath a Pompeii-inspired French painted wall cloth. A pair of harvest baskets were found in Isle-sur-le-Sorgue, in Provence.

As with his interiors, Yeager takes a freestyle fashion approach. A typical outfit could combine Ferragamo tasseled loafers ($10 at the Town School Clothes Closet), fisherman's pants, a vintage Brooks Brothers Oxford-cloth shirt, an Hermès foulard, a decade-old Pringle cashmere sweater, and a Jean-Claude Jitrois leather jacket (a gift from his friend John Traina).

The barn is artfully decorated with provincial antiques, mostly French, that give the interior an air of eighteenth-century Provence. There are hand-carved, rush-seated chairs, gold-rimmed porcelains, vitrines, an old carriage (the horse got away), and a series of pedestal tables, which are ideal for impromptu lunches.

It is here in the red barn, with views down a valley and across oaks and elms, that Yeager paints and displays his virtuoso canvases. He hangs works in progress so that he can meditate on them; the walls are his biography.

With his colorful, gestural canvases Yaeger paints into existence the romantic European world he wishes to inhabit. With equal Francophile intensity, he paints and draws the eighteenth-century France in which he wishes to dwell. He signs some paintings "von Yäger 1785" in the manner of Swedish court painters of the time of King Gustav III.

"I admire everything French and eighteenth-century Swedish and the Napa Valley countryside," said Yeager, who studied painting in Paris while in his twenties. "In a sense, I am re-creating perhaps a Swedish or French country barn here. The eighteenth century was a golden era in France and Sweden—the blossoming of design , courtly life, fashion, art, music,

and culture. I'm curious about what it all means. I paint characters of that period and collect the antiques so that I can understand that century and come face-to-face with the philosophy and daily life."

Yeager has been making his mark on the San Francisco art scene since the fifties. He studied art at the San Francisco Art Institute with early teachers such as Richard Diebenkorn, Nathan Oliveira, and Elmer Bischoff. In the sixties and seventies, Yeager studied and painted in Italy, Paris, and Morocco and lived for a decade on the island of Corfu, off the coast of Greece and Albania.

"The Napa Valley is a wonderful place for an artist," said Yeager. "It's relaxed and incredibly beautiful through the seasons. I can disappear for days and throw myself into my paintings, or I can head down Highway 29 to the French Laundry or the Swanson Winery salon, and be very social. I might drive over to the St. Helena Olive Oil Company to buy the best olive oil in the world. Here everything is possible in the best of all possible worlds, as Voltaire said."

The picture-perfect red barn, designed by architect Richard Horwath, looks as if it has been standing on his property for decades. It's a romantic, bucolic scene, with eagles soaring and deer silently nibbling tender grass shoots.

Yeager is vividly involved in the moment, but it's clear that the true metier and milieu of this painter is the past. For Ira Yeager, whose antique chairs and tables suggest earlier centuries, there is always his brush with the golden and glorious eighteenth century.

"I open the door, and it takes me straight back to Uzès in the south of France," said Yeager. "This setting knocks my socks off." ⊛

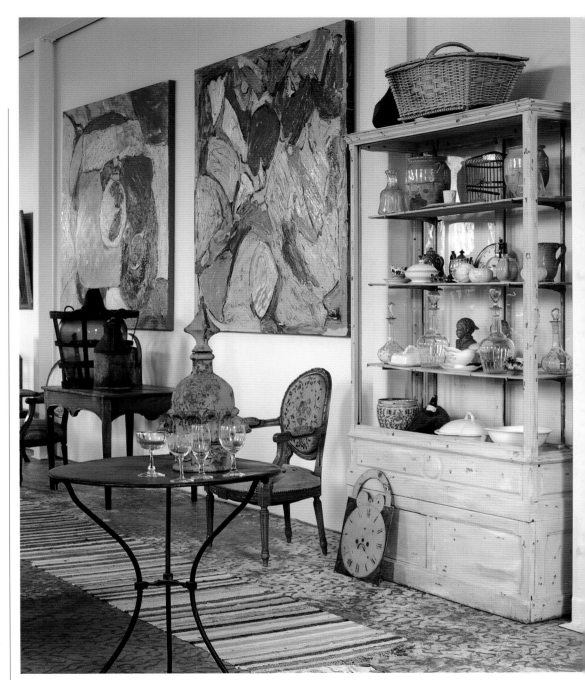

HAPPY DAZE (*Above*) Yeager's bravura oil paintings were composed from an Emily Dickinson poem:

A Sloop of Amber slips away
Upon an Ether Sea,
And wrecks in peace a Purple Tar,
the Son of Ecstasy—

Yeager said he wanted paint to go beyond paint, "to be scumbled and jumbled and crackled." Antique wine jars, a French vitrine from a shop in the South of France filled with porcelains, Venetian coral, French platters, and objects of his affection enhance the French impression.

A Victorian, Romanced

CHARLEY BROWN & MARK EVANS IN PACIFIC HEIGHTS

In their Pacific Heights Victorian house, San Francisco artists Mark Evans and Charley Brown have created a private world of Bangkok bronzes, Cambodian antiques, artful treasures, Asian sculptures, antiques, and opulent silks, all with a dash of irreverence.

Stepping through the front door of Evans and Brown's Victorian house, built in 1874, a guest embarks on mood-altering time travel. The bustle of Fillmore Street fades as a feeling of late-nineteenth-century ease and gentility takes over.

Carved marble mantels, plaster walls with the faded, mottled hues of a Venetian palazzo, threadbare Oriental carpets, and grayed-down silk upholstery intensify the romantic allure of their fantasy world. The Evans & Brown decorative painting company is in demand for grand-scale paintings and Veronese-esque murals, and they've taken their sense of theatricality home with a new persimmon-colored foyer and an elaborate painted and gilded Indonesian armoire.

Charley and Mark, both deeply committed to charitable work, acquired the house in 1990 just five years after they founded their company, Evans & Brown, based in San Francisco.

Cool light spills into the living room through tall painted wood shutters, casting dramatic shadows across antique tables laden with coral branches, gilded Balinese buddhas, and Casablanca lilies. Carved antique wooden bowls from Laos gleam with collections of mineral globes from around the world. Gilt buddha hands are gathered in gestures of peace.

Between extensive projects around the world, and time out to travel in Asia, Africa, and Europe, the partners have worked on the new residence.

WILDE CHILD (*Opposite*) The living room faces north, so the light there is always soft and rather eighteenth century in tone. Mottled plaster walls—some stripped, some faux—provide a neutral background for Charley Brown's large-scale paintings, and the tall shutters, painted with trompe l'oeil moldings, emphasize the elegant proportions of the room. Treasures from their travels include real and faux coral branches, Balinese towers, shells, Greek urns, archaeological fragments, Chinese porcelains, and Cambodian buddha hands. The antique painted table is Venetian.

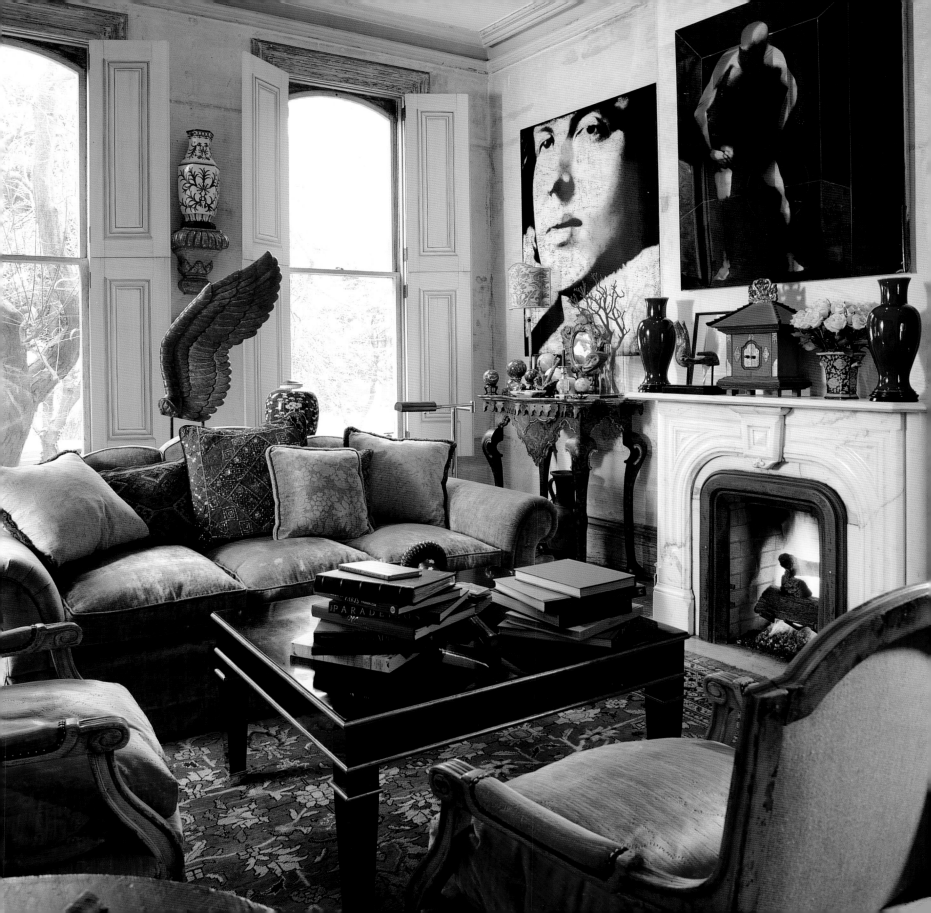

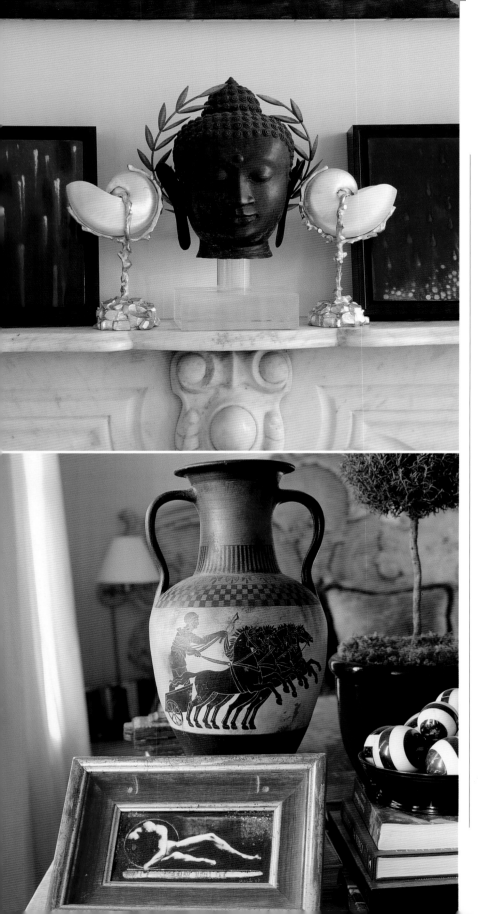

"The interior architecture came with a stripped-down elegance that was very pleasing," said Mark. "No previous owner had junked it up or tried to modernize any of the rooms. It wasn't fussy, and the rooms were generous. The bones of the house are classic Victorian, and beautifully proportioned. The ceilings were high, which makes the house feel larger. Best of all, when we moved in, there was nothing about the architecture that said 'today.' It was a blank slate."

> **"No previous owner had junked it up or tried to modernize any of the rooms. It wasn't fussy, and the rooms were generous. The bones of the house are classic Victorian, and beautifully proportioned."**

The partners first put their energy (and budget) into repairing walls, fixing (not tearing out) the original redwood plank floors, and remodeling the kitchen, an ongoing project. They assiduously edited, paring down trim and extraneous and inappropriate detailing.

New hardware throughout the house is all in the traditional style, and all doors and woodwork are detailed in the late-nineteenth-century manner.

"We wanted to keep the rooms rather austere," Brown said. "For months at a time, we stripped the plaster and paint and paper off the walls, but only to a certain point."

As the walls were slowly cleaned and buffed and prepped for painting and eventual glazing, the partners discovered that they liked the resulting mottled patterns, with their faded colors and air of elegant abandon.

"Some of the raw plaster walls are the real thing, untouched, and some are faux," noted Evans. "Charley is a master of painted finishes, so even up close I can't tell which are the original stripped surfaces and which ones he dreamed up and enhanced."

The fifteen-by-twenty living room looks at once rather formal and quite playful. A Venetian baroque console table from Ed Hardy

San Francisco, painted in a vivid tortoiseshell pattern, offers up faux coral branches, an African mask, an Italian rococo mirror, convoluted shells, and a Fortuny silk lamp. They're juxtaposed with handsome Louis XVI–style fauteuils and a velvet-covered sofa.

One collection of mineral globes gathered in Kenya, Arizona, China, Thailand, Cambodia, Italy, and Mexico fills a nineteenth-century Flemish folding table, and more of these jewels are balanced on an eighteenth-century English carpenter bench.

Upstairs in the twenty-five-hundred-square-foot residence are just one bedroom with a large deck overlooking the garden, a library / study, and a bathroom. The grand curlicued stairway with an elaborate handrail curving up from the foyer adds to the sense of grandeur, of times past.

The back of the house opens to a broad terrace shaded with lavish topiaries and scented with heirloom rose bushes, lavender, and sage in terra-cotta pots. In summer, with the doors flung open, the terrace becomes a sunny extension of the house and takes on the air of a leafy conservatory.

Now that their restoration is almost completed, the Victorian flavor of the house is there to be savored, without frills or fretwork. The partners say they finally feel a great sense of satisfaction.

In the evening, Brown and Evans light the living room fire, close the shutters tight, set out a myriad of beeswax candles, and fill the rooms with the sounds of Bartok, Stravinsky, Bach, or a dash of Missy Elliot.

Time travel, indeed. ◉

TIRELESS TRAVELERS (*Opposite and right*) Evans and Brown travel extensively to Asia, Europe, and around the Pacific Ocean each year, bringing back bronze and gilt buddha hands, mineral globes, antique playing cards, Thai carvings, and Laotian artifacts, all of which coexist in great style. Italian playing cards are scattered beside a Fijian war club on a gilt-edged, leather-bound album. On the marble mantel, a pair of outstretched buddha hands (symbols of fearlessness and charity) are posed beside a Javanese spirit house. Their "Greek urn" is a commissioned piece of pottery, which they have painted to look as if it had been dug up in Delos. Keats would love it! The shells on gilt stands by Andrew Fisher honor a Thai Buddha head.

A Cosmopolitan Point of View

SERGE & TATIANA SOROKKO IN MILL VALLEY

Serge and Tatiana Sorokko are at home in the world. Originally from Latvia and Russia, respectively, the couple has lived in Paris, New York, and Los Angeles and has finally landed in San Francisco, where Serge has his art gallery, Serge Sorokko Gallery, specializing in contemporary art and sculpture.

Six years ago, they acquired a house under construction in Mill Valley.

Its modernist skeleton was promising but not precisely tailored for the couple, passionate collectors of art, rare books, and vintage couture. Serge commissioned San Francisco architect Stanley Saitowitz to perform life-saving surgery on this work in progress, to improve its proportions and perfect the existing layout.

"The house now suits us very well," said Serge. "Stanley is a genius at paring down, rationalizing design, giving rooms logic. It's like a large gallery, with unadorned white walls, broad hallways, decks overlooking the hills, and beautiful light from dawn to spectacular mountain dusk."

Theirs is a California dream location hidden among mossy oaks, bay laurels, and manzanitas on a hillside within hiking distance of the peak of Mt. Tamalpais.

For Tatiana, too, the house is a retreat from an often frantic professional life.

As an editor with Russian *Vogue* she attends the couture collections twice a year in Paris and travels to New York to report on fashion, designers, and events. There are always friends to visit on Capri or in Cannes, art exhibits to catch, and artists to meet. The couple always drops in on the Venice Biennale and are enticed by antiques shows throughout Europe.

"After the fashion madness of the Paris and Italian collections, it feels so sane and peaceful here in Mill Valley," said Tatiana. "We like to keep the decor pristine and simple so that the art and the antiques look their best, undisturbed."

CAPTURING LIGHT *(Opposite)* Tall windows and doors on three sides of the living room draw light into the elegantly simple interior. Paintings by Yuri Kuper, Jannis Kounellis, Carlo Mattioli, and Lev Meshberg hung on the white walls command attention. Above the fireplace is a sixties oil painting by Jacques Doucet. The bronze chair beside the fireplace and the coffee table are by Yuri Kuper.

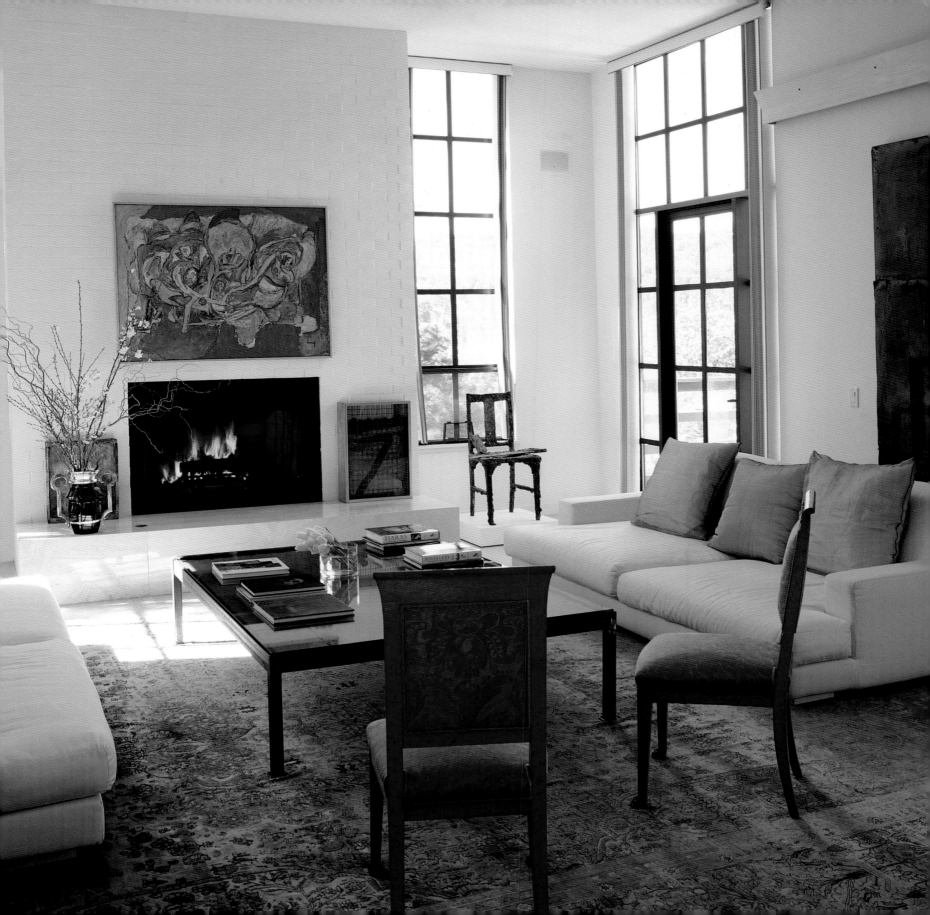

FELINE FRIEND *(Above)* Cosmo, the Sorokko's Russian blue cat, likes to bask in the sun on a Russian neoclassical Karelian birch chair with bronze mounts, which was re-covered by the Belmar Company with Fortuny fabric. Behind him on hallway walls is a series of Charles Jones photographs of vegetables.

ROMANOV MEETS MODERNISM *(Opposite)* The chairs and table are early nineteenth-century Russian Jacob in mahogany with a painting by Carlo Mattioli.

The couple also collect furniture by artists. In the foyer is a French school bench charmingly painted by Yuri Kuper. A bronze chair by Kuper stands beside the fireplace.

Tatiana, who for years was a top fashion model in Paris, has collected vintage Paris fashion with fine connoisseurship for more than fifteen years. In her dressing rooms and closets are silk satin couture gowns by Ralph Rucci, dresses by Poiret and Galinka, Chanel jackets, Pucci dresses, Philip Treacey hats, Manolo Blahnik shoes, Gaultier couture gowns, twenties Jean Patou dresses, Comme des Garçons skirts, a Masai necklace, a Directoire tiara, and a nineteenth-century Italian coral tiara. Her treasures are all carefully catalogued, shelved, aligned, and stacked and boxed along with jewel boxes containing a Russian river pearl tiara, a Fabergé cigar box, neoclassical Russian adornments, and an eighteenth-century Chinese minaudière.

"I started collecting couture and vintage when I was modeling in Paris, and I love to wear these pieces," said Tatiana. "The twenties pieces and contemporary couture are all so exquisitely made, with embroideries and lace, beautiful, sensual fabrics. Inspired designers like Gaultier or Galliano can create magic."

For Serge, the pristine house offers the daily pleasures of a wine cellar and a series of gilt-framed Charles Jones vegetable "portraits," works by Jannis Kounellis, neoclassical Karelian birch chairs, a somber painting by Lev Meshberg, and a hologram by John Allen.

This is a house as haven and gallery, and it works, most elegantly. ✹

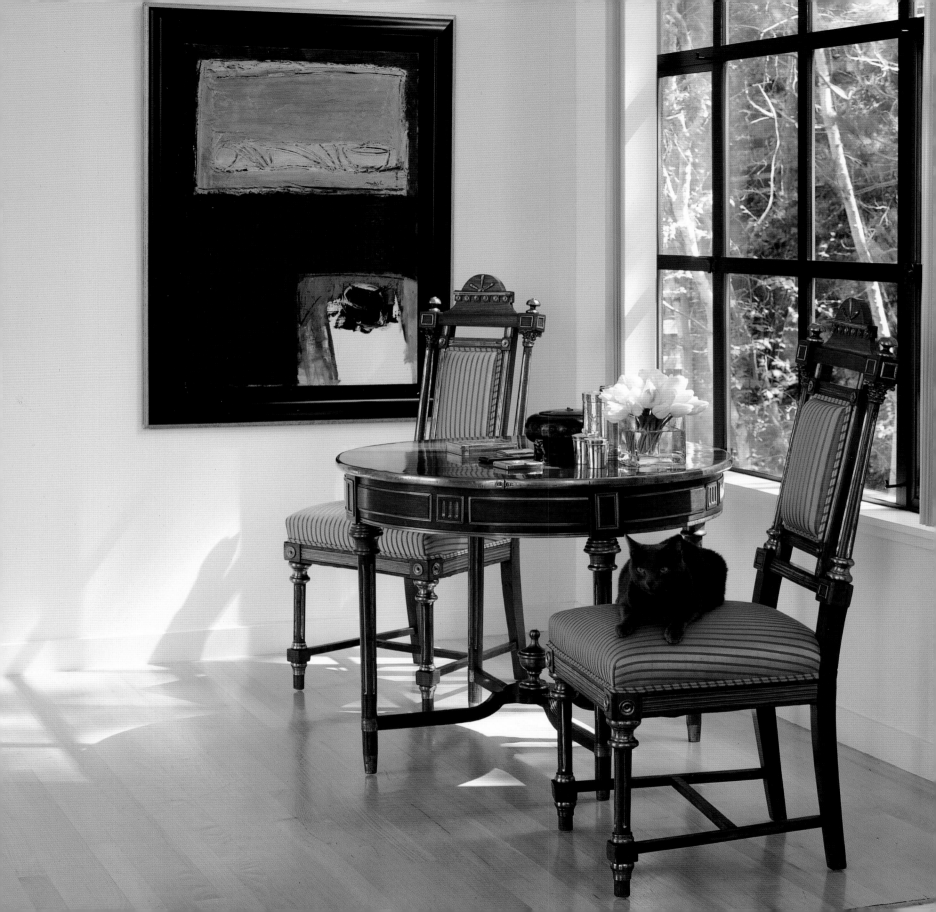

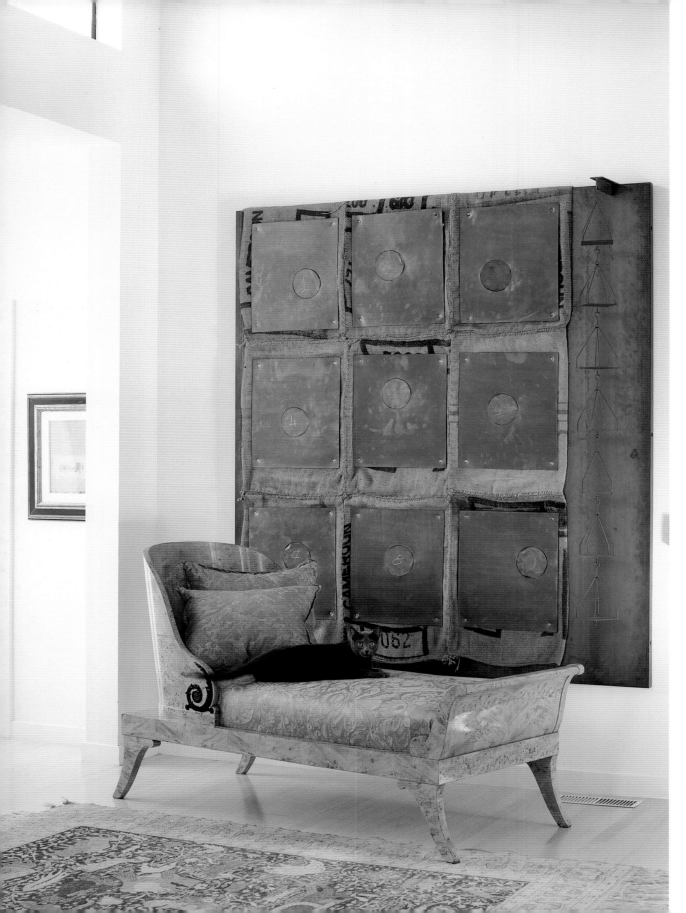

ART BEAT *(Left)* Above a Russian neoclassical chaise, upholstered by Belmar in Fortuny fabric, is a Yuri Kuper constructivist piece. The artist, who has exhibited in Japan, Europe, and the United States, is represented in the collections of the Metropolitan Museum and the Museum of Modern Art in New York. Noted for his mystical still lifes, the artist often uses found objects in his art.

SILVER SCROLLS *(Opposite)* A work by Kuper hangs in the dining room. Yuri Kuper is among the international roster of artists at Serge Sorokko Gallery. The chandelier is Russian.

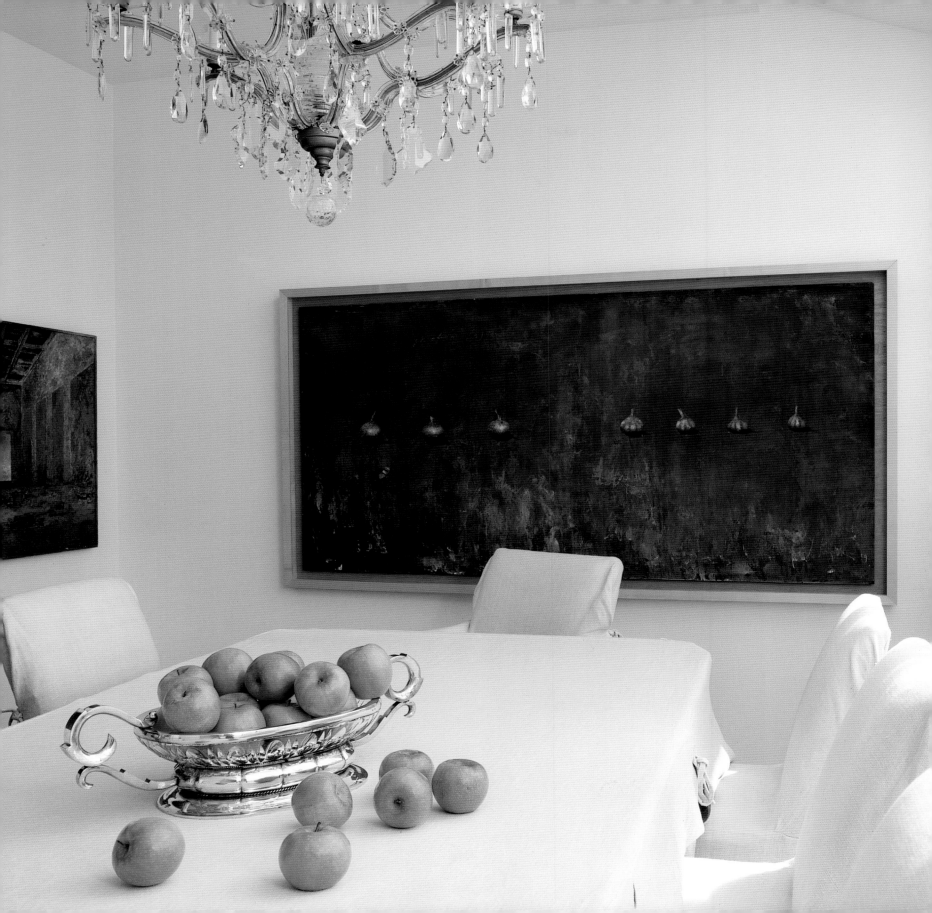

Painted Worlds

MICHAEL DUTÉ IN HAYES VALLEY

With skill, buckets of paint and brushes, infinite patience and passion, San Francisco decorative artist Michael Duté creates magical interiors and exotic worlds.

During the week, Duté paints luscious murals and glamorous rococo-inspired decorative wall panels for clients all over the map. But after hours he paints for his own pleasure, and out of his desire to experiment. He sets himself the most difficult tasks—painting Italian Renaissance scenes, a nineteenth-century Chinese fishing port, intricate faux marble, tricky malachite, costumed figures parading around a jungle pagoda.

For the last eight years Duté has spent weekends and evenings painting the rooms of his Hayes Valley flat. First it was a Pompeian bedroom, finely portrayed down to the last festoon and dove. Then it was his office, with its Palladian cabinet and neoclassical ornamentation.

Seven years ago, Duté began work on his tour de force, a chinoiserie library now embellished with captivating murals of Chinese scenes, a pagoda-shaped bookcase, three-dimensional cartouches, and lavish *faux bois* effects. Over the years he has transformed every surface of the room—the doors, the coved ceiling, all the walls.

"I painted the walls in the tradition of eighteenth-century European artists who created highly detailed seascapes and panoramas of people and temples and trees and landscapes they had never seen," said Duté. "I'm willing to put in years of effort to make these paintings exceptional and timeless. I never tire of them. There's always a detail or a scene or an implied interaction that captures my attention."

Painting for hours a day, and often for weekends at a stretch, Duté has taken the time to execute his murals, foyer, bookcase, ceilings, and painted woodwork in the minutest detail, down to the frothy waves on lively seascapes, the woven belts and jade ornamentation on Chinese robes. Over time, a sadness, the need for solace, moments of joy, and painting breakthroughs were his driving forces, his faithful companions adding to the richness of his meditative work.

SEASCAPES OF THE IMAGINATION (*Opposite*) A pair of Louis XV–style chairs in raspberry silk cut velvet stand guard over the minutely detailed seascape, depicting the China silk trade. Duté also painted the columns and moldings to suggest a portico overlooking the scene. The cartouche above the painted door is also an artistic conceit.

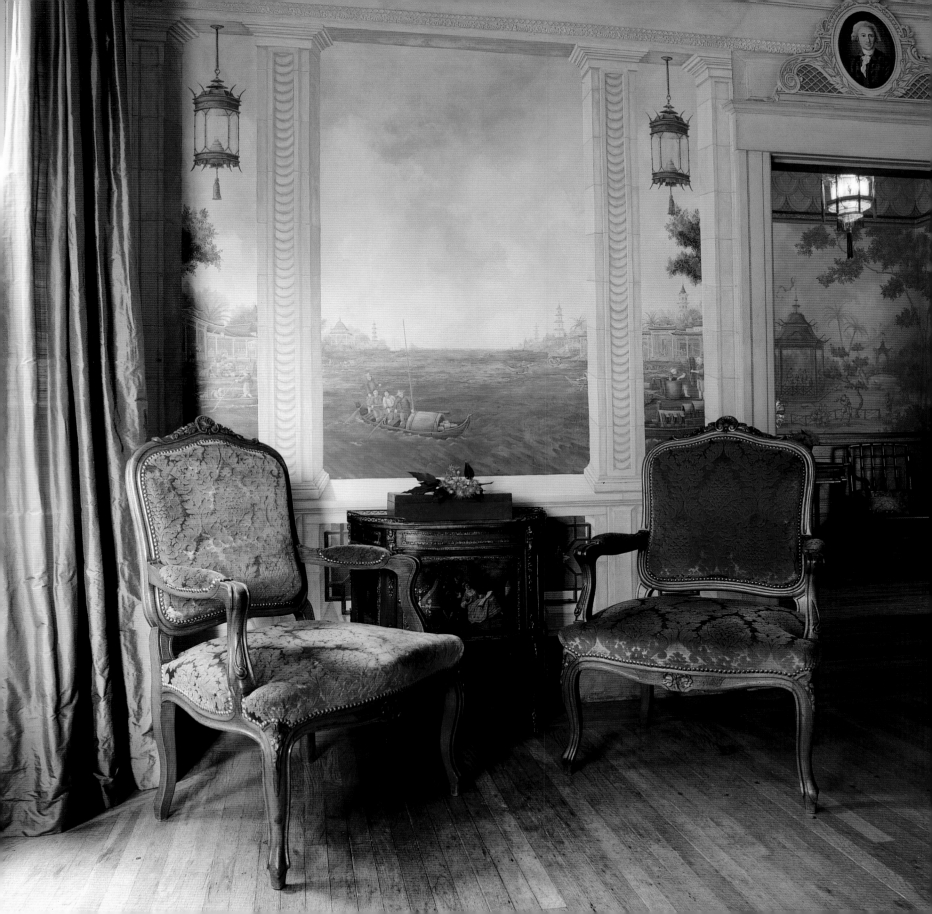

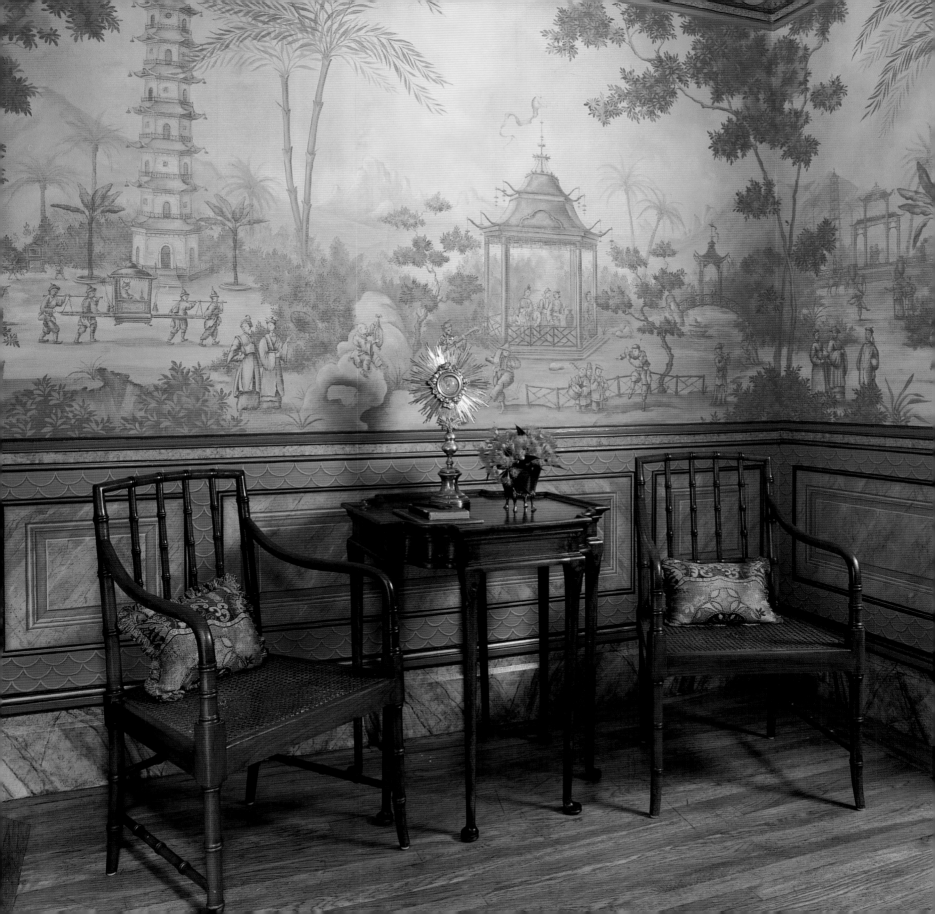

"My vision for the library and the foyer was to suggest the residence of an eighteenth-century French or Italian philosopher/scientist who was crazy for the idea of China and Venice," said Duté. "He had never actually been to China or even the Veneto. But he'd seen paintings and porcelains. They were the inspiration. He loved the exoticism."

Duté designed his nine-foot-tall pagoda-inspired bookcases with a quick sketch. He outlined a pair of bold columns supporting a bell-adorned traditional pagoda roof.

"My original plan was for a rather authentic chinoiserie design, but it became more and more Italianate and baroque as I worked on it," the artist noted.

Inspired by the trees that flourish just outside his windows, he first painted the main cabinet a pale eucalyptus green strié. This was a mere prelude to the wildly creative techniques that followed. Pilasters are coral-colored *faux marbre,* ledges and baseboards are striped ocher *faux marbre* with black outlines. Doors and crown molding are elaborate golden brown faux burlwood. The ensemble is pulled together with shots of gold leaf around the crown molding and Venetian red door panels.

On the opposite walls of his study, Duté has painted virtuoso murals depicting the China silk trade, complete with a bustling harbor, wave-tossed junks, picturesque riverside villages, weavers, bridges, palm trees, and tiny people, all in exquisite detail. A pair of red tole tasseled lanterns suspended in the upper corners are painted so convincingly that they appear to move in a light breeze.

MASTER OF DETAIL *(Above)* Michael Duté will spend hours and weekends perfecting the wood grain effect in his study, or creating a multidimensional sense of Chinese porcelain jars, birds, flowers and leaves, and rich marbel on his flat surfaces.

ANCIENT TECHNIQUES *(Opposite)* Duté worked in an exacting two-color technique to craft the foyer murals. The minutely imagined scenes took several years to complete. As in original French and Chinese murals and printed papers, perspective is replaced with fantasy, supposition, and enhanced delight.

Michael Duté's artistry would have done Louis XVI or Gustav III proud. It is all the more impressive to discover that Duté has never studied art.

"I arrived in San Francisco in 1989 from Philadelphia, and I didn't even know I wanted to be a painter," said Duté, who had previously designed fabrics and crafted ceramics.

"I answered an advertisement for an 'artist's assistant,'" recalled Duté. "I needed a job, and knew I could rise to the artistic challenge."

Fortunately for Duté, the artist was the magnanimous Carlo Marchiori, a world-renowned master muralist and decorative artist who lives in Calistoga.

"My first assignment was to paint murals in a Las Vegas hotel," said Duté. "From Carlo, I learned how to render in 3-D. It was a crash course, and Carlo was a great instructor."

"In my painting and subject matter, I am always inspired by French artists like Fragonard and Boucher, who painted exuberant, exotic scenes and landscapes based on their romantic views of idyllic life in the countryside, and in China," he said. "Like Boucher, I love to depict leisure scenes, but I'm a pragmatic artist, so I also put my people to work weaving silk, fishing, harvesting, washing clothes in the river, dyeing silk, rowing a boat. This gives the paintings more energy and movement and lends them some bite. They're dynamic, not too sweet."

Two years ago, Duté started work on murals for the entry hall.

"I wanted to depict an imaginary Chinese landscape, as seen through European eyes," Duté recalled. "Italian and French nobles in the seventeenth and eighteenth centuries acquired Chinese silks and porcelains and had such illusions about the real China."

Duté painted the chinoiserie in pale Venetian red on a creamy background, an exacting traditional technique that requires great finesse and patience. Across the panorama march fifty-three people gathering for a festival. Every detail of his lively scenes are imbued with mystery, grace, and charm. Palm fronds, painted in minute details, appear to flutter, and a man pulling a water buffalo seems to move through a rice field. Tiny people are engaged in lively conversation and engrossed in building a pagoda.

For Duté, the best way to spend the day is creating lost worlds, landscapes of his imagination, romantic scenes of legendary places.

"I love to come home and enter a dream world," he said. "I've created my own world. It's a fantasy—and it's my reality. I wake up, and I can be in eighteenth-century China. My spirit is uplifted. It's the best way to start the day. It's like living inside a painting." ⚙

WHITE IS RIGHT *(Above and opposite)* The pale cream and white palette of Michael Duté's kitchen/dining room is a visual relief from his intensely detailed and colorful murals. The curtains were made by Lauren Berger of Petaluma. The cartouche, painted by Michael Duté, represents his romantic vision of the discovery of the New World.

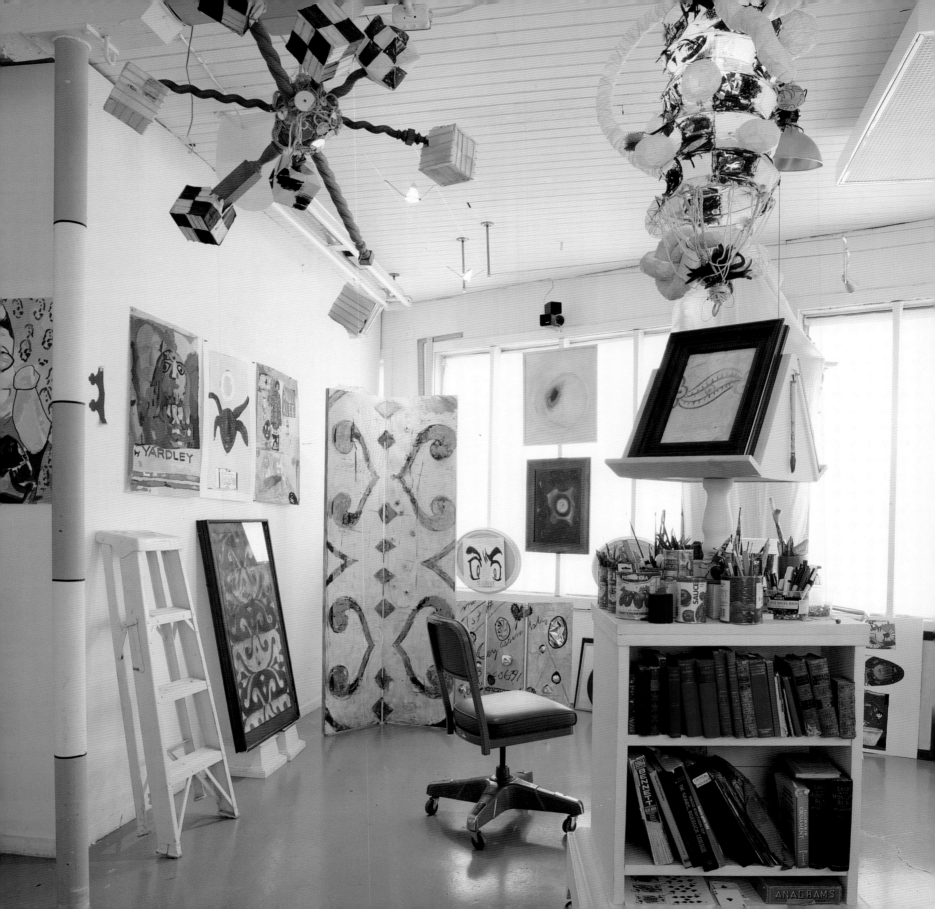

MYSTICAL Eye

When they first arrived in San Francisco from the East Coast a decade ago, artists Brett Landenberger and Scott Waterman prided themselves on living in a neighborhood known for its foggy summers. Close to the ocean, their street was the first to be blanketed in swirling gray fog. At first they relished the muted light and found the cool air conducive to their quiet, meditative art, but eventually the long-time partners wanted some sun, some cheerful brightness.

Waterman and Landenberger found their ideal residence in a quiet area of Oakland. The neighborhood, close to the Bay Bridge and graced with ornate Victorians, was formerly known affectionately as Dogtown.

"We loved the configuration of the 1890s building, which had a studio downstairs and all the living areas upstairs," said Waterman, whose large-scale murals and commissioned artworks are popular among San Francisco's top interiors designers.

"Unlike a big open loft in a former industrial building, we have the studio in close proximity—but it's not all one big space," noted the artist. "I like having my paints and brushes so near because my work is a consuming passion. I can go downstairs and work on a collage or canvas at any time."

Although Waterman has always seen their interiors as an improvisational act, his sense of decor is changing.

"I'm inspired by minimalism and empty interiors with everything stored away," he said. "The Japanese aesthetic is my ideal, though I am not sure I will ever attain that rigorous simplicity. I've stopped going to flea markets. I produce a lot of work, and I would like to focus on that rather than on acquisition or flat-out decor."

Waterman's work—collage, acrylics, stencils, monoprints, block prints, large-scale murals of repeating patterns, and mixed-media explorations—stays fresh.

LAYERS OF MEANING *(Opposite)* The flatiron-shaped studio was formerly an old corner grocery store. Banks of windows on two sides are now covered with cotton scrim to beam diffused light into the room. Most of Waterman's equipment is on wheels so that he can easily change the configuration for each new project. Collages, a screen, elaborate paintings and exuberant constructions are by Scott Waterman.

"My latest inspiration is computer animation and nonrepeating patterns on the monitor screen that are responsive to music," said Waterman. "I always play music while I am painting. It keeps the energy going. Now I'm into trip-hop, which has a great beat and movement and spirit. I like to convey as much of a sense of movement and life as possible in my art, and this urban beat pushes me along. I think it's important to be of one's time and to take advantage of technology and music that comes along."

"I'm inspired by minimalism and empty interiors with everything stored away," he said. "The Japanese aesthetic is my ideal, though I am not sure I will ever attain that rigorous simplicity."

Waterman was once fixated on the Renaissance and classical paintings for reference. Now it's images of today, random repeats, and the play of chance he finds appealing.

"My art is a story unfolding, and the plot is always changing," noted Waterman, presciently.

Landenberger, now an office and projects manager in medical research, and Waterman pride themselves on being adventurous and open to new ideas and possibilities. They have recently moved their tent (and their beds, brushes, and paints) to Los Angeles, where they are once more urban pioneers, living in a loft downtown near Skid Row. ◉

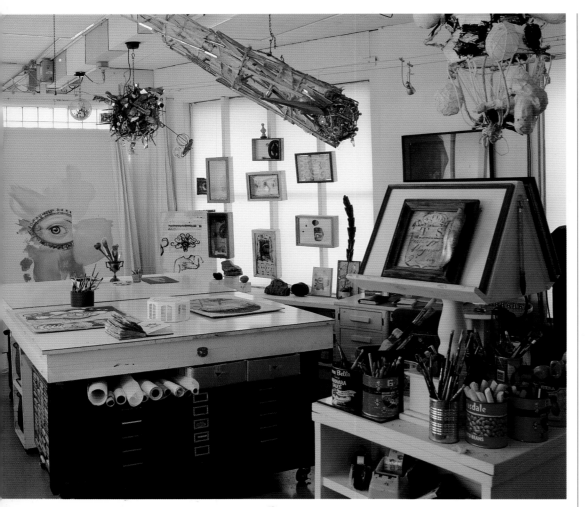

PAINTED DREAMS (*Above*) The eye of the artist captured a painting of an eye (a work in progress) inspired by a Victorian miniature. The acrylic work draws the gaze to the epicenter of the studio. Large tables on wheels, desks, shelves, flat files, and coffee cans and flowerpots sprouting brushes furnish the practical studio.

MAKING THE MOST (*Opposite*) Waterman and Landenberger improvised the day bed from a chaise longue found at a garage sale, a frame, and linen draperies. "We were expecting a guest and wanted to make her a romantic place to sleep," said Waterman. "This is now our day bed/guest room/living room." The floor design was improvised after a red pool of wine was spilled by a guest on the sisal carpet. "We painted large circles with acrylic paints directly on the sisal, and it has been surprisingly durable," he noted. "It was such a plain surface, it was begging to be decorated."

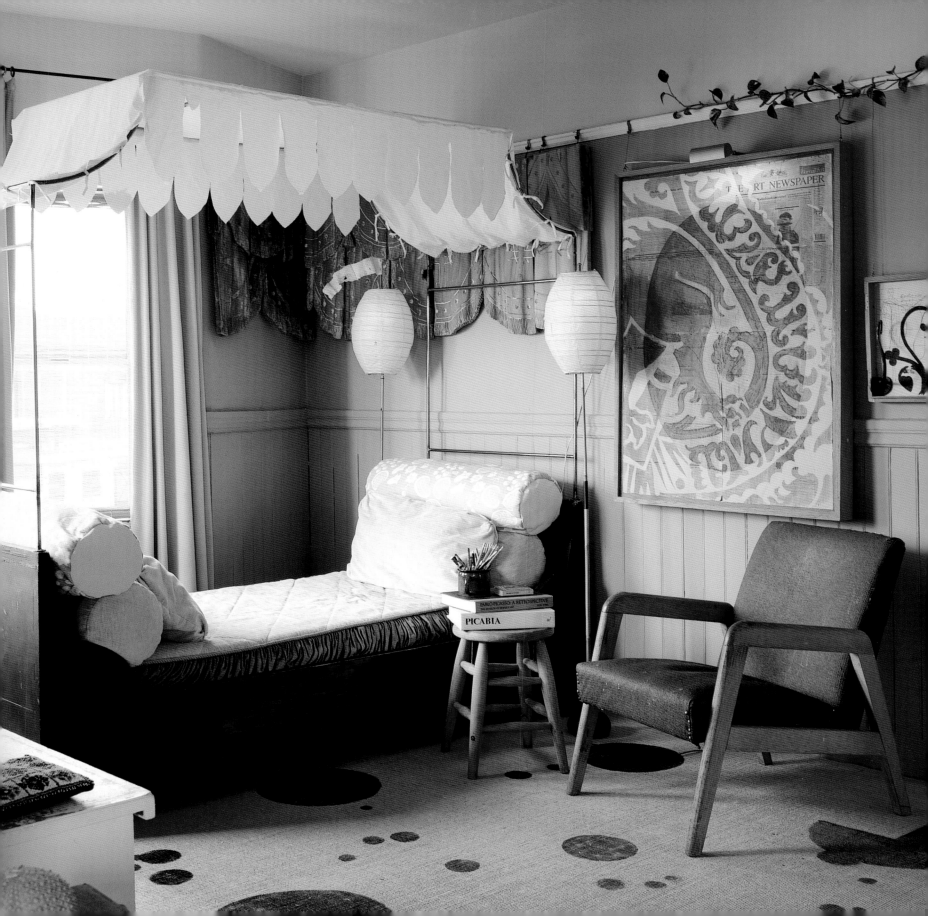

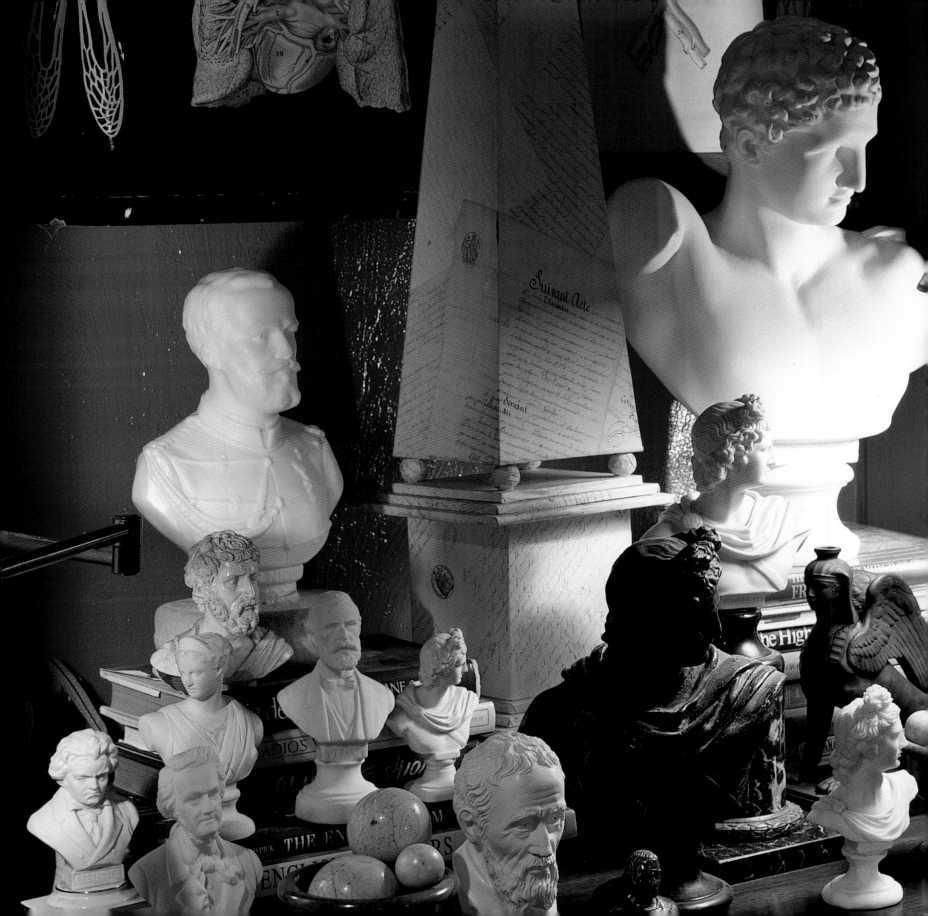

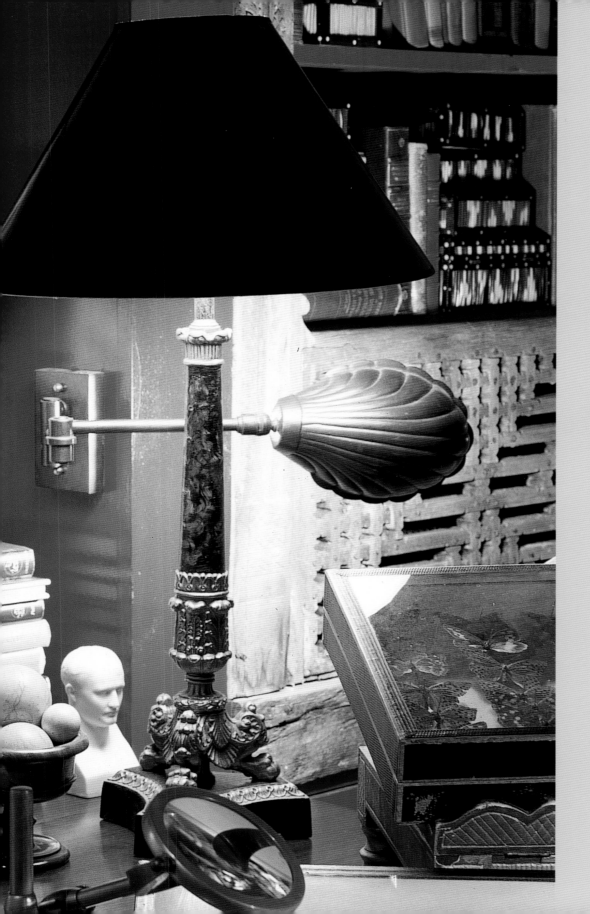

COLLECTORS

FOR SUCH IS OUR TASK: TO IMPRESS THIS FRAGILE
AND TRANSIENT EARTH SO PASSIONATELY UPON OUR HEARTS
THAT ITS ESSENCE SHALL RISE UP AGAIN, INVISIBLE IN US.
WE ARE THE BEES OF THE INVISIBLE.

Rainer Maria Rilke
Letter to a friend, November 1925

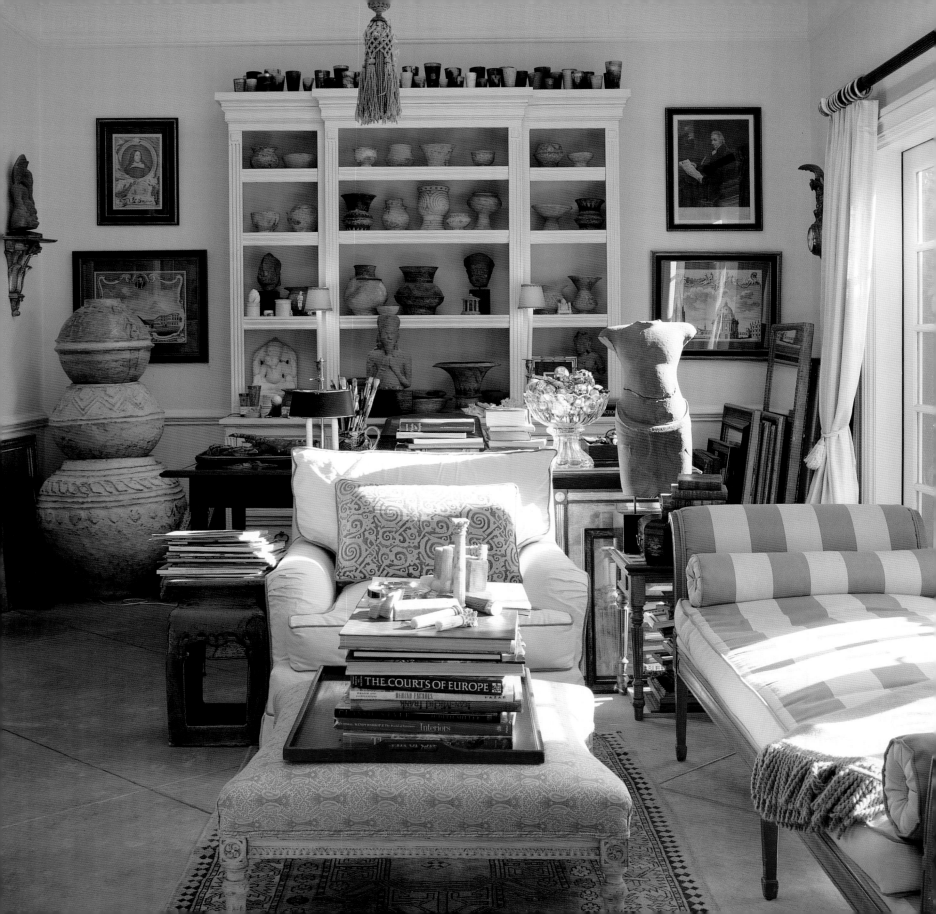

The PASSIONATE Eye

JOHN VAN DOORN IN PACIFIC HEIGHTS

It's hardly credible that interior designer John van Doorn began his career as a minimalist. Every surface of his Edwardian house in San Francisco is enriched with and embellished by beautiful, eccentric, rare, and dazzling objects.

On the living room mantel is an array of Dutch gilt bronze candlesticks cheek-to-cheek with coral branches, venerable Chinese porcelains, eighteenth-century silver-gilt candlesticks from Paris, Viennnese bronze lizards, and Persian picture frames with mother-of-pearl and bronze inlay.

Beside the front door, antique English silver-mounted bamboo walking canes jostle for space in an umbrella stand with vintage English riding boots and a jumble of gilt frames (no pictures).

Large coral-pink conch shells bloom on wall shelves in the bathroom beside collections of framed mezzotints and a pair of luscious gilded *appliques* with crystal drops from the venerable place d'Aligré flea market in Paris. Turquoise globes (after all, the planet's mostly ocean), pressed-glass pedestals, mother-of-pearl boxes, Persian frames, bronze Napoleon figures, plaster busts, monastery dinner plates, rare gold-embossed books, and dusty chandelier crystals are clustered on a dining table.

"Before the collecting bug bit me, my house used to be quite austere, and I kept my worldly possessions to a minimum," recalled van Doorn, now surrounded by lustrous porcelain birds, Laotian urns, Thai pottery, prehistoric terra-cotta pots, marble spheres, bronze armillaries, and quill boxes.

"Twelve years ago, I liked the idea of traveling light. But then my nomadic lifestyle led me to Europe, where I was immersed in the best antiques galleries and flea markets—and the rest is history," said van Doorn, who displays some of his wares in a vitrine at the Antique & Art Exchange in San Francisco. He now admits, somewhat guiltily, that his growing collections number around ninety and counting. Some of them are choreographed in lively tableaux in the rooms of his Queen Anne house. Others, for the moment, are kept in storage.

GATHERED ANCESTORS *(Pages 150–151)* In his library, Van Doorn's collections of known and unknown worthies meet, pose, and preen.

SUNNY DELIGHT *(Opposite)* John van Doorn's living room, which has a bank of French doors overlooking his jasmine-scented garden, is also the repository for many of his favorite collections. On the shelves are antique horn cups and old ivory figures, and on his table alight Christmas ornaments, bronzes, and design books.

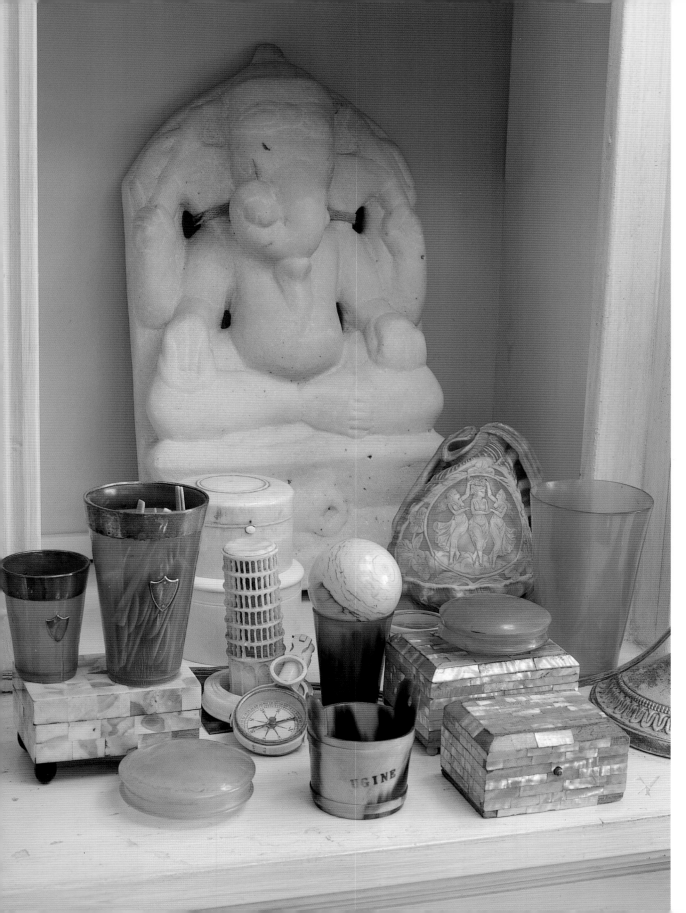

THE WORLD BROUGHT HOME *(Left)* Horn and antique ivory collections from around the world—Scotland, Argentina, France, Belgium, India, Japan, England, and Brazil—pose in alignment on a cabinet painted the color of the winter North Sea just as the sun rises.

THE PASSIONATE COLLECTION *(Opposite)* John van Doorn's eye has captured such treasures as an antique buddha head and a superbly carved antique rickshaw; a Burmese buddha head, scallops, and the washed-ashore sawtooth of a sea creature; Christmas ornaments in a crystal bowl; and coral and ostrich eggs on his living room mantel.

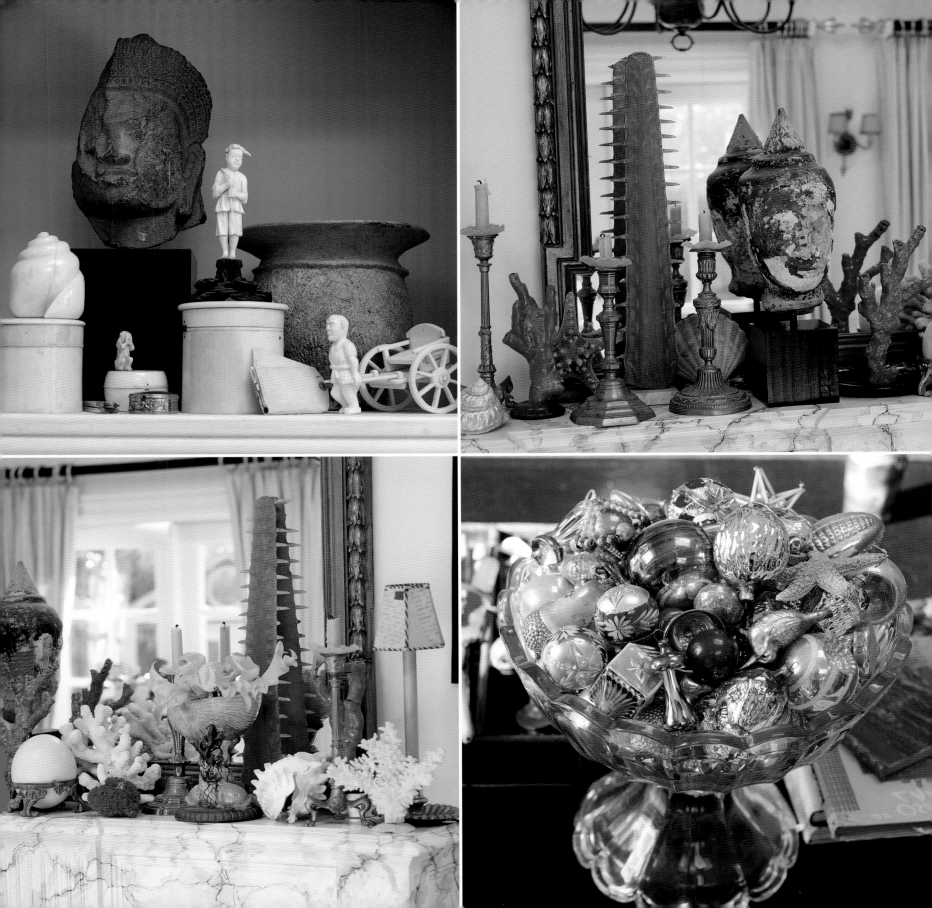

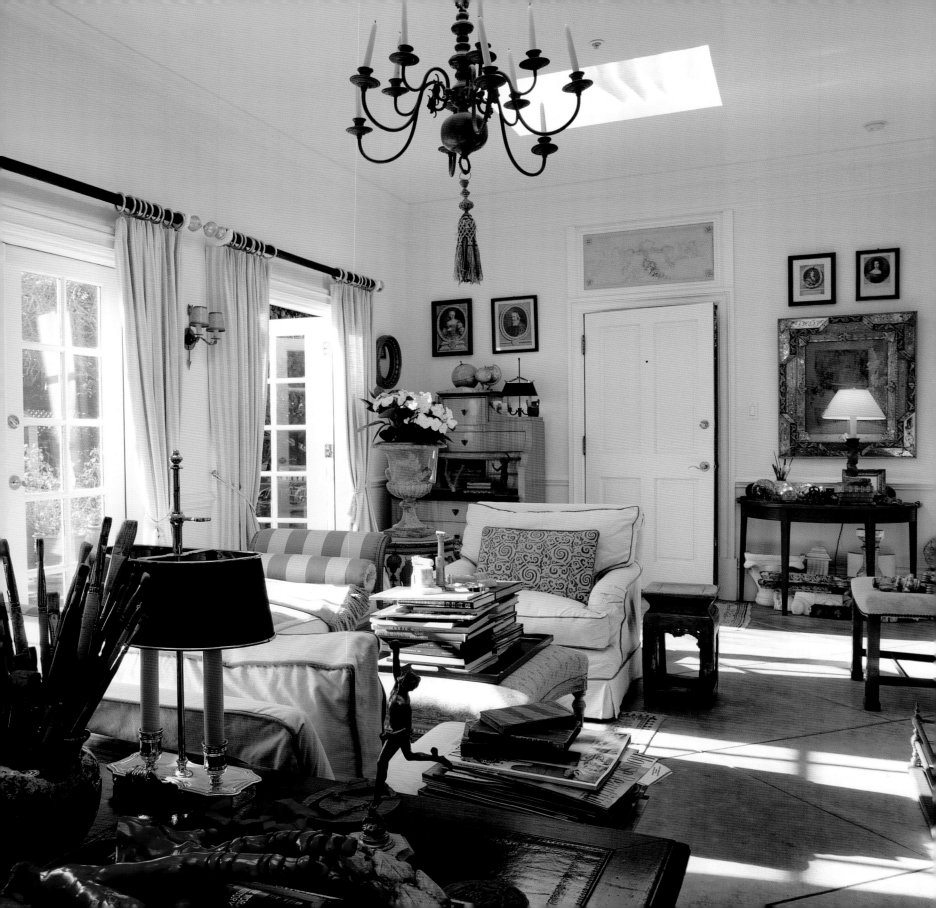

"One find leads to a collection, and one engraving or ormolu sconce leads to another, and soon I am completely hooked," said van Doorn.

The varied collections, which span thousands of years and many continents, are surprisingly compatible. Seventeenth- and eighteenth-century Chinese blue-and-white porcelains are juxtaposed happily with early-nineteenth-century French silver candlesticks with melon-colored silk shades and metallic gold thread trim. Framed eighteenth-century Dutch mezzotints hover over Indian papier-mâché storage vessels. Porcelain birds with vivid plumage seem ready to perch on a stack of elaborate old Dutch gold frames piled on the floor beside a carved chinoiserie table.

There's no museum-like formality. And van Doorn presents them all equally, no matter the provenance, value, era, source, or delight.

"I collect these pieces because I want to live with them and see them every day," said the designer. "I hate it when collections are given that overly precious treatment, cordoned off from everyday life, in a sense. Collections are boring when they are perfectly dusted off and never touched or moved. That looks dead, too much like a museum. This is a living, growing, and changing collection. It's rather out of control. And I love the clutter."

A trip to Mallorca, Andalusia, Belgium, Venice, Paris, or New York results in more stacks of old gilt frames, lamps, Polish Christmas ornaments, bronzes, and porcelains.

"The majority of my antiques are made of some organic material," observed van Doorn. On shelves are horn cups, quill boxes, crystal spheres, ebony and bamboo walking canes, shells carved with vistas of Mt. Vesuvius eruptions, an Indian stone bust, and Cambodian stone heads and weather-worn Thai terra-cotta vessels.

Four or five times a year, van Doorn heads for Paris, where he keeps an apartment in the Marais. There he roams far and wide to look for more treasures. His collections, and the richness of his life, are embroidered with more beauty. ◈

FAVORITE THINGS (*Above and opposite*) From his antique French desk, John van Doorn can view a Biedermeier secretaire, globe collections, and the butter-yellow walls. Beneath a nineteenth-century Venetian mirror, are a series of mezzotints, a mercury glass collection, Parisian bronze figures, and shells van Doorn could not resist.

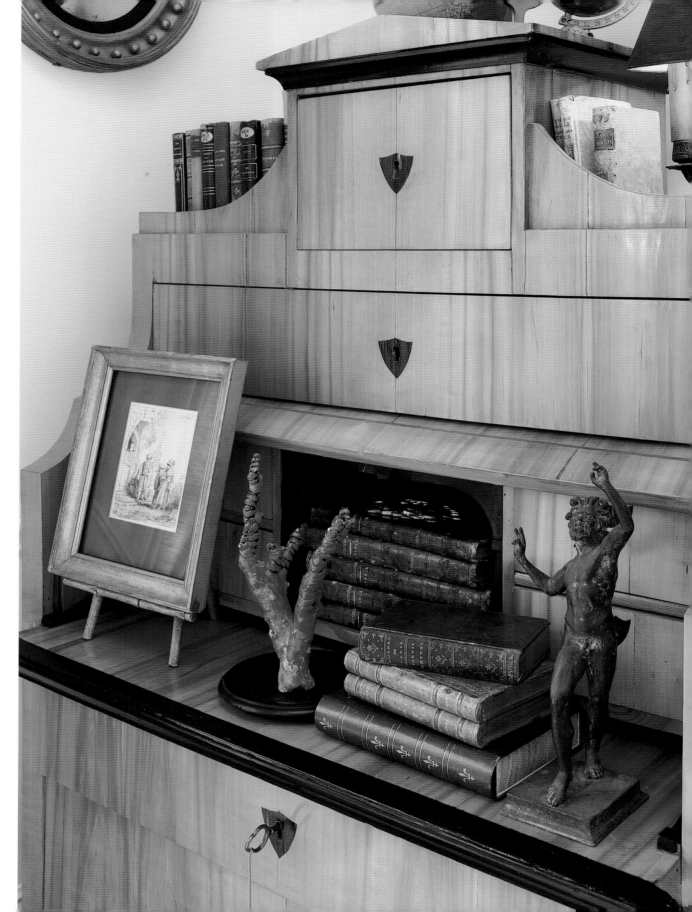

I'LL TAKE PARIS *(Opposite and right)* Van Doorn's French and Asian trips have resulted in lively and varied collections. On these pages are mercury glass groups on a *demi-lune* table, witty coral branch collections (newly fashionable), Thai bowls, and globes and bronzes on a Biedermeier desk. Tip from van Doorn: to find the best from flea markets, it is necessary to go very early, and to go often. His favorite hunting grounds include Marché Paul Bert and Marché Vernaison in Paris, and obscure corners of London's Portobello Road, plus Palma, Majorca, and Prague. J. van Doorn purveys antiques at Antique & Art Exchange in Pacific Heights, San Francisco.

The Doctor is in

DR. PAUL TUREK & ASHLEY STILES TUREK IN BERNAL HEIGHTS

When Dr. Paul Turek went house hunting, he found a residence in Bernal Heights with some possibilities and lots of flaws. Turek, an internationally renowned specialist in male reproductive medicine and surgery, is the associate professor of urology at University of California, San Francisco, and director of the Male Reproductive Laboratory. He is also an avid lifelong surfer and collector of surfer memorabilia.

According to Cass Calder Smith, his architect for the remodel, "This was a sixties box with a pathological floor plan. Even worse, the house was plagued with an abundance of vinyl wallpaper and missed city view opportunities."

The house and the budget required a regimen of simplicity and architectural rigor. Calder Smith told the client not to aim above a B+ and not to overelaborate. Rich walnut floors and substantial stainless-steel details were used to dress up a restrained white cube.

"Fortunately," noted Smith, "the client was a modernist without hesitation."

On the ground-floor level the garage was carpeted to protect Turek's coveted '69 Maserati and Alpha Romeo Giulia. The second floor was completely reconfigured to feature the view. Inserting a window the length of the living space, the architect also minimized obstructions by housing most of the kitchen in a twelve-foot-long counter-height island. The third floor remained the sleeping quarters and was enhanced with a Bizazza tiled bathroom.

The scale of the project required selective editing in the furnishing process.

"I knew that Paul was a purist who purchased the home with an eye toward housing his growing collection of mid-century originals," said Kelly Lasser, the interior designer, whose San Francisco design firm is called ShelterDesign. "I aimed for a high/low mix that would signal Paul's design cred and stay consistent with the attitude of the remodel." ◈

CATCHING A WAVE *(Left)* In the bedroom, Dr. Paul Turek's surfboard is a classic sixties chambered balsa board by Paul Kraus of North Pacific Shapers in Mendocino. Designer Kelly Lasser paired it with a platform bed by Poliform from Arkitektura. The Gloss lamp is by Pablo Pardo. Inspired by landscapes and seascapes, the Horizon striped silk rug is by Fort Street Studios.

HOMAGE TO MID-CENTURY OPTIMISM *(Opposite)* Kelly Lasser's approach: a sleek walnut floor, a Greek flokati rug with dreadlocks of wool, and an iconic Note white lacquer and steel table by Piero Lissoni for Cassina. Juxtaposing curved and linear silhouettes she placed the table and a black leather Swan chair by Arne Jacobsen side by side. The Cactus colored-vinyl and polyurethane-covered Divina chair was designed by Piero Lissoni for Knoll. An antique wood fireplace screen from de Vera covers part of the flagstone fireplace facade the architect left intact "to preserve a thread to the past." The top half of the fireplace column was covered in Sheetrock with a minimal stainless-steel shelf to serve as the mantel. The allium bulbs and vase are from Fioridella.

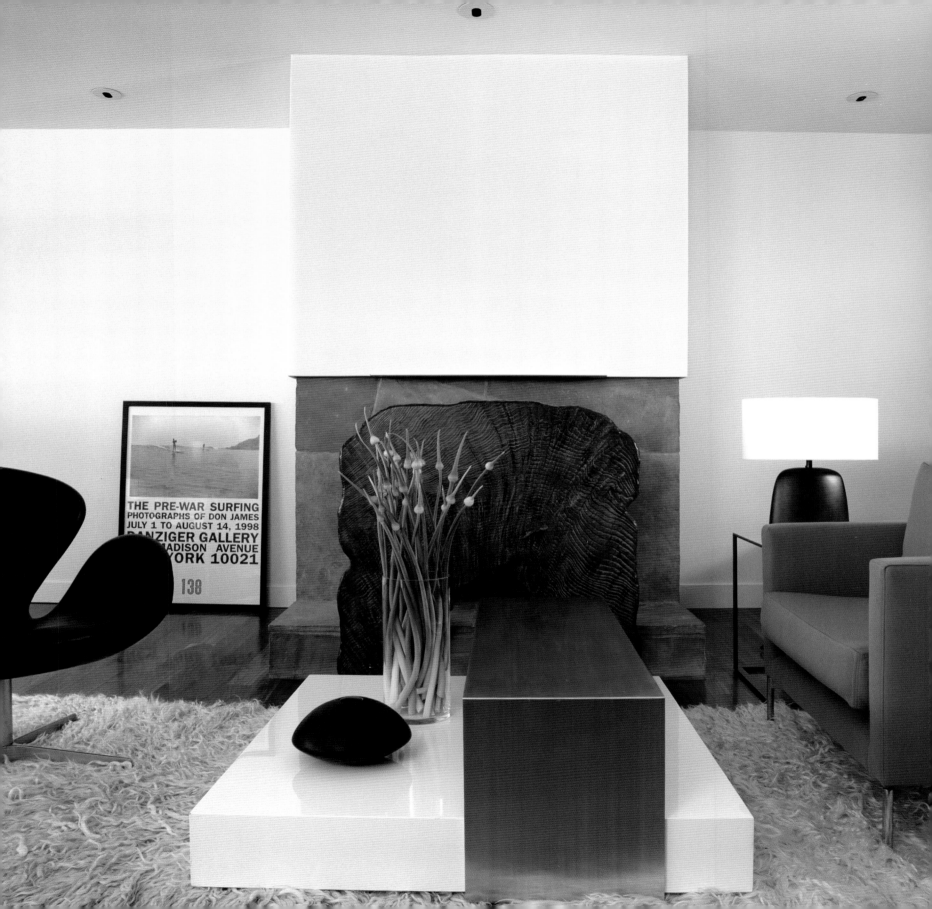

THE PRE-WAR SURFING
PHOTOGRAPHS OF DON JAMES
JULY 1 TO AUGUST 14, 1998
DANZIGER GALLERY
MADISON AVENUE
YORK 10021
138

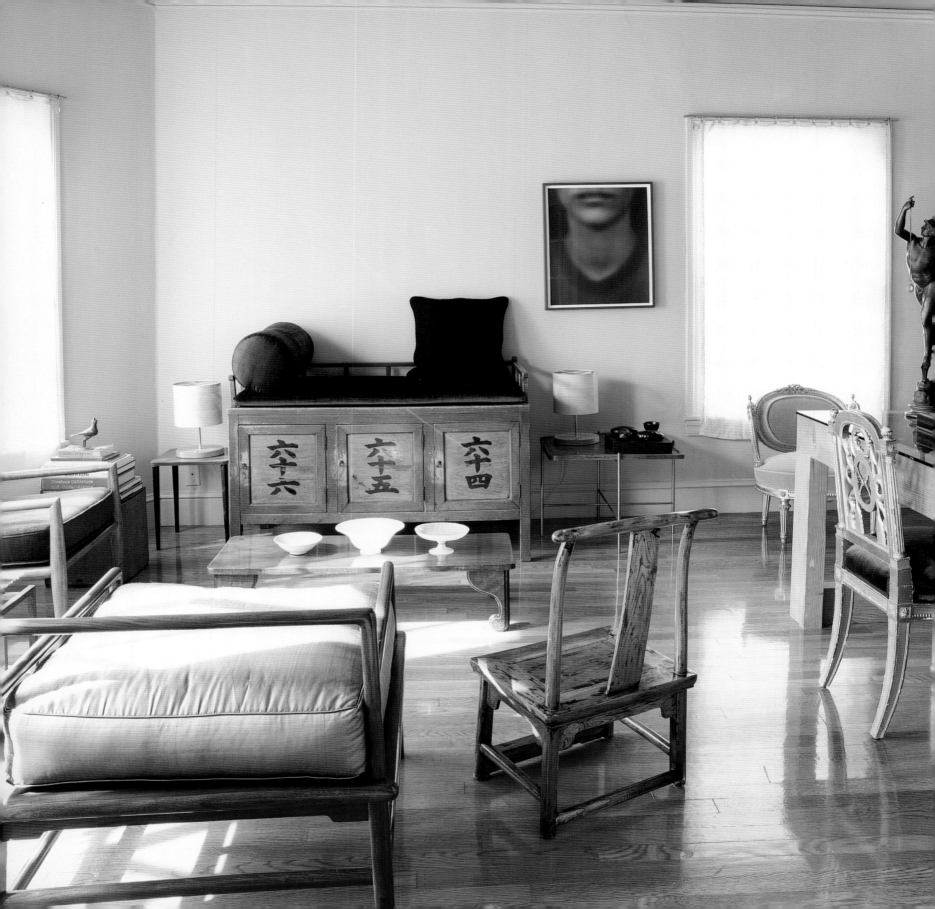

An ORIGINAL Spirit

FEDERICO DE VERA IN THE MARINA

Federico de Vera opened his first de Vera gallery Gough Street in San Francisco ten years ago. Featuring Venetian glass and de Vera's own decor, the small gallery became a cult address. De Vera recently opened his new de Vera design store in Little Italy, in New York City, and now dashes back and forth across the country managing both his Manhattan and Maiden Lane stores. His monastic Marina retreat is even more essential.

With a connoisseur's passion for beauty in its myriad forms, Federico directs his design, jewelry, and style galleries, where rare vintage Venetian glass, antique ivory saint figures from Goa and the Philippines, Japanese lacquerwork, handblown glass by Santa Cruz and Berkeley artists, carved French mirrors, gilded Thai buddha hands, and a fearsome Japanese brass temple dog are displayed within pared-down, clean-lined interior architecture.

"I love the ephemeral nature of beautiful glass pieces," said de Vera. "They're alluring and superbly crafted and exquisite, and it could all disappear instantly with one wrong move."

Over the last decade, de Vera has developed an enthusiastic following for his designs for residential, restaurant, and retail interiors. Clients who walk into his superbly art-directed stores are seduced by his expressive, playful, and single-minded approach.

"I didn't set out to be an interior designer as well as a gallery owner, but clients liked my display, my eye, my collections, and they asked me to design their lofts, apartments, and stores," said de Vera. He also designs furniture.

Followers of de Vera—he is an internationally known figure among those who worship the exquisite, the arcane, the off-beat, and the luxurious in design—admire his provocative juxtapositions of beautiful and antithetical objects on his shelves. A smooth Tibetan silver bowl is displayed beside a quirky seventeenth-century Japanese patinated bronze incense burner in the shape of a rabbit. Rare Reticello glass from Murano gleams beside Goanese ivory and a Tibetan bronze buddha jeweled in turquoise.

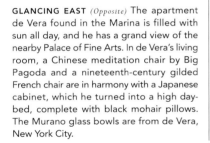

GLANCING EAST *(Opposite)* The apartment de Vera found in the Marina is filled with sun all day, and he has a grand view of the nearby Palace of Fine Arts. In de Vera's living room, a Chinese meditation chair by Big Pagoda and a nineteenth-century gilded French chair are in harmony with a Japanese cabinet, which he turned into a high day-bed, complete with black mohair pillows. The Murano glass bowls are from de Vera, New York City.

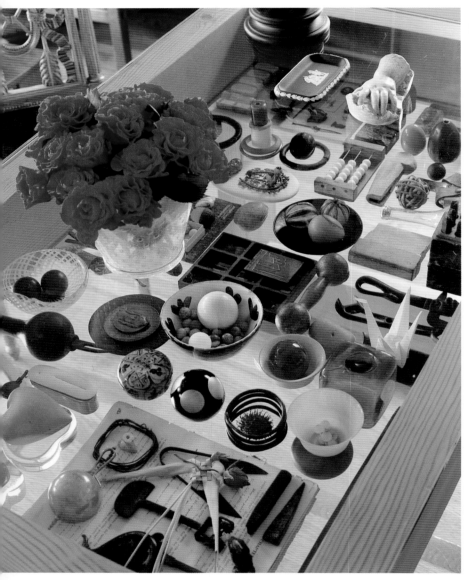

EVERY OBJECT TELLS A STORY *(Above and opposite)* For the living room, de Vera designed a Donald Judd–esque fir table with a glass top so that he could display his collections. Treasures gathered here, some fetishy, include a bottle of holy water, rusted old tool parts, a jade bowl, a bone toothbrush, slide rules, graphite seedpods, a fly in a glass bottle, pre-Columbian figures, a chipped Picasso painted bowl, an abacus, and old Japanese eyeglasses. On the tall fir plinth grins an antique French mannequin head.

"I like to create both harmony and visual provocation in my displays," said the designer. "I want people to be surprised, amused, disturbed a little, and to enjoy the delicate scale of small antique and handcrafted objects—alongside bold, sculptural, and overscale pieces."

A Japanese ink pot ornamented with a circle of bats is placed beside a jewel-like Chinese pagoda crafted in vermeil, jade, coral, and turquoise.

"Good design is about editing, paring down, selecting carefully, staying true to your own aesthetic— and using color with great discretion."

The forty-year-old designer, who was born on the island of Luzon in the Philippines, credits his parents for their early encouragement of his design yearnings and experimentation.

"My parents collected antiques, so I've always had an appreciation for rare and special things," recalled de Vera. "As a boy I started collecting stones, coral, and seedpods and later small antique objects. "I later became a passionate collector, and I realize now that my stores and way I display my design collections are an extension of my early experimentation with order, perfection, contrast."

He often stayed at El Nido beach on Palawan Island in the Philippines, which has steep limestone hills and is remote and unspoiled.

"It's like Capri, but in the tropics, so it's chic yet restful," he said. "I can dream, make plans there."

De Vera studied architecture, then headed for San Francisco. His first position was as an assistant at Japonesque, Koichi Hara's iconic Japanese art and sculpture gallery on Montgomery Street.

"Working with Koichi refined my taste, and trained my eye, and I learned a deep understanding of Japanese craftsmanship," noted de Vera.

"In my own residences and at the gallery my aesthetic tends toward simple, clean lines and unpretentiousness," he said. "But I can't resist collections."

De Vera opened his first gallery on Gough Street and David Bowie, Hillary Clinton, Stanley Saitowitz, Geoffrey Beene, Susie

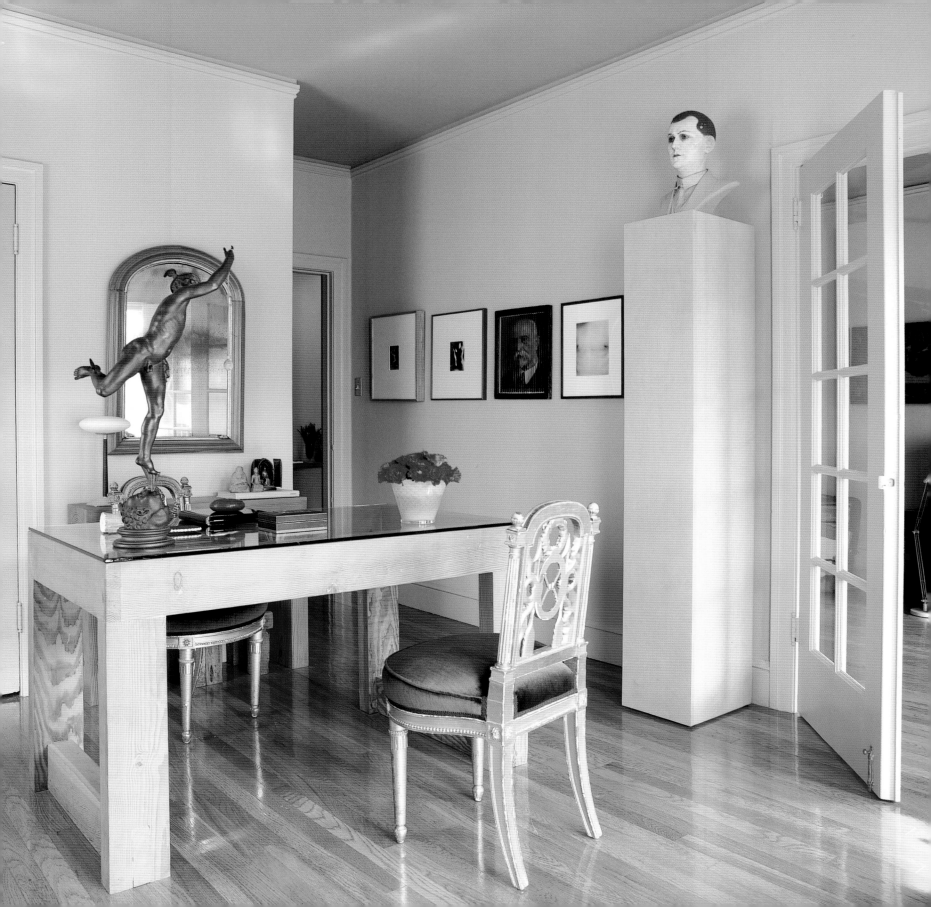

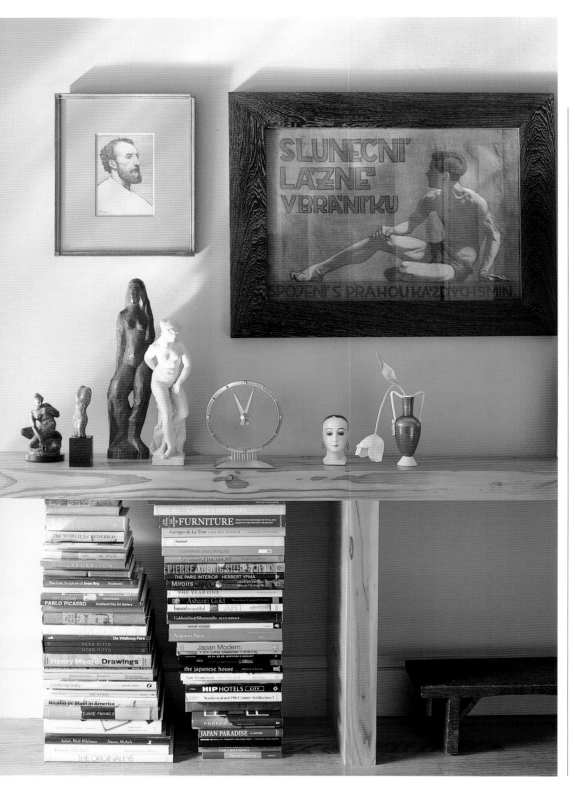

Tompkins Buell, and Danielle Steel were among his early fans.

"Good design is about editing, paring down, selecting carefully, staying true to your own aesthetic —and using color with great discretion," said de Vera, who travels for much of the year to handpick everything in his stores.

"My eyes are always open," he noted. "At the Louvre, I visit the Richelieu wing, to see the sculptures in the Cour Marly. In the Sully wing, I head for the Crypt of the Sphinx and collections from pharaonic Egypt. The sculptures are timeless, powerful, optimistic. In New York, my first stop is at the Metropolitan Museum to wander through the new Greek rooms. Such beauty!"

Inspiration can strike anywhere, but he guides his inspirations diligently.

"Wherever I am in the world, I enter churches to experience religious architecture, for spiritual uplift, to be quiet, to listen to myself," said de Vera. "I observe the architecture and the craftsmanship, absorb the life and history of the place. In Venice, I always visit the Basilica of the Frari, and in Florence, I walk to Santa Croce. They are filled with a sense of harmony, joy, and artistry." ◈

TIMELESS TRAVELS *(Left)* Federico de Vera designed the pine table, which serves as a display stage/altar. Books, a Prague poster, a French mezzotint, Spanish religious figures, and miniature antique ivories form a harmonious tableau. "In my travels, I visit antiques shops, galleries, artists' studios, flea markets, and auctions, and I always find something that speaks to me. I like to see the hand of the artist, signs of life and time," said de Vera.

PAST PERFECT *(Opposite)* An antique French Empire bed is bedecked with a mohair cover, a bolster edged with silver-flecked antique sari silk, an Hermès blanket, and a gray cashmere pillow from Banana Republic.

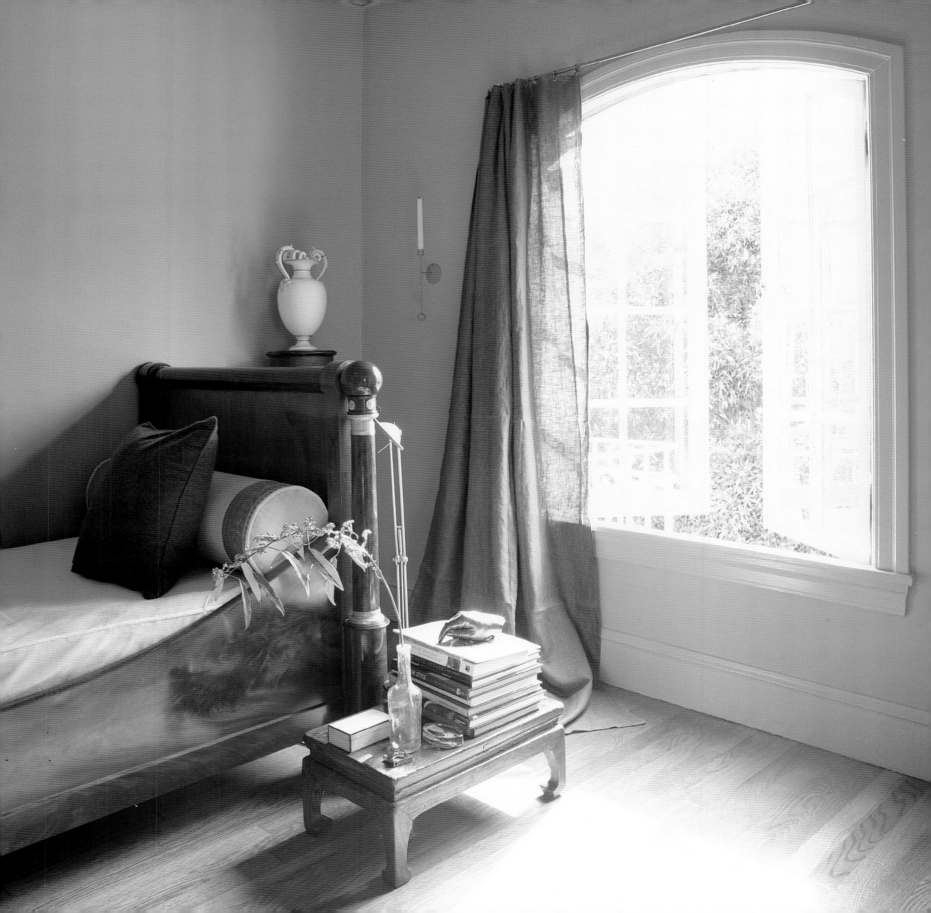

THE POWER OF SUGGESTION *(Left)* On a pine wall-shelf, Federico de Vera creates poetry, drama, beauty, and a touch of the surreal with a steel display frame, a marble bas relief, an antique Italian figure, coins and slightly faded muscari. Dada meets David Hicks.

THE STRENGTH OF REPETITION *(Opposite)* One etching or chair is interesting, and in de Vera's miniscule breakfast room, a multitude is memorable. A Japanese brush painting, a tintype, prints, a maxi-frame, and a de Vera-designed table become a visual feast.

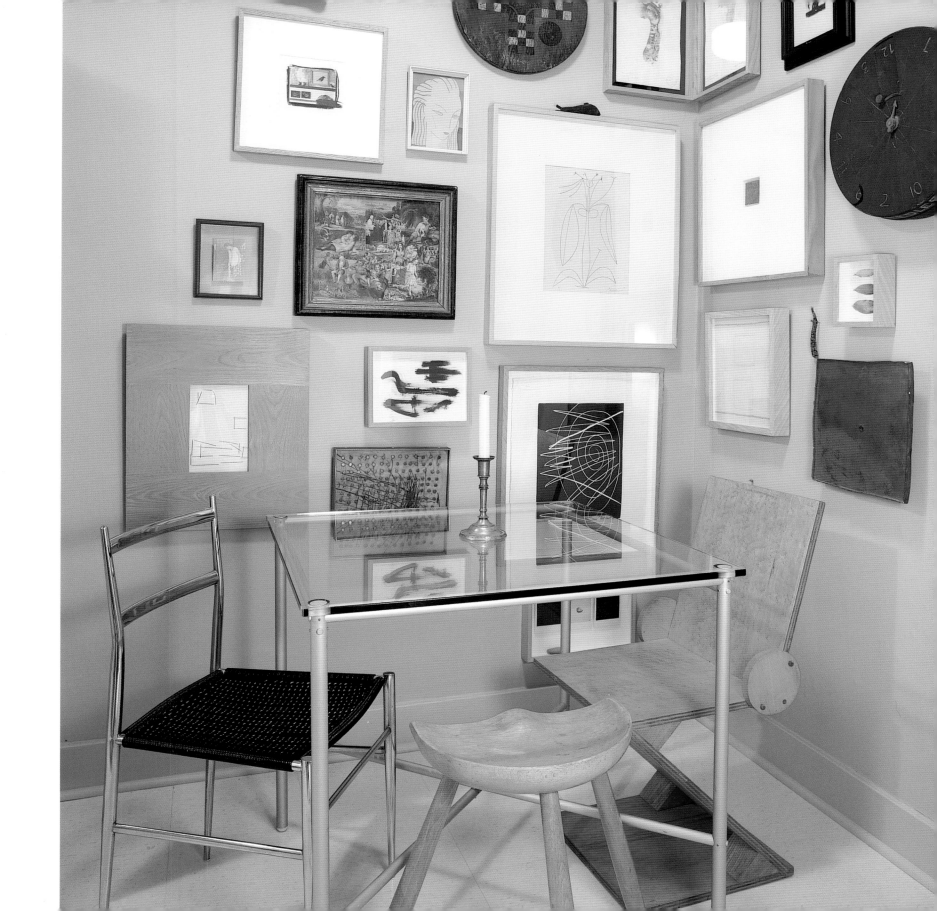

FRENCH TRANSLATION

FRED & WENDY TESTU IN BERNAL HEIGHTS

Antiques dealer Fred Testu lives an idyllic year-round outdoor life that is classic sun-tanned California. When the surf is up, he heads down the coast from San Francisco to catch the waves near Half Moon Bay or San Gregorio Beach or along the rugged shores north of Santa Cruz. Come winter, he heads to the Sierra to snowboard. And in between, he drives up to the lakes and rivers near Lake Tahoe to hike, fish, and commune with nature. Otherwise, he's combing the French countryside for antiques. Needless to say, Testu is hard to reach by cell phone.

In between waves, Normandy, and the occasional fishing trip, Fred and his partners run their antiques/vintage design store, Interieur Perdu, which sells French country antiques, vintage linens, French provincial decorative objects, and French provincial furniture.

Fred, his sister, Coco Reichborn, and their friend, Pamela Fritz, started their to-the-trade concern, based at a funky loading dock beneath the Bay Bridge, in September 1997.

Many of the antiques—rusty iron beds and baby cribs, mottled ironstone, well-worn old farm tools, white-painted garden furniture, mouth-blown wine bottles, cast-iron garden tables, wine flasks, iron vases, and urns—come from remote corners of Normandy. There, Coco and Fred's mother, Josette Testu, gather eccentric, charming, and highly collectible goods. Josette ships them back to San Francisco.

"Everyone loves a little bit of French furniture in their house," said Coco. "We have an eye for rusted things, worn pieces, old furniture with the nicks and patina of age and dusty attics. We don't polish things up. We love the rust and dents. We like the way rain and wear add character and texture to the furniture."

The store quickly became a favorite of interior designers, movie set designers, art directors, and clued-in dot-com denizens of South of Market who prized the funky and fabulous French fare.

VICTORIAN VISTA *(Opposite)* Like most Victorian dwellings, Fred and Wendy Testu's Bernal Heights house offers generous rooms with bay windows and clear, bright light. Fred and Wendy fearlessly dressed the rooms in white paint to create a seamless background for their quirky, charming French antiques. In the living room a French Madonna statue watches over an iron daybed, assorted tables, Wendy's clay sculptures on the walls, and colorful, relaxed textiles. The daybeds, crafted in France in the early twentieth century, serve as sofas, guest beds, gathering place, and stages for blankets, quilts, and pillows.

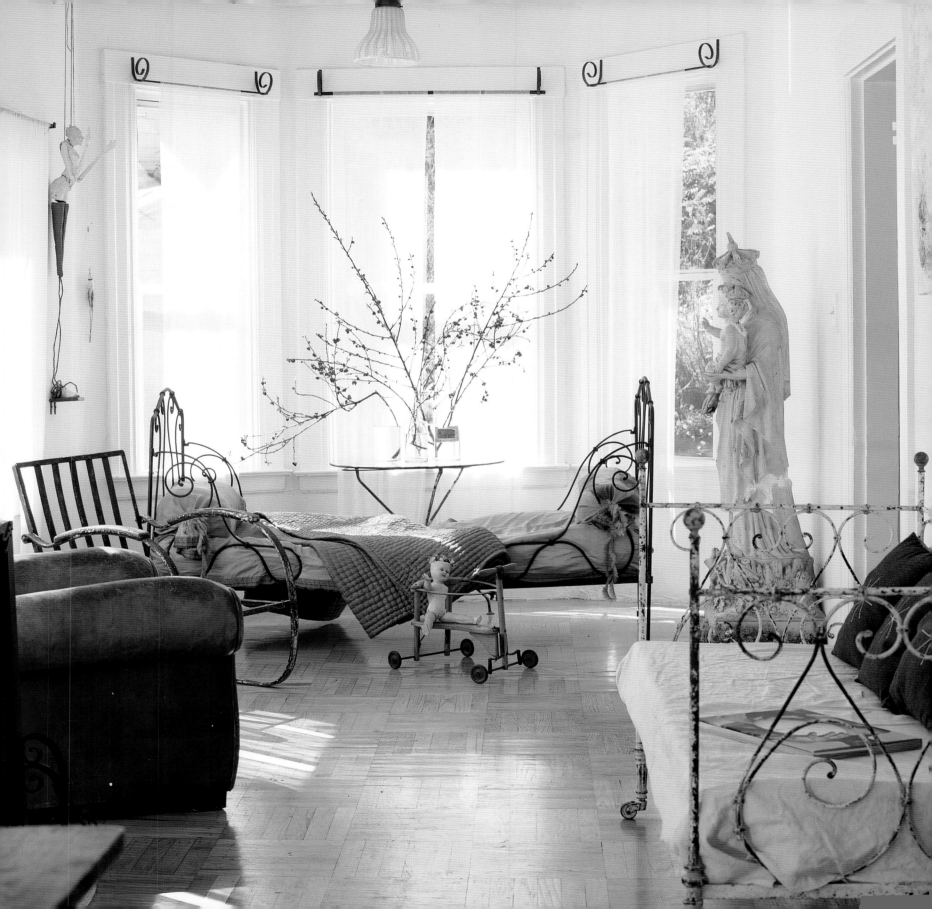

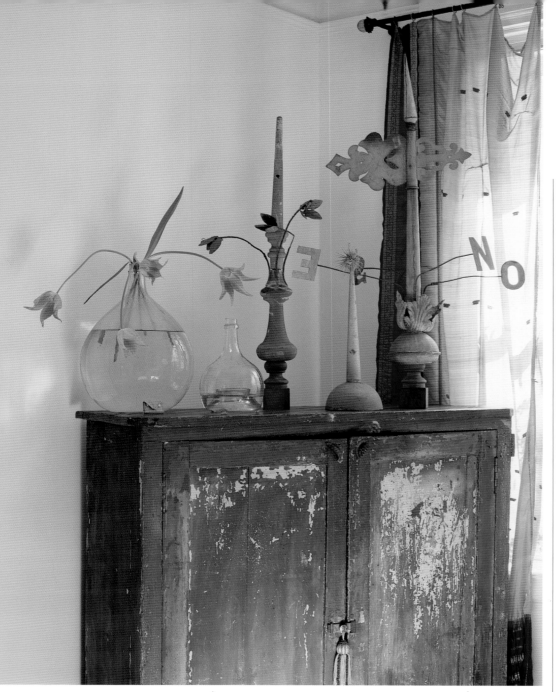

FRENCH COLLECTIONS *(Above and opposite)* Fred and Wendy have a special fondness for objects and furniture that bear the patina of wear and time. A swaybacked daybed, some old wine bottles, and a painted cabinet have spirit and give their sitting room/parlor a friendly, come-hither appeal. Even the flowers possess a casual curve. On the wall, a vintage industrial steel frame was turned into a graphic picture display for their collection of antique studio portraits from an obscure Indian town.

Fred, married to artist Wendy, found a city home base in Bernal Heights three years ago. Their three-bedroom Victorian house had been built in the early part of the twentieth century as a worker cottage and retained its original charm. It had a broad central hallway, a large living room/dining room, a sitting room, and a large kitchen. Upstairs were acres of space for a bedroom and eventually a nursery for young Lolita, their daughter.

"We love this hidden hillside location, the view of shipyards and San Francisco Bay, and the quiet neighborhood and friendly people," said Fred. Next door an empty lot overgrown with fragrant wild fennel lends the house a country air.

The house was in fine fettle and had not been aggressively remodeled, so the Testus got a supply of white paint and a series of brushes and got to work.

"We painted everything white," said Fred. "It's the perfect background for our antiques and statues and art."

When Fred's not watching the surf report and weather forecast, Fred and Coco also run two bars in San Francisco. Julip, in the Tenderloin, is decorated with Interier Perdu antiques and mirrors. Dalva, his bar in the Mission, has a south-of-the-border flavor.

"We like our life here," said Fred. "We take the occasional trip back to France to see our family and to buy antiques. And then we return to Bernal Heights. It's a nice, relaxed corner of the world to come home to." ◈

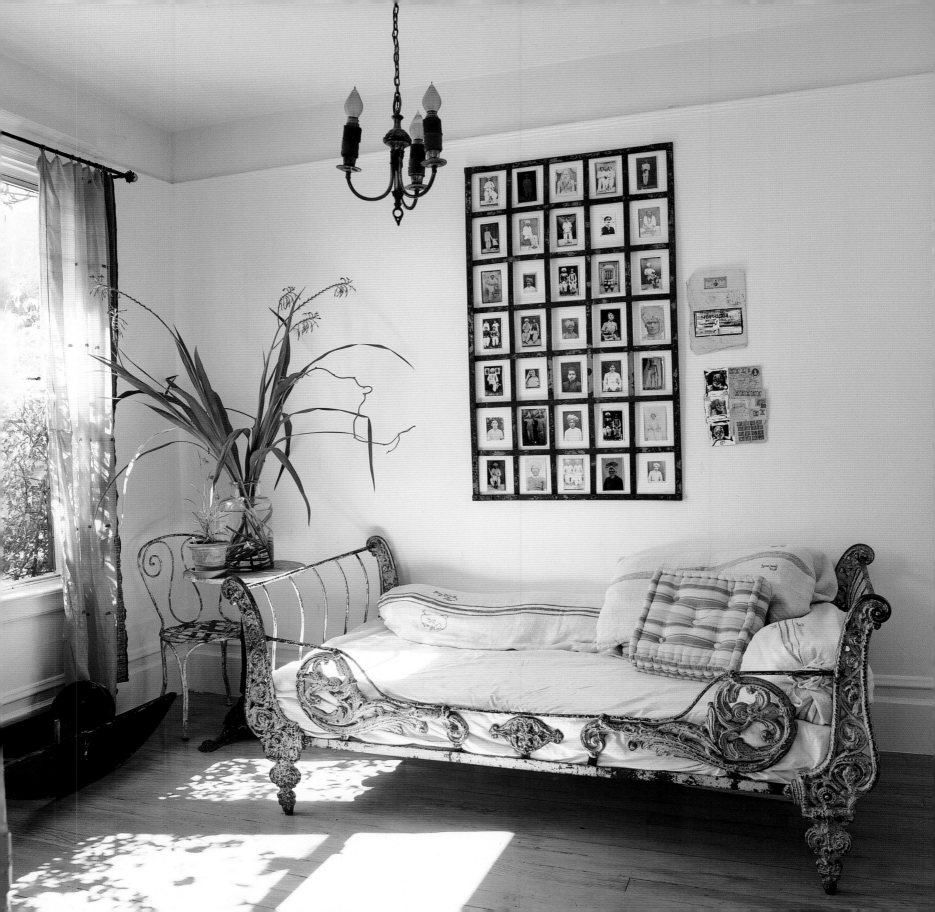

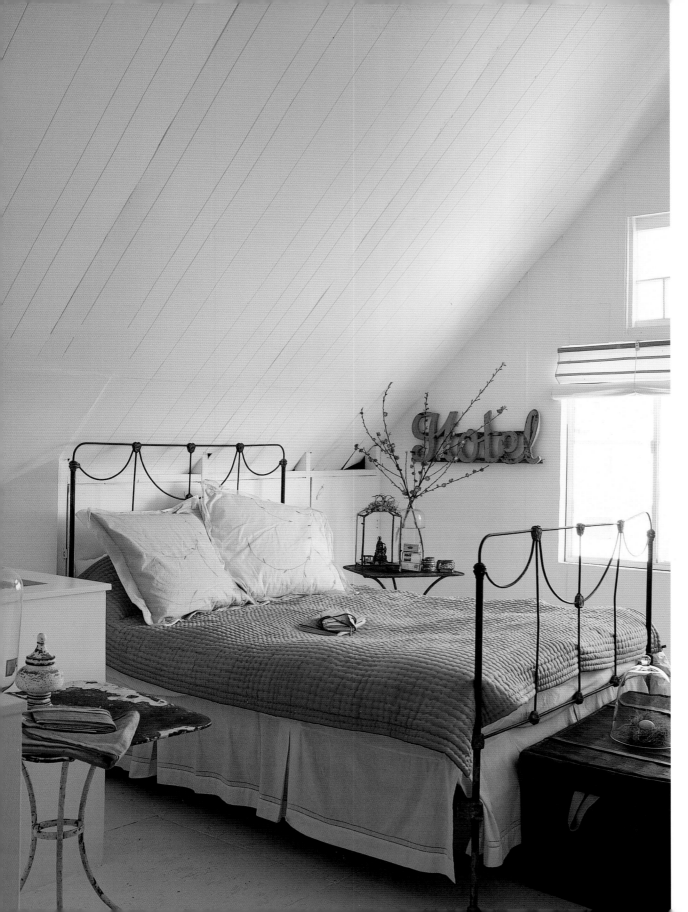

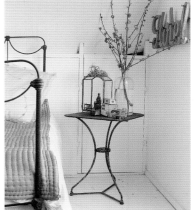

SWEET DREAMS *(Left, above, and opposite)* Sleeping in an attic suddenly became much more stylish with Fred and Wendy's all-white approach. The second-floor space has been opened up to become one large open room, with the parents' bedroom at the east end and little Lolita's bedroom/nursery on the west side. The bathroom is in between. The iron bed and the baby's cot are all French country antiques. For Fred and Wendy, old signs, gym lockers, a rickety table, blown-glass vases, handwoven linens, and wire baskets are all treasures to be rescued and used and appreciated for their authenticity and unintentional style.

COUNTRY Utopia

JEFF DONEY & BILL HUGHES IN FREESTONE

Living a low-key weekend life is the secret desire of many city dwellers. Finding a weekend house in the country not far from San Francisco can take a year or more—or if fortune smiles, it may happen fast, by pure chance.

Bill Hughes, a real estate broker associate with TRI Coldwell in San Francisco, and his partner, Jeffrey Doney, an architect and antiques dealer, had been invited to visit friends at their weekend house among apple orchards and redwoods in the rolling hills northwest of Sebastopol.

"We got lost along the miles of winding country roads, and in the process of looking for our friends' house we ended up exploring remote areas of western Sonoma County we'd never seen before," recalled Hughes. "It's just an hour or so northwest from the city, but it's completely undeveloped. Along the way, we decided that this would be an ideal area for our own country house."

Meandering along the deserted roads in the region the following weekend sold them on the idea of a weekend retreat. Weekend life for them would be quiet, with a true country flavor.

Hughes and Doney eventually found their unpretentious dream house near Freestone, about five miles inland from Bodega Bay. Originally built as a farmhouse surrounded by an apple orchard, it had been the country retreat of San Francisco interior designer Orlando Diaz-Azcuy. The house had been thoughtfully renovated to keep its rustic charm.

Hughes and Doney loved the simple architecture and couldn't wait to plant daffodils and jonquils on the three-acre property. The pair likes to entertain weekend guests who drive north for country air and local cuisine. They wanted to add a larger kitchen and create more space for a home office and a study.

IDYLLS AND ANTIQUES *(Opposite)* Jeff Doney and Bill Hughes built a new guesthouse on their Freestone property in the rural vernacular of the existing country cottage. A rustic tongue-in-groove ceiling and plaster walls colored a pale sage green (the hue designed by Victoria Fay) are the backdrop for a pair of neoclassical French painted chairs, c. 1880, and turn-of-the-century chairs covered in green mohair. Antique butterfly collections and an Avery Boardman sofa-bed offer comfort and delight. The floor is sea-grass matting over color-stained and waxed concrete. Doney is a longtime collector of rare orchids.

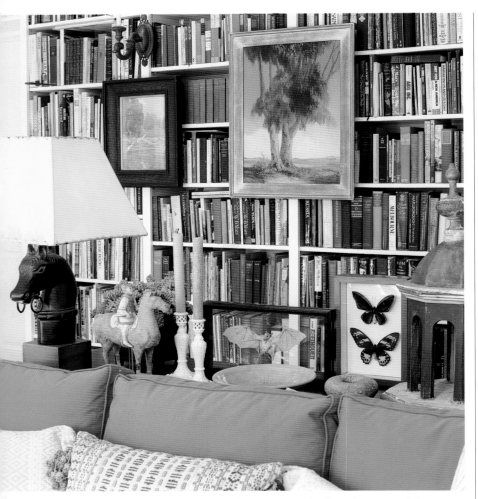

DISCERNING COLLECTORS *(Above)* Jeffrey Doney's and Bill Hughes's turn-of-the-century collections of butterflies, moths, and insects are presented as carefully as precious jewels. A pair of Han horses and California plein air paintings are eye candy for guests. "I've been finding old butterfly collections since I was a boy," said Doney, an architect. The library includes signed first editions and volumes on ornithology, entomology, the arts, and natural history.

THIS OLD BARN *(Opposite)* An old tractor barn, about to tumble, was restored with a new cupola, new doors and windows, and is now an office in the rural barn style. Ming and Han jars, terra-cotta seashell planters, a century-old albino tortoise shell, volcano gouaches, and a lifetime of gardening books and popular novels provide a soothing setting for Tula, a beloved Rhodesian ridgeback. The slate-topped table from Michael Taylor's estate required eight men to move it into the barn. A pair of chairs, c. 1750, are French-inspired American Federal, covered in cornflower blue linen.

The town of Freestone is hard to find, and that's just fine for long-time residents and weekend visitors like Bill Hughes and Jeff Doney. Five miles from the coast, the town is a five-minute drive from their weekend retreat and it's one of their first stops on a Saturday morning.

Once a bustling logging town, Freestone is now just a dot on the map. Hidden among the old redwoods and valleys inland from Bodega on the Sonoma County coast, it's never been discovered or "boutiqued" like the Napa Valley or Sonoma County. There's just a handful of enterprises, including the Osmosis spa, popular for enzyme baths, and the Wishing Well nursery. Best of all for Hughes and Doney is the Wildflour bakery, which produces handcrafted fougasse loaves, sticky buns, cheese breads, and hearty French-style breads—all snapped up as soon as they are brought forth from the ovens.

"We craft our weekend menus all year around the Wildflour breads," said Doney. "For lunch we'll make sandwiches for our friends, and for dinner we love their cheese-filled rolls."

Their three-bedroom, 1940s house sits on a ridgetop with views of the coastal range and Mount St. Helena in the distance.

"When we want to hide away here, it's easy, but we're close enough to Petaluma and the Russian River or the coast to take our friends sightseeing on Saturday afternoons," said Hughes.

Doney and Hughes go to relax, but they also immerse themselves in shaping and tending their garden. They landscaped the property with a hundred roses, added a vegetable garden, planted two hundred rhododendrons, and added sheltering hedges of oleander, cypress, escallonia, and rosemary.

A gnarled sixty-year-old wisteria *longissima alba* winds around the front door.

"It's an ideal weekend house because it's not too big, and all the rooms open to the outdoors," noted Hughes. "In the morning you can step right out the French doors onto the lawn. That's what you come to the country for. We spend most of our time outdoors in the summer."

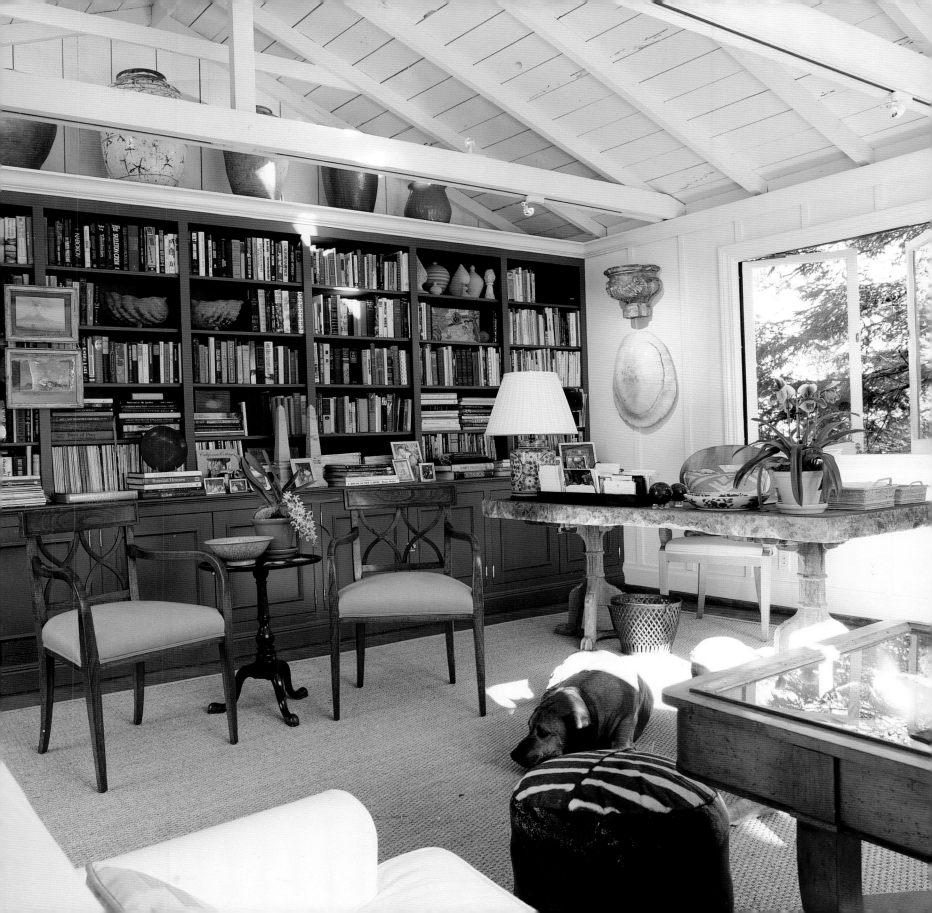

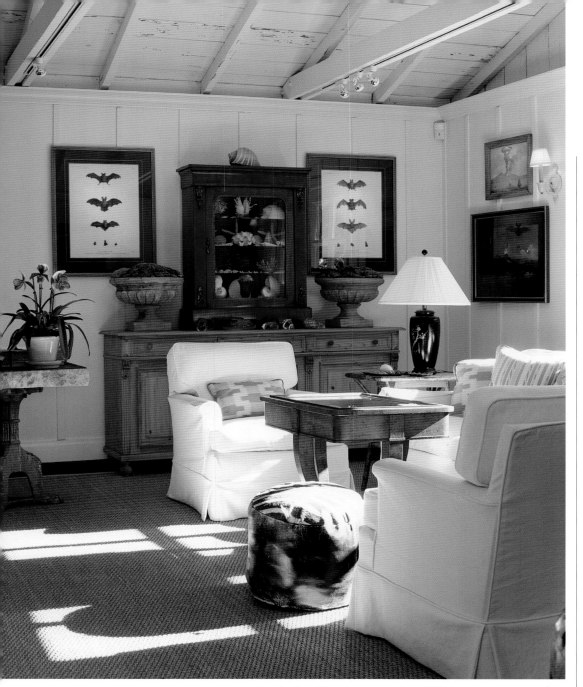

BAT SOCIETY *(Above)* Hand-colored French bat engravings, 1790, hover above a Portuguese pine console. A nineteenth-century English shell collection is protected in a George III mahogany cabinet.

SHADES OF WHITE *(Opposite)* In the winter living room: one of the few new pieces of furniture in the house is the contemporary round coffee table of ocher-stained wood, which marries well with terra-cotta finials from Majorca and a terra-cotta urn from Barcelona. An antique kilim rug tops the sea-grass matting. French engravings of Egyptian relics stand among bugs, candlesticks, and iron urns.

After enlarging their kitchen, Hughes and Doney built a 650-square-foot library/guest house on the north side of the garden, surrounded by old apple trees. They also renovated a tumbledown tractor barn, gave it a new roof and cupola, and turned it into a studio/office.

"We took our design cues for these outbuildings from the house and gave them the same tongue-in-groove exterior and painted them raw umber," noted Doney. The interior of the guest house is painted pale sage green, designed by color consultant Victoria Fay.

White clematis and climbing roses now arch over its black-framed French doors and windows.

Doney and Hughes added a garage/workshop where they propagate plants for their small organic vegetable garden. They topped it with a cupola with birdhouses custom built to attract barn owls.

"Now that we've finished all the work, we're going to sit around and read books and play with our dogs," joked Doney. Their canine companions are Simba and Tula, a handsome pair of Rhodesian ridgebacks.

"We'll also have time to explore the region— which is one reason we decided to come up here in the first place," said Hughes.

"With long-distance travel looking less appealing, we are looking forward to spending more time in the country cultivating our garden," said Hughes. "Maybe if we spend even more time there, the gophers will get bored with our company and go and dig holes in someone else's lawn." ◈

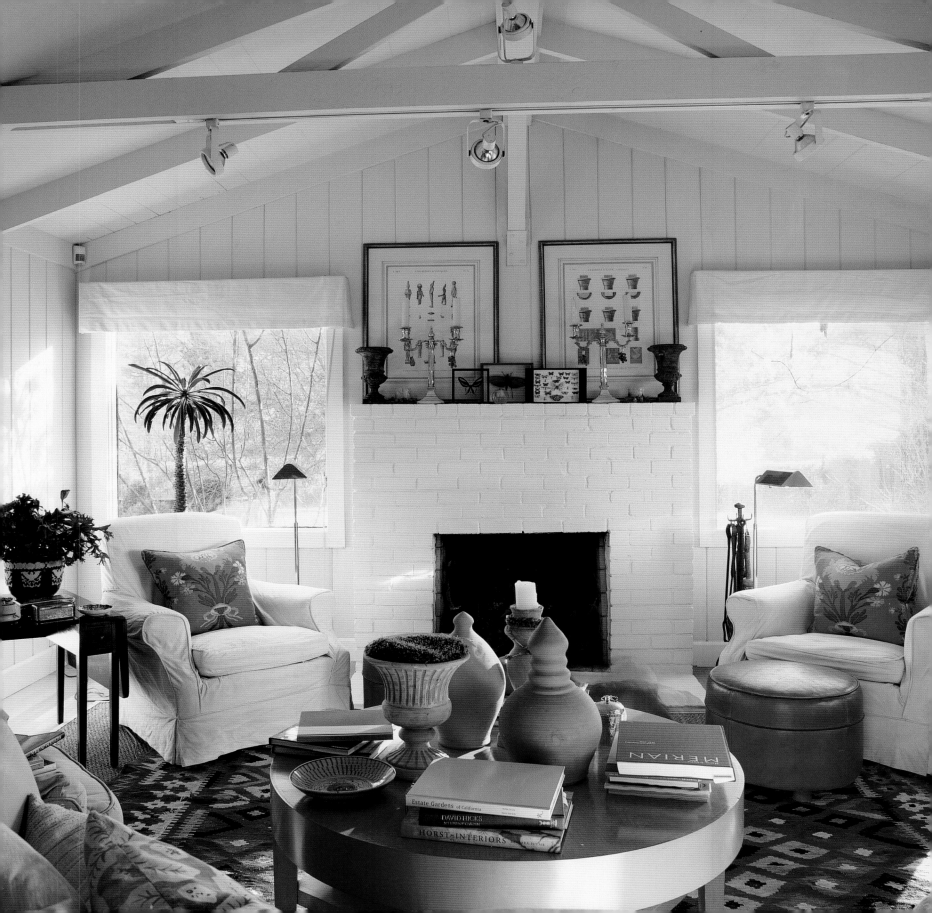

ENTYMOLOGIST'S DREAM *(Above)* Ready for an afternoon of study, an antique drafting table from South Africa holds decades of collections of lepidoptera cases, bugs, and scholarly English gatherings of tropical butterflies.

WINDOWS ON THE WORLD *(Top right)* In the top of a Biedermeier display case, Doney and Hughes have styled an inherited collection of specimen sea creatures gathered over a century ago from the world's oceans.

TABLES OF DELIGHT *(Right and opposite)* Chinese green-glazed oil lamps, Majolica begonia leaf bowls, and an orchid set a green tablescape in the sunny dining room of their Freestone house. An eighteenth-century painted Venetian chair and a Spanish olive oil jar paint a cosmopolitan scene with an antique chandelier from a dismantled historic bakery in San Francisco. The pumpkin-glazed walls and French doors frame an enclosed terrace filled with box topiaries.

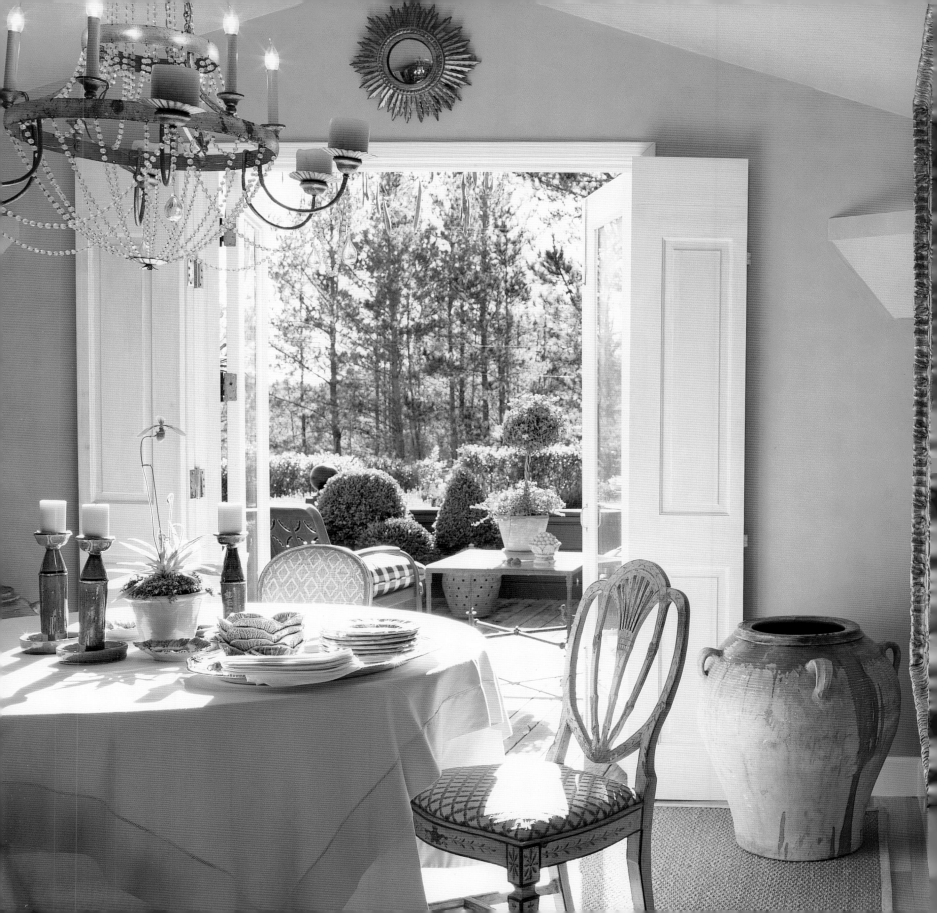

ROCOCO AND ROSES

BRUNNO & URANNIA RISTOW IN THE NAPA VALLEY

The Napa Valley would seem to be one of the most verdant, luscious, and productive wine appellations in the world. Plant a vine and it will grow, no? But the terrain is often rocky, sandy, chalky, or solid clay—and surprisingly inhospitable to young plants. Try to dig a hole, and the shovel will hit rock, and beneath that, more rock. Brunno and Urannia Ristow have spent the last fourteen years grooming, sculpting, and nurturing their extraordinarily lavish gardens and twenty acres of vineyards on a rock-strewn hill to the east of the Silverado Trail.

In the early morning, the Ristows walk beneath pergolas of creamy white wisteria and pale pink Cécile Brunner roses with the Napa Valley in the misty distance. Graceful topiaries surround the swimming pool. White agapanthus and purple wisteria frame and wind across traceries of treillage and reveal a garden designed on a grand scale.

"We called the vineyard Quinta de Pedras—Portuguese for 'estate of stones,'" noted Brunno, an internationally respected plastic surgeon who was educated in Brazil and the United States. Dr. Ristow has pioneered many aesthetic surgery techniques.

"We were determined to have our dream garden. We've experimented with plants to make it all work, and it has been a deeply satisfying project," said Urannia, who has shaped the elegant flower gardens.

In fact, it has taken serious excavation with heavy earth-moving equipment to build a strong and healthy foothold for their roses, as well as for the maples, yews, and olives. There's very little soil on the hillside, and for some years their weekend retreat turned into a kind of geology project. Every olive tree, every rosebush, and every vine became the subject of trial and error. Today Ristow Estate vintages consistently get rave reviews from wine connoisseurs.

BAROQUE CURVES *(Opposite)* Urannia Ristow gathers her roses in the early morning for freshness and arranges them in crystal vases on a gilded antique Italian chest in the living room. The gilded chairs, upholstered in pale blue-gray silk, are also Italian.

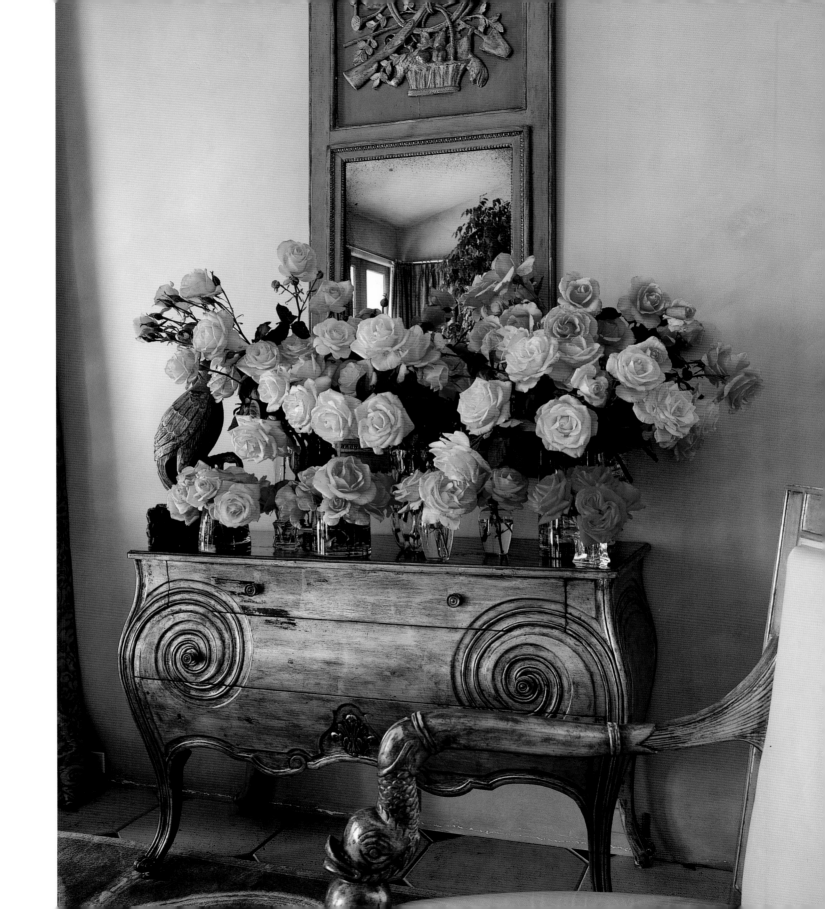

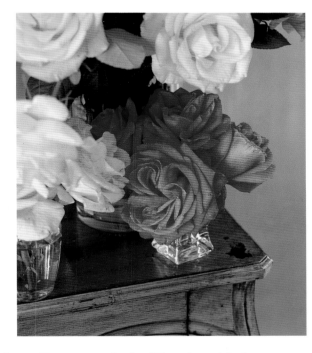

Extravagant beds of Brandy and Iceberg roses, outlined with chartreuse-green clipped box hedges, now flourish above dry-stacked stone walls. Rocks cleared from vineyards below were used to create this mellow, handcrafted garden architecture. Cascades of vivid yellow and pink Peace, as well as Fountain Square and Karen Blixen roses offer blooms for cutting throughout the summer.

"I chose Brandy roses to frame the vista of the valley, and Jacobite, Bewitched, and Carefree Wonder for fragrance," said Urannia, whose family farmed coffee in Nicaragua. "Finally, the garden is in harmony, and my favorite form of relaxation is to spend an afternoon pruning and weeding. All of our hard work is in the past. Today, it is all pleasure."

Beauty is sweetest when it triumphs over all odds. ◈

CECILE BRUNNER FLOURISHES *(Above)* The Ristows planted Cecile Brunner roses to climb a gray-painted trellis. The pink blooms have flourished. The Ristows believe more of a good thing is a great thing.

ROCKS AND ROSES *(Opposite and above left)* Roses love the warm days and cool nights at Quinta de Pedras. The roses' perfectly formed buds and voluptuous blooms make a sunny display and are ideal for cutting.

On the CALIFORNIA Coast

SUSIE TOMPKINS BUELL & MARK BUELL NEAR STINSON BEACH

Susie Tompkins Buell, cofounder of the world-famous fashion and accessories company Esprit, and now a noted political activist and arts and education philanthropist, spent her idyllic childhood in a small coastal town an hour's drive north of San Francisco.

There in the fifties and sixties she and her circle of friends would roam far and wide along the shore of the lagoon, exploring the caves and cliffs of this wild stretch of Pacific Ocean and lingering on the wide beaches long after twilight. It was—and is—an exceptionally beautiful and wild region of California, its funky and natural charm fiercely protected by longtime residents.

Thirty years later, Susie acquired a prized property with sweeping views of the quiet tidal lagoon and beyond it the wooded hills surrounding Mt. Tamalpais. Her land was blessed with an old barn, a turn-of-the-century cottage, and an apple orchard.

Susie and her husband, Mark, imagined entertaining the family at Thanksgiving, cooking with friends in the skylit kitchen, and relaxing on easygoing sofas after a day kayaking in the lagoon or tramping through the hills.

The house was built with ecologically correct materials and recycled timbers and furnished with Paris flea market finds, vintage furniture, and their lifelong art and antiques collections. It's sensitive to the local ecosystem, and its copper roof presents a modest profile.

Their town was founded around 1860 as a fishing village, with a natural harbor for shipping out redwood timber. A scattering of Victorian houses and small weekend houses iced with fanciful fretwork are positioned among the eucalyptus and pine trees along the edge of the cliffs and a dramatic plateau.

From the start, Susie was determined that her house would suit the family's needs without appearing imposing or overly grand.

PRIVATE RETREAT *(Opposite)* The living room, with its plank-formed concrete fireplace, possesses the noble proportions of a traditional barn, complete with beams and trusses. Susie's style: a mix of American vintage finds and Paris flea market accessories. Chairs made by Marco covered in cotton boucle by Glant surround a coffee table by Charlotte Perriand. F.R.L. Fletcher redesigned the room's decor.

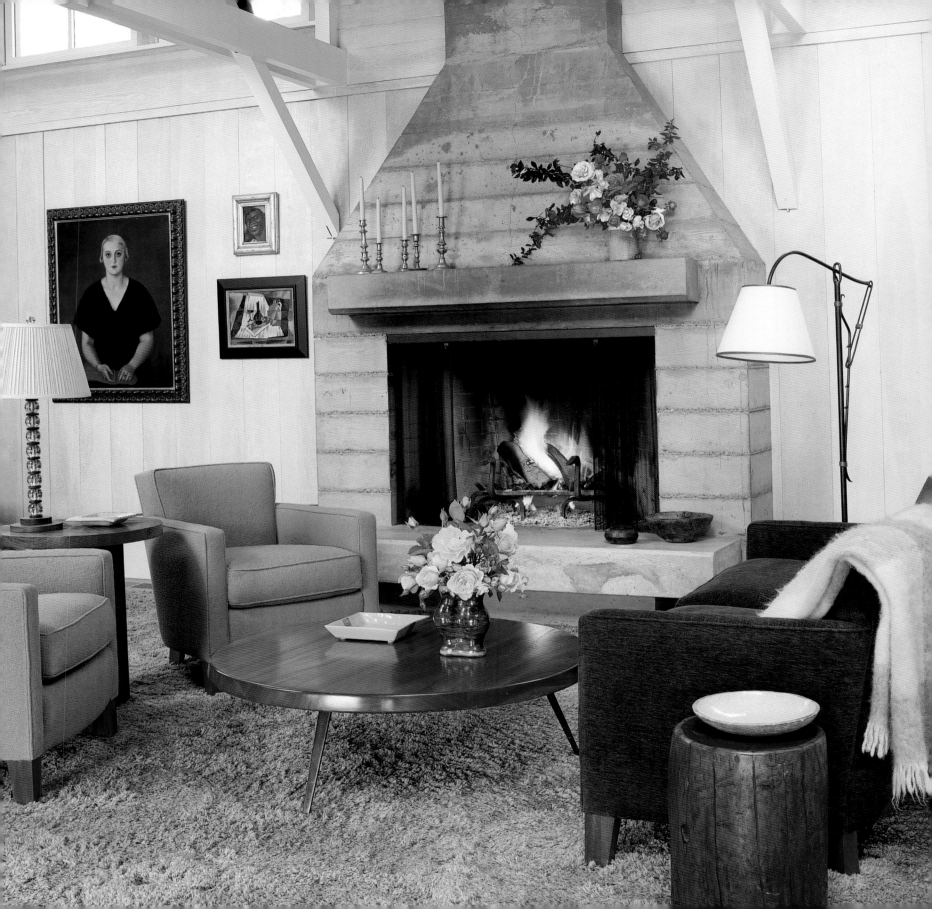

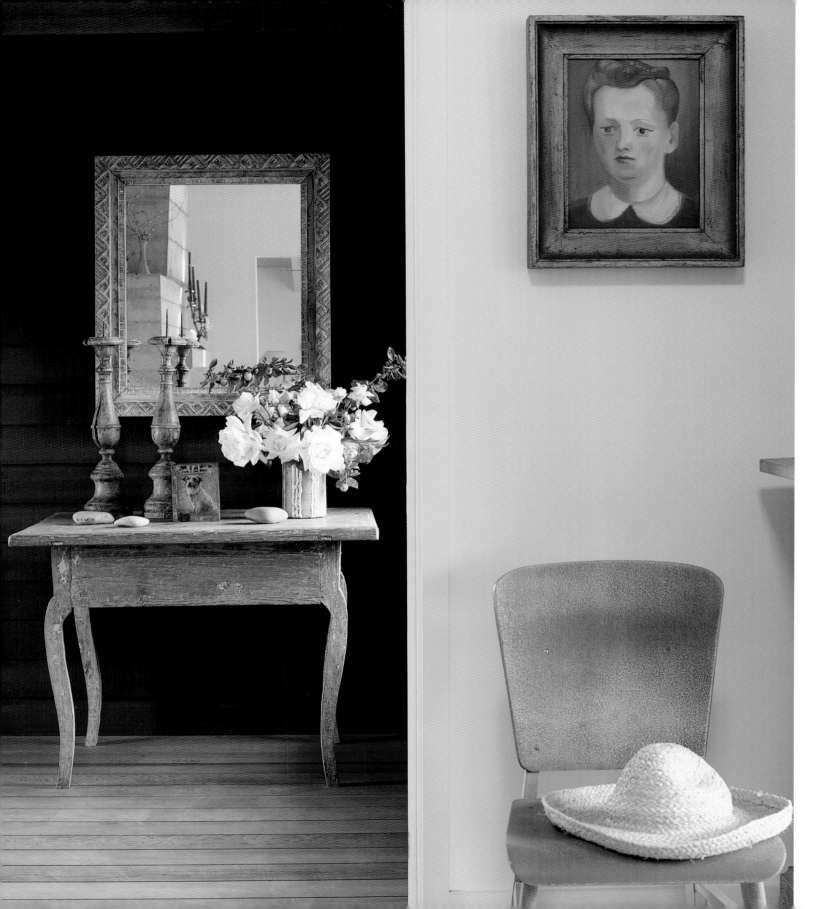

"I've always loved that quiet part of the coast and wanted to protect this hillside," said Buell. "There's a heron sanctuary nearby, seals bask on the sandbanks of the lagoon. Nature abounds. Now we've planted an organic garden to provide us with fresh vegetables and fruit most of the year."

Susie spent several years walking the site with her architects and planned an updated farmhouse, where she and her husband and their children and grandchildren and all their friends could gather on a summer weekend, for a wedding in the orchard, or for a quiet winter spa retreat. The architecture was created in the California vernacular, with broad verandas and a scoop of terrace sheltered from the wind. Recently, they worked with designer F. R. L. Fletcher to redesign the decor of the rooms and to freshen the style.

The easygoing house, set in a swale above the marshlands, is now surrounded by handsome old oaks, cypress hedges, dry-stacked walls, and an informal border of large granite rocks that looks as if it rolled down the hill in a winter storm and landed at Susie's front door.

"We lead a natural, outdoor life here," said Susie. They cycle across the mesa to isolated beaches, hike, wander along the beach, make organic salads with local lettuces, and huddle beside the fire on rainy winter evenings. Susie's childhood does not seem so far away.

Susie noted that the area has changed little since the sixties, when it was a favorite haunt of hippies heading north from Haight Ashbury. Residents still proudly maintain the privacy and low-key style of the region. They have made it a well-intentioned habit to cut down road signs directing drivers heading along the coastal highway into their town. The signs disappear as soon as the highway workers put them up.

"Residents are very protective of this special place," said the Buells. "Anyone building a house here should make it fit into the landscape. From our windows we want to look at the clouds and sky and hills." ◈

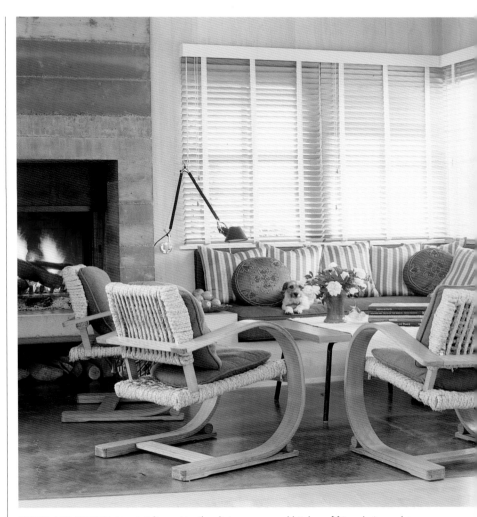

SMOKE AND REPOSE *(Above)* Adjacent to the dining room and kitchen, fifties chairs and a velvet-upholstered banquette invite the family to relax around the winter fire. Susie's Jack Russell terriers like to take in the view. Green is Susie's favorite color, so it was used judiciously on walls and fabrics—with a dash of red and tan for contrast. The interior design is by F.R.L. Fletcher.

SCANDINAVIAN CHIC *(Opposite)* A painted antique Swedish table, found at a Paris flea market, stands in the hallway. This timeless vignette is visible from the bedroom, which has been reconfigured to include an easygoing sitting area with views of wild lawns, gnarled willow trees, and the ever-changing geography of the tidal lagoon.

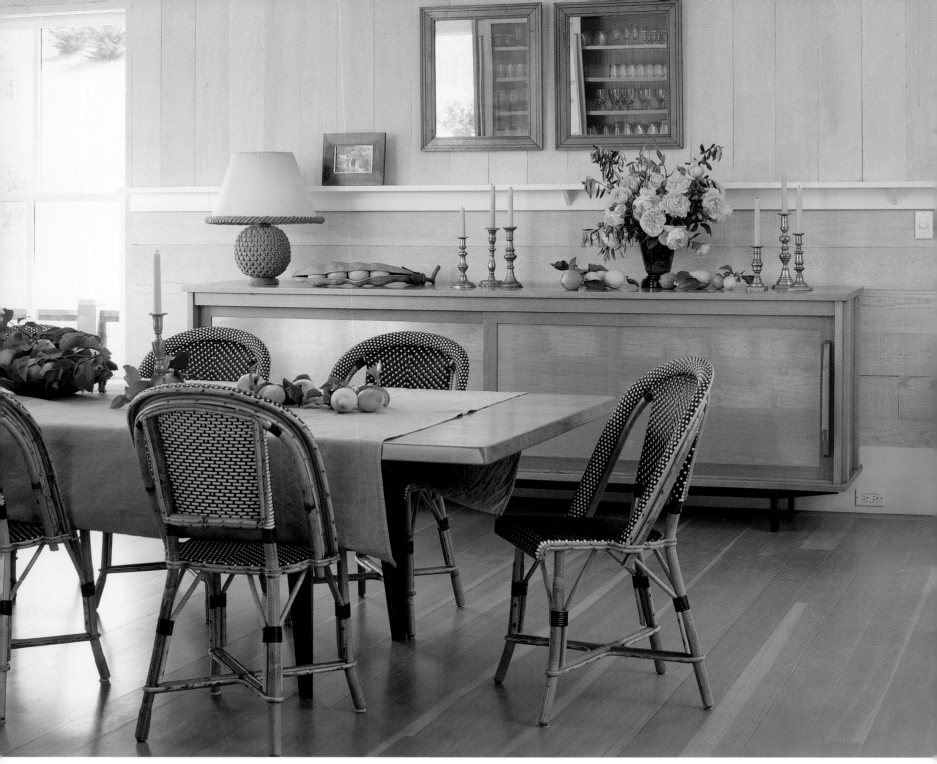

SUMMER ABUNDANCE *(Above)* Seasonal flowers are an essential part of Susie's roomscapes. The Jean Prouvé–style buffet was crafted by David Barrett. Flowers from the Buell gardens are styled by Susan Woods.

GREEN CUISINE *(Opposite)* The kitchen is well equipped with wide butcher-block work counters, easily accessible shelves, a large walk-in pantry, and all-day sunshine. Best of all, the architecture is not over-detailed. Susie's friend revered Chez Panisse chef Alice Waters often cooks here, and national political figures are frequent visitors. Vegetables are gathered from the garden, at the local farmer's market, and from nearby family farms. With space for reading the newspaper or discussing issues, the open kitchen was built for crowds of friends and for hungry beachgoers and hikers.

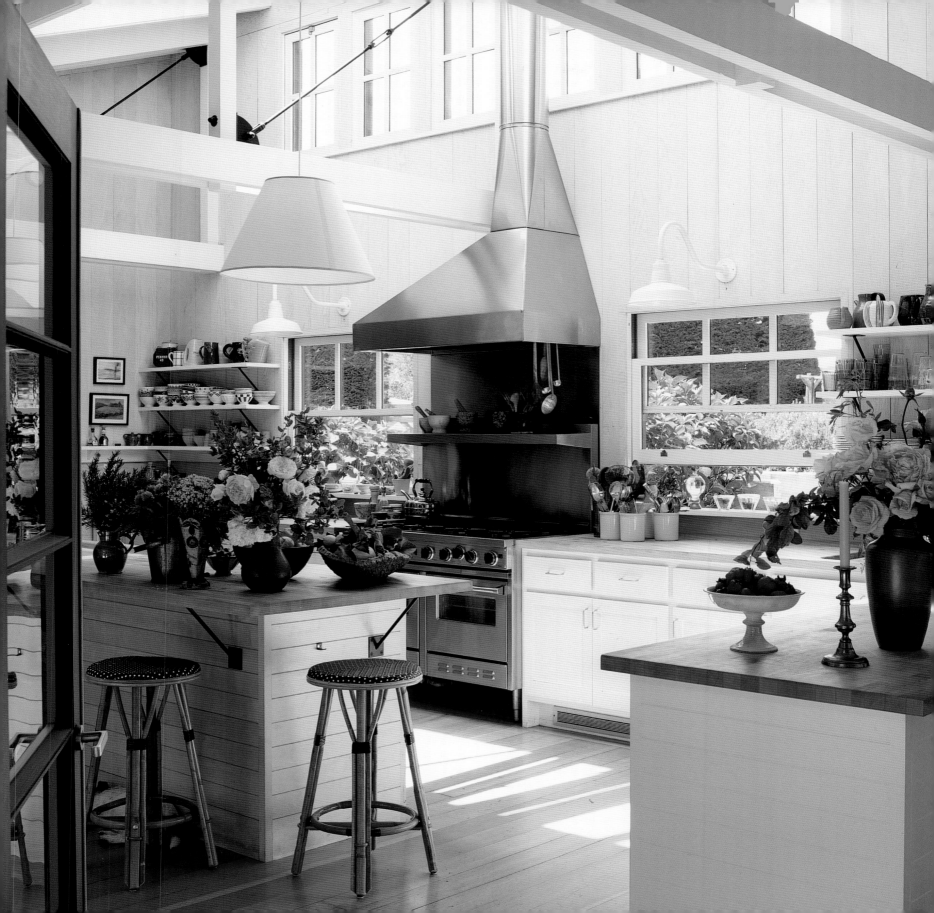

Where to Shop, View Art, Find a Friend, Take in the View, & Get Inside San Francisco

by D I A N E D O R R A N S S A E K S

My special picks of design stores and showrooms, art, ideas, inspiration, galleries, flea markets, and antiques galleries around northern California.

ADDISON ENDPAPERS
6397 Telegraph Avenue, Berkeley
(510) 601-8112

Julie, Geneva, and Marina Addison craft and design exquisite letterpress and silk screen papers, cards, boxes, and handcovered books with a sense of fantasy. Call ahead. The highly creative trio are sometimes so immersed in creation they forget to put their sign out.

ALABASTER
597 Hayes Street
(415) 558-0482

Delectable decor in ivory and white. Nelson Bloncourt's vintage white pottery, framed etchings, pale furnishings, and fragrance make for a heady mix. New: Fortuny collections, along with Vintage glass, luscious Santa Maria Novella toiletries, and modern portraits.

ALEMANY FLEA MARKET
Exit Alemany Blvd from Hwy. 101.

This fabulous flea market is open Sundays 6 A.M. – 2 P.M. Arrive early to find furniture with character, quirky household goods, odd paintings, colorful collectibles, photography, and rugs.

ANTIQUE & ART EXCHANGE
3419 Sacramento Street
(also 151 Vermont Street)
(415) 567-4094

Top decorators drop in for everchanging, well-priced displays of plein air paintings, chinoiserie, tansus, silverware, painted furniture, and tramp art.

Vitrines present quirky and stylish collections of boxes, porcelains, horn cups, Orientalia, silver, prints, and glass.

BACCARAT
343 Powell Street (near Post Street)
San Francisco
(415) 291-0600

In addition to glamorous and dramatic new designs, Baccarat also offers classic pieces by taste-makers like Van Day Truex, Andrée Putman, French glass designer Matthias, Pascale Mourgue, Catherine Noll, the "Tranquility" collection by Barbara Barry, and even Salvador Dalí.

BANG & OLUFSEN
345 Powell Street
(415) 274-3320

Elegantly designed Danish audio and video technology—candy for sound fiends—are the mainstays.

BEAUTIFUL ORCHIDS
2550 California Street
(415) 567-2443

Colorful and rare orchids are presented in antique and highly original contemporary pots and handcrafted vases. Fresh-cut, potted small, and bravura orchids are all vividly displayed. The owners are very helpful, the orchids vivid.

BEE MARKET
3030 Fillmore Street
(415) 292-2910

Modern European collections, including Catherine Memmi, Retrospective, and Modénature.

BELMAR
2525 16th Street, 2nd floor
(415) 621-7447

Markus Miretsky first learned traditional upholstery techniques in Russia, working with his grandfather, a Ukrainian master upholsterer who restored furniture for the Hermitage Museum in St. Petersburg. Belmar's chairs and sofas are still made in this traditional fashion, with hardwood frames, hand-tied steel springs, down-filled and double-stuffed cushions, and a covering of muslin before final upholstery. All of Belmar's chairs, headboards, and sofas are custom-made, and seat and back depth and firmness of cushions and arms are adjustable. Once a secret decorator source, Belmar now handcrafts for discerning clients, by appointment.

BLOOMERS
2975 Washington Street
(415) 563-3266

Patric Powell sells the most beautiful blooms. He also features an outstanding selection of vases and always the freshest orchids, lilies, branches, and spring bulbs. A wall of vases and a charming ribbons and gifts department make Bloomers a must visit.

BONHAM'S & BUTTERFIELD'S
220 San Bruno Avenue
(near 15th Street)
(415) 861-7500

This is the top auctionhouse in the west, now owned by Bonham's of London, featuring a broad range of specialists, and a surprising range of auctions: from cars and wines to rugs, jewelry, Western memorabilia, rare books, Orientalia, paintings, and always notable estates.

BOUCHERON
230 Post Street
(415) 362-6020

The most delectable jewels—and spectacular Ruhlman-esque decor to inspire chic diamond seekers.

BRITEX FABRICS
146 Geary Street
(415) 392-2910

Queen of fabrics. Four (newly retrofitted) floors of couture fabrics, trim, buttons, pillows, and off-the-rack fabrics for quick interior improvement.

BUILDERS BOOKSOURCE
1817 Fourth Street
Berkeley
(510) 845-6874

This twenty-one-year-old classic bookshop features a definitive selection of volumes on architecture, interiors, furniture, building, and gardens. It's an outstanding and constant resource!

BULGARI
237 Post Street
(415) 399-9141

Bulgari's diamonds and precious gems are so dazzling, and the watches so compelling, that one might miss the colorful collections of tableware, table decor, and silver upstairs. Patterns of plates and cups were inspired by Venetian and Siennese themes as well as by the seasons. Delirious!

COLONIAL ARTS
463 Union Street
(415) 362-8206

Furniture, ceremonial objects, silver, masks, carvings, and textiles from (former) Spanish colonies (Philippines, Mexico, Bolivia), and from former colonies such as India, Indonesia, and Vietnam, along with Peru and countries in Central America.

THE COTTAGE TABLE COMPANY
550 18th Street (near Third Street)
(415) 957-1760

The Cottage Table Company specializes in large-scale tables. Tony Cowan and his colleagues recently completed a cherry table measuring a Herculean eighteen feet long and handsome tables in Bubinga wood and African vermillion. Cowan, a philosophical man, loves rare woods and takes craftsmanship seriously.

CRATE & BARREL
55 Stockton Street
(415) 982-5200
(800) 323-5461

Well-priced modern design that's functional, practical, and versatile. Glassware is especially compelling, and handblown glass vases in seasonal colors are an elegant bargain. Excellent catalogs.

DEN
849 Valencia Street
(415) 282-6646

Raymond Long's lively gallery of mid-century modern masters, also pops with hand-carved African stools, Asian armoires, and artist-painted furniture. Recent offerings included rare Eames children's furniture designs, Knoll and George Nelson pieces, along with quirky no-name contemporary designs.

DERAPAGE
120 Hickory Street (by appointment)
(415) 552-9040

Mark Sommerfield's superb atelier produces custom-made *verre eglomisé* mirrors, credenzas, bold chairs, lighting, finials, and a variety of extraordinary furniture in both contemporary and antique modes. Mark has a passion for rich detail: his perfectionism and art show in the rich finishes and hand-sculpting offered through this studio, founded in 1997.

DESIGN WITHIN REACH
(800) 944-2233
www.dwr.com

Founded by Rob Forbes, this catalog/Internet modernist design company has been remarkably successful very quickly. Forbes finds and encourages new designers and manufacturers and offers great value (and cool design) to customers as well as speedy delivery.

DE VERA
29 Maiden Lane
(415) 788-0828

Federico de Vera's outstanding gallery of style sells Venetian glass, antique and rare handhewn tables, Japanese baskets, and handcrafted jewelry. At this jewelry and objets d'art shop hidden behind Gump's, it's sometimes necessary to use a magnifying glass to enjoy the detail of each jewel, objet, and antique.

DIPTYQUE
171 Maiden Lane
(415) 402-0600

Yves Coueslant and Christiane Gautrot founded Diptyque in Paris in 1961 with traditional English potpourri and a hawthorn-scented candle. The chic San Francisco store is decorated with the same tapestry-patterned walls, Paris flea market antiques, and vintage apothecary-style fixtures. Diptyque candles are made in 53 fragrances. Diptyque has a cult following for its Feu de Bois and Figuier candles, along with Virgilio, L'Ombre dan L'Eau, and classic musk, rose and tuberose scents. The complete Diptyque collection includes room sprays, burning essences, soaps and bath and body products. Diptyque recently introduced their exclusive Essence of John Galliano candle, which has been a huge hit.

FIORIDELLA
1920 Polk Street
(415) 775-4065

Kelly Schrock's colorful flower shop also sells handcrafted Mexican accessories, recycled glass vases, and orchids in terra-cotta pots.

FRETTE
124 Geary Boulevard (near Stockton Street)
(415) 981-9504

Duck in here to find sumptuous and silken Egyptian cotton sheets (sigh) and cashmere blankets of the finest quality. Frette offers extravagant bed linens crafted on old looms and machines, and the dimensional effects on the sheets take your breath away. Frette's baby designs include hooded white terry toweling bathrobes with ivory pique trim, and cotton pajamas. A traditional braided straw baby basket is covered in white damask.

THE GARDENER
1836 Fourth Street, Berkeley
(510) 548-4545

Owner Alta Tingle perfected natural garden style indoors and out. Here she sells handcrafted furniture, terra-cotta pots, glassware, and fine bath products.

GEORGE
2411 California Street
(415) 441-0564

Paradise for pets, offering toys and cedar chip–filled dog beds. The best dog treats: handmade organic whole-grain biscuits and holistic dog food.

GREEN APPLE BOOKS AND MUSIC
506 Clement Street
(415) 387-2272

A literary pit stop for true booklovers and seekers of inspiration and seren-dipity, Green Apple features an especially fine collection of used and new design and photography books, superb Taschen volumes, along with art monographs and gardening books on the most recherché subjects. Funky, fabulous.

GUMP'S
135 Post Street
(415) 982-1616

This historic emporium is an essential scene for first-time visitors to San Francisco—and for design fans. Walls of porcelains (including Richard Ginori, Herend, and the rarest and dearest) and cases of silver and crystal draw brides and grooms and gift givers. Jewelry displays and art glass inspire a frisson.

MAGNIFICENT MULTIPLES

Pottery Barn and Restoration Hardware—with hundreds of stores around the country and superb design catalogues—were both founded in the San Francisco Bay Area and show two sides of California creativity and fine quality.

POTTERY BARN
(800) 922-9934

The best selections are in the catalogues, but I love wandering into the shops to road test the chairs, pillows, sofas, and tableware. Smart buyers check the swatch books, touch the fabrics, circle around furniture, and make a friendly inspection, then purchase. Glasses and frames are a great value.

RESTORATION HARDWARE
(800) 762-1005

Steady as she goes, Resto (as the company is known in the trade) offers top-quality collections of furniture, along with lighting, mirrors, storage, and decorative accessories. The store and catalogues offer well-selected, classic designs that are never frivolous or trendy. Excellent home office furnishings and lighting.

SAN FRANCISCO DESIGN CENTER

This world-class furniture and fabrics, lighting and accessories design center at 2 Henry Adams Street, and at 101 Henry Adams Street, houses the finest design showrooms in northern California. Among the most rewarding and inspiring showrooms are Clarence House, Enid Ford Atelier, Kneedler Fauchere (elegant Ironies collections, Christian Liaigre, Holly Hunt, and Dessin Fournir), and Randolph & Hein (Michael Taylor Designs, the Michael Smith Collection).

Showroom highlights also include the Donghia collections, Summit Furniture, Sloan Miyasato, and the de Sousa Hughes showroom.

At Shears & Window, the Ann Getty House collection of fine reproductions, and the Stephen Shubel French antiques collection are of particular note.

Century Furniture in the Showplace building shows Oscar de la Renta's grand designs. Charles Gaylord & Co., in the Showplace building, purveys antique European mantels, fireplace accessories, and furnishings.

Also in the Design District, and worth a detour (essential on a design tour), are Ed Hardy San Francisco, Henry Calvin Fabrics, the McGuire showroom (seek out Orlando Diaz-Azcuy's classic designs and Robert Kuo's classic Asian-inspired pieces), John Drum Antiques, Antique & Art Exchange, Holmes-Samsel (antiques and decoration), and Therien Studio (superb handcrafted antique-inspired furniture).

HEDGE
164 Townsend Street
(415) 357-1102

Designer Stephen Volpe and his partner Roth Martin have created a super-chic collection of Parisian forties-inspired furniture and accessories. Quality and craftsmanship are of the highest order. Best of all, the new line's forty designs—which include dining chairs detailed with crocodile, a polygonal mirror, and drawers with a hidden signature "H,"—are shown in this stripped former industrial space along with vintage French originals by Adnet, Poillerat, and Prou, as well as singular pieces by San Francisco icon John Dickinson.

HERMÈS
125 Grant Avenue (at Maiden Lane)
(415) 391-7200

I have been collecting Hermès silk scarves for as long as I have been visiting Paris—and I now have a tower of Hermès boxes! The watches, too, have their great charms. There is always a reason to visit Hermès: the exquisite porcelains and silver for the table, along with the finest crystal, silver, and all those luxury not-quite-necessities that Hermès seduces one into acquiring. Request tips on scarf tying.

JAPONESQUE
824 Montgomery Street
(415) 391-8860

Japanese sculpture, handcrafted glass, and limited-edition handmade furniture can all be found in this tranquil gallery.

JEFFERSON MACK METAL, INC.
2261 Shafter Avenue
(415) 550-9328

Blacksmith Jefferson Mack handcrafts iron gates, fences, balustrades, and furniture the old-fashioned way—with handmade tools and a traditional superheated forge.

KIEHL'S
2360 Fillmore Street
(415) 359-9260

The handsome interior architecture of this venerable store makes it look as if it's been there for decades. Connoisseurs of beauty and bath products love the simplicity and purity of Kiehl's lotions and gels and creams. Designers appreciate the straightforward print labels—which have a retro-chic air.

KOZO ARTS
1969A Union Street
(415) 351-2114

This is the place to find handcrafted papers, elegant wedding albums, guest books, and heirloom-quality photo albums.

LORO PIANA
212 Stockton Street
(415) 593-3303

Sexy, sensual, divine Italian cashmere blankets, shawls, wraps and pillows—along with handsome apparel, in colors that remind fans of the Italian countryside. Chic and collectible.

MACY'S
Stockton Street and Geary, Union Square
(415) 296-4780

The new Hotel Collection of superb bed linens, along with the Oscar de la Renta collection and in-depth furniture, rugs, and fine accessories bring devotees to Macy's home floors.

MARCH
3075 Sacramento Street
(415) 931-7433

This super-chic design store mixes a collection of antiques, vintage and new upholstered pieces, handsome tables, and quirky chaises longues. Everything's in cool monochromatic tones that make visitors want to redecorate in this understated manner—instantly.

NEIMAN MARCUS
150 Stockton Street, Union Square
(also at Stanford Shopping Center, Palo Alto)
(415) 362-3900

The galleries here display truly original and elegant tableware, gifts, dramatically scaled glass, glamorous handpainted porcelains, and the most beautifully crafted silver. Special presentations of Mexican silver, Italian glass, and Tibetan crafts are typical of the Neiman Marcus scope and flair.

NEST
2340 Polk Street
(415) 292-6198

2300 Fillmore Street (at Clay Street)
(415) 292-6199

Two great locations. One, a delicious corner of France/Morocco/exotic lands, is on a great stretch of Polk Street that now houses a wealth of antiques stores, cafés, book stores, the great Smoke Signals magazine and cigarettes shop, and the Real Foods organic market. The Fillmore Street shop, near the vintage Clay Theater, is a must for colorful bed covers and pillows, Mariage Frères teas, books, children's dreamy garb, and decor.

OLIVIERS & CO.
2208 Fillmore Street
(415) 474-1408

POLANCO
393 Hayes Street
(415) 252-5753

SCHARFFEN BERGER
CHOCOLATE MAKER
Café, Bakery, Factory

American client of France's Astier de Villatte antique–inspired white chateau tableware. She sells Diptyque soaps and fragrance, Santa Maria Novella scents and potpourri, Mrs. John L. Strong stationery, and crystal galore, always changing. Faithfuls (and great entertainers) shop here weekly.

SUGAR
804 Sutter Street
(415) 409-7842
Mid-century mod decor and handcrafted furniture by Randy Castallon, and Jonathan Adler's ceramics in a cool all-white interior are featured here.

y, this
aker's
he finest
ftsmanship,

IO

as commis-
speople
essories,
glass of
ingston
niture is

(and New
itty and
merchant
he stocks the
cashmere
biggest

AL

or Showcase
cific Heights
447-3117).
at brings
designers,
tists, lighting
gners, and
ended.
Antiques
Show at Fort Mason (415-896-0909) comes to town at the end of October

each year. It's a world-class, dazzling event highlighting top antique furniture and decorative arts dealers, rare book dealers, print dealers, and textiles collections. Silver, rugs, fine jewelry, folk art, garden ornaments, books on antiques, and now twentieth-century design add to this show's allure. Not to be missed: the opening night preview party.

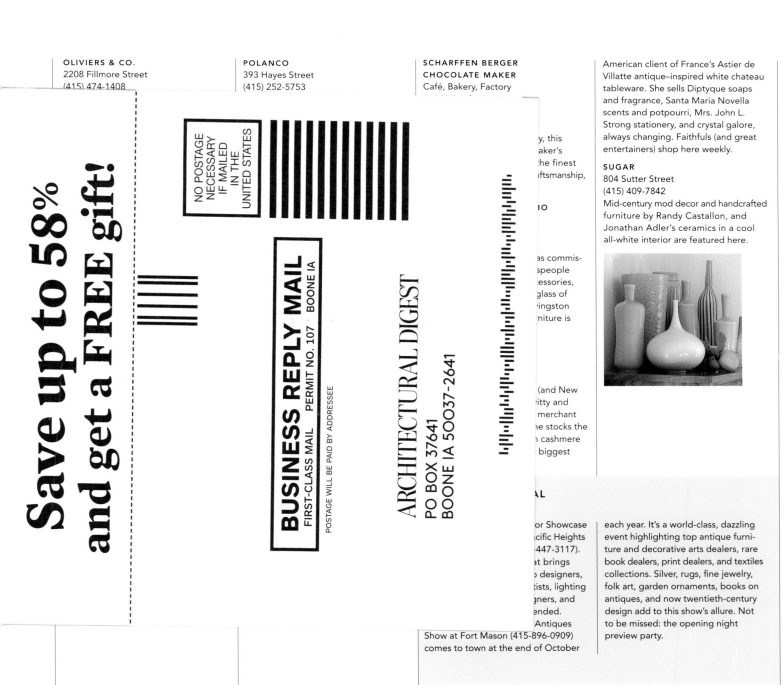

FAVORITE ANTIQUAIRES

ANTIQUE & ART EXCHANGE
3412 Sacramento Street
(415) 567-4094

151 Vermont Street, No. 6
(415) 522-3580

Howard and Keith orchestrate a delectable feast including Francophile J. van Doorn's special vitrines, as well as quirky and splendid collections of horn boxes, prints, silver, Orientalia, California plein air paintings, and armoires.

ED HARDY SAN FRANCISCO
188 Henry Adams Street
(415) 626-6300

Elegant selections of French, Italian, English, Chinese, and Swedish antiques include painted Venetian tables, glorious Piedmontese tables and cabinets, Continental gilt mirrors, and French thirties and forties chairs and tables. Swedish neoclassical giltwood tub chairs with lion mask terminals and versatile pale blue-painted pine Gustavian benches were recent offerings.

FOSTER GWIN
38 Hotaling Place (off Jackson Street)
(415) 397-4986

Designers fly here from all over the world, clients in tow, to find bravura antiques of extraordinary variety and character.

PETER PAP ORIENTAL RUGS
470 Jackson Street
(415) 956-3300

Peter is admired around the world for his expertise in Oriental rugs. His selections are an education—and the beginning of a lifelong obsession, no doubt.

THE STEPHEN SHUBEL COLLECTION
SHEARS & WINDOW
Galleria, San Francisco Design Center
101 Henry Adams Street
(415) 621-0911

Shubel travels to Paris and Angers, in the Loire Valley, to find antique French painted and gilded lamps and tables, cabinets, chairs, and armoires with superb proportions and exquisite finishes.

KATHLEEN TAYLOR
THE LOTUS COLLECTION
445 Jackson Street
(415) 398-8115

Kathleen Taylor's discreet studio offers a world of fine antique textiles, tapestries, and pillows made from antique fabrics and tapestry fragments.

DANIEL STEIN ANTIQUES
458 Jackson Street
(415) 956-5620

Eighteenth- and nineteenth-century English and Continental furniture, works of art, and scientific instruments are all specialties.

THERIEN & CO.
411 Vermont Street
(415) 956-8850

Antiquaire Bob Garcia travels to Lisbon, northern Italy, Stockholm, and Paris often to find superb examples of richly detailed Portuguese, Continental, and Swedish neoclassical tables, painted chairs, and Russian chandeliers.

URBAN CHATEAU
3228 Sacramento Street
(near Presidio Avenue)
(415) 673-8026

Terry Gross has a particular fondness for painted finishes and French and Italian gilded furniture. Recently displayed in her glamorous gallery were a circa-1740 Italian rococo console with elaborate carved acanthus-leaf motifs and a serpentine-fronted marble top.

SUMMERHOUSE
21 Throckmorton Lane
Mill Valley
(415) 383-6695

This store is an excellent source for big fat chairs, handcrafted glassware, fragrant soaps, pillows, vintage furniture, and easygoing decor.

SURPRISE PARTY
1900 Fillmore Street at Bush Street
(415) 771-8550

Susan Howell sells seashells from the seashore. She also sells sensual and softly hued beads, coral, sponges, and other sea creatures, all correctly documented, of course, as well as swags of amethyst and citrine beads, African glass beads, Moroccan silver, and necklace findings

SWALLOWTAIL
2217 Polk Street
(415) 567-1555

Sheri Sheridan's territory is a must for vintage and antiques collectors—of all stripes! In this beautifully lit interior (glorious on a late afternoon in summer), she stacks Venetian mirrors, French prints, lab glass and steel medical cabinets, French armoires, photography, jewelry (opals, recently), coral, and Taschen books.

TAIL OF THE YAK
2632 Ashby Avenue
Berkeley
(510) 841-9891

Alice Erb and Lauren McIntosh founded their magical store thirty-one years ago—to sell eccentric, quirky, rare, beautiful, and astonishing decorative objects, and antique jewelry from around the world. Saint figures, Italian paintings, Mexican crafts, ribbons, handcovered books, folkloric textiles, and Swan Papel handprinted papers stand out.

TIFFANY & CO.
350 Post Street
(415) 781-7000

A magnet for new brides and thoughtful hostesses, Tiffany also offers some of the great design classics: Elsa Perretti's superb crystal bowls and desk accoutrements, Van Day Truex's extraordinary rock crystal candlesticks and classic wine carafes, along with Paloma Picasso's tasty rocks.

THERIEN STUDIO WORKSHOPS
151 Vermont Street
(415) 864-0212

Offering Japanese-inspired credenzas with fine hand-rubbed and lacquered finishes, upholstered furniture, screens, desks, and other antiques-inspired and contemporary designs, this is a favorite designers' source for dining tables, bold chairs, armoires, and mirrors.

TREAT
1928 Fillmore Street
San Francisco
(415) 567-0166

Aveda Central! Lovely Tammy Redsun and partners and colleagues welcome you into this airy, sunny spot for foot massages, nature-inspired skin and hair products, and heartfelt information. Thank you, Horst!

21ST ARRONDISSEMENT
309 Healdsburg Avenue
Healdsburg
(707) 433-2166

Myra Hoefer and Ken Pacada fly to Paris and the South of France often to find the rare and unusual: country theater stage decor, lacquered tables, elegant painted chairs, old books, tables, urns, platters, and beautiful iron daybeds, which they dress lavishly with silk-covered mattresses and draperies. Also worth a detour: plaster sculptures, to-order painted armoires and desks, along with framed rare French prints, silver, and pleat-ruffled silk pillows.

WATERWORKS
55 Geary Boulevard (near Grant Street)
(415) 982-1970

235 Kansas Street (near Fifteenth Street)
(415) 431-7160

Waterworks, with the most elegant bath fittings, fixtures, and accessories, can guide designers and homeowners through starting a bathroom project, as well as selecting tubs, basins, evaluating stone, and selecting fittings and metal finishes. With Waterworks' assistance, all can venture forth as instant experts on the watery world of double bullnose tiles, body sprays, thermostatic mixers, robe hooks, tub spouts, and towel warmers.

WILKES BASHFORD HOME
375 Sutter Street
(415) 986-4380

Wilkes Bashford is San Francisco's style legend—gregarious, visionary, magnanimous, and trendsetting. This bustling home department store offers vivid and luxurious collections of bed linens, glassware, books, Pratesi, silk and cashmere throws and blankets, and the occasional wonderful antique. (Don't stop there; trip upstairs to the shoe department, take in Frank Ancona's pearl necklaces, and wend back down through the sportswear departments.) You may be fortunate enough to meet Wilkes Bashford himself.

WILLIAM STOUT ARCHITECTURAL BOOKS
804 Montgomery Street at Jackson Street
(415) 391-6757

Stout offers the finest collection of books on architecture, design, interiors, gardens, graphics, and art, as well as an extraordinary selection of obscure and limited-edition architectural monographs and wild manifestos. Design books are downstairs. Best of all: books are books here, and it is the lively content that matters. Used books are mixed in with the new. Hurrah!

WINGARD
2127 Union Street
(415) 345-1999

Architecture-trained Ken Wingard's self-confident modernism has turned his design collection into a hot commodity. Designers especially appreciate Wingard's spare and graceful super-sleek ceramics, his chunky steel vases and minimal candleholders, and his witty, fashion-conscious raw silk and appliquéd pillows. This is a great place to find gifts.

WORLDWARE
336 Hayes Street
(415) 487-9030

Everything here is over-the-top gorgeous: dramatic decor, handmade candles, lavish chairs and table decor, grand mirrors, plus Worldware's exclusive designs.

ZINC DETAILS
1905 Fillmore Street (near Bush Street)
(415) 776-2100

Vassili and Wendy Kiniris, who founded this world of design right out of college, have created their own lively and colorful territory of classic American modernism and Scandinavian classics. This is one of the few design stores in San Francisco offering in-depth, witty, fresh modern design. They also have a store on Fourth Street, in Berkeley, a cheerful find for design lovers.

LIFE ENHANCEMENT

ANGEL ISLAND STATE PARK
(415) 435-1915

Take the ferry from San Francisco to indulge in idyllic nature walks and bicycle trails just twenty minutes from the city.

ASIAN ART MUSEUM
200 Larkin Street
(415) 581-3500

Gae Aulenti rethought the old Main Library into a handsome new setting for one of the world's finest collections of Asian art. The Avery Brundage Collection is here, in all its glory, along with Doris Duke's collections, Himalayan sculptures, Indian religious art, Japanese baskets, Korean ceramics, Chinese jades (a highlight), Cambodian buddhas, Indonesian puppets, and Japanese kimonos.

CALIFORNIA OUTDOOR ROLLERSKATING ASSOCIATION "FRIDAY NIGHT SKATE"
(415) 752-1967

Meet in the parking lot, near the Ferry Building, at the foot of Market Street. Hundreds of in-line skaters traverse the city for free. Also high-energy: Skating in Golden Gate Park, Sunday.

CALIFORNIA PALACE OF THE LEGION OF HONOR
Thirty-Fourth Avenue
(at Clement Street)
(415) 863-3330

On a superb setting overlooking the bay, this elegant neoclassical museum houses a jewel-like collection of modern art (Monet, Picasso), along with a print collection, furnished historic French rooms with intact boiseries, and imposing Rodin collections (*The Thinker* ponders in the courtyard).

CRISSY FIELD
Parking at Marina Boulevard
at Baker Street

Take this scenic walking and jogging trail along the bay shore, all the way to historic Fort Point and the Golden Gate Bridge. This former Presidio military base is now a bird sanctuary, picnic spot, and board sailing venue, with historic buildings superbly preserved.

MH DE YOUNG MEMORIAL MUSEUM
75 Tea Garden Drive, Golden Gate Park
(415) 863-3330

Now under construction, with a new design by Swiss architects Herzog & de Meuron, this museum, which houses one of the finest collections of American art in the United States, will reopen in 2005.

EXPLORATORIUM
3601 Lyon Street
(415) 563-7337

In the handsome Palace of Fine Arts, this museum of science and wonder is fun both for children and adults. Visual artists, performers, and filmmakers come together with scientists for provocative and witty presentations.

FERRY PLAZA FARMERS' MARKET
Ferry Building
On the Embarcadero at the foot of
Market Street
(415) 291-3276

This beautiful market features an extra-
ordinary selection of organic produce,
olive oil, and plants, all from family
farms, as well as free-range eggs and
artisan breads. The newly transformed
and magnificent Ferry Building is a bustle
of bakeries, chocolatiers, cavier, oyster,
fresh fish, and Japanese delicacies
vendors, and restaurants. (The Slanted
Door and Delica are favorites.) Look
for McEvoy olive oils, Scharffen
Berger chocolates, Cowgirl Creamery
cheeses, and the Book Passage by the
Bay bookstore.

FOOTNOTES LITERARY WALK
(415) 381-0713

Stroll through North Beach to learn
about the haunts of Mark Twain, Maya
Angelou, and Jack Kerouac and about
San Francisco literary history. Guided
walks take place 10 A.M. Tuesday to
Saturday. Meet at the corner of Union
and Columbus Streets.

FORT MASON CENTER
Buchanan Street at Marina Boulevard
(415) 441-3400

This former army base has become a
vibrant, scenic center for cultural and
nonprofit organizations such as the
Oceanic Society and the Playwrights
Center. The Mexican Museum, the
Magic Theater, tai chi workshops,
and the SFMOMA rental gallery are
of particular interest.

MUSEUM OF CRAFT AND FOLK ART
Fort Mason (Bldg. A)
(415) 775-0991

This small charming museum features
changing exhibits of contemporary arts
and international crafts.

SAN FRANCISCO MUSEUM OF
MODERN ART
151 Third Street
(415) 357-4000

In a dramatic building by Mario Botta,
this impressive museum houses growing
collections of Impressionist and post-
Impressionist paintings and in-depth
contemporary collections by interna-
tional greats. Check out the design
galleries, the multimedia collections,
and the fine café. The Fisher Galleries
are of particular interest. Curators are
especially tuned into new technologies
used by artists and digitally literate
architects. Experimental filmmaking
is showcased.

SAN FRANCISCO PUBLIC LIBRARY
100 Larkin Street
(415) 557-4400

The Main Library's handsome new
ecologically designed building includes
the Wallace Stegner Environmental
Center.

OAKLAND MUSEUM OF
CALIFORNIA
Tenth Street and Oak Street
Oakland
(510) 238-2200

This museum focuses on California—
in history and through the eyes of
contemporary artists and craftspeople.
Artifacts illuminate the state's culture
and ecosystems.

STRYBING ARBORETUM AND
BOTANIC GARDENS
Ninth Avenue and Lincoln Way,
Golden Gate Park
(415) 661-1316

Here you'll find peaceful, inspiring
gardens as well as docent-led botanical
and birding walks.

UNIVERSITY OF CALIFORNIA,
BERKELEY ART MUSEUM
2626 Bancroft Way
Berkeley
(510) 642-0808

Changing exhibitions of contemporary
art as well as photography shows
include provocative world art
overviews, quilts, video, performances,
and installations.

YERBA BUENA CENTER FOR
THE ARTS
701 Mission Street
(415) 978-2787

Here you'll find changing exhibitions of
contemporary art and thought-provoking
performances. There are also spaces
for music and dance concerts, as well
as a gift shop.

PLACES TO DINE

ABSINTHE
398 Hayes Street
(415) 551-1590

Chef Ross Brown, a New Zealand
native, has a passion for vegetables
and seafood. Absinthe is perfect for
dining before the opera. Murals are by
artist Willem Racke.

AQUA
252 California Street
(415) 956-9662

Superb seafood. Passionate chef
Laurent Manrique, who grew up in
Gascony, makes this a favorite in the
Financial District.

BACAR
448 Brannan Street
(415) 904-4100

Exceptional California cuisine by chef
Arnold Eric Wong and an outstanding,
esoteric wine list.

LA BOULANGE DE POLK
2310 Polk Street
(415) 345-1107

French-style breads, brioches, and fruit
tarts are all handcrafted with organic
flour. This lively café also serves organic
coffee, sandwiches, and quiches.

BAMBUDDHA LOUNGE
601 Eddy Street (at Larkin)
San Francisco
(415) 885-5088

Chef Joe Bosworth crafts outstanding
pan-Asian dishes that sparkle on the
palate. The sexy decor is by Eric Brand.

BARAKA
288 Connecticut Street
San Francisco
(415) 255-0370

Moroccan small plates with exquisite
flavors on Potrero Hill. Decor is as sexy
as an evening in Ouarzazate. Chez
Papa, by the same owners, is just a
block away.

BAY BREAD
2325 Pine Street
(800) 833-8869

Hearty French-style breads and classic pastries made with organic flour are the mainstays here. Fans line up early for superbly crafted fruit tarts, almond croissants, and seasonal French delights.

BOULEVARD
1 Mission Street
(415) 543-6084

Ask for a table overlooking the bay, and enjoy Nancy Oakes's hearty Mediterranean-inspired cuisine with bridge views.

CAMPTON PLACE RESTAURANT
340 Stockton Street
(415) 955-5555

Inspired menus change seasonally but are always "close to nature." A six-course tasting menu with paired wines is always offered by Chef Daniel Humm.

CHEZ PANISSE
1517 Shattuck Avenue
Berkeley
(510) 548-5049 and (510) 548-5525

Chef/owner Alice Waters has been promoting the importance of family farms, conscious living, organic gardening, and seasonal cooking for almost thirty years. Her daily fare: simple and dazzling.

CITIZEN CAKE
399 Grove Street
(415) 861-2228

Iconoclastic pastry chef Elizabeth Falkner tempts with outrageously rich cakes of deconstructed decoration, handmade chocolates, fruit tarts, and olive-oil and caramelized onion focaccias. You can enjoy all these at the café.

CHARLES NOB HILL
1250 Jones Street
(415) 771-5400

Clubby decor and inventive, fresh cuisine.

FIFTH FLOOR RESTAURANT
Palomar Hotel
12 Fourth Street (at Market Street)
(415) 348-1555

Chef Laurent Gras offers utterly refined, subtle, and sensual French-inspired cuisine—in a glamorous silken salon.

FABULOUS FLOWERS

BLOOMERS
2975 Washington Street (between Broderick and Baker Streets)
(415) 563-3266 and (888) 563-3266

Patric Powell's flower gifts are exceptionally thoughtful: he sends out tulips, peonies, paperwhites, or lilies in bud, so that the full life of the flower, from bud to romantic fade-out, can be enjoyed. Featuring exceptionally elegant orchids, lilies, and spring blossoms, Bloomers is a classic.

CHALK HILL CLEMATIS
11720 Chalk Hill Road
Healdsburg
(707) 433-8416 (by appointment)

The largest field grower of rare cut-flower clematis in the world, Kaye Heafey's superb nursery offers glorious white, purple, blue, mauve, lavender, pink, and pale green clematis of the finest quality, both cut flowers and plants.

FIORIDELLA
1920 Polk Street (near Pacific Avenue)
(415) 775-4065

Heady whiffs of "my trip to Mexico" float through the pungent gardenias, swooning regale lilies, budding amaryllis, ruffled peonies, and moss-tangled branches in this wildly stylish shop.

THE FRENCH LAUNDRY
6640 Washington Street
Yountville
(707) 944-2380

Chef/owner Thomas Keller has received every possible national and international recognition and award for his extraordinary restaurant set in an historic former French laundry in the heart of the Napa Valley. Perfection is practiced daily. Under Keller's sure guidance, each dish ambushes the

STANLEE R. GATTI DESIGNS
1208 Howard Street
(415) 558-8884

Stanlee Gatti (who is also the city's arts' commissioner) is San Francisco's favorite social florist and long-standing grand party designer. He creates the most elegant wedding settings, memorable private and civic celebrations, and inventive arts events. Stanlee's style is dramatic, glamorous, and classical with a modern vibe.

FLOWERS CLAIRE MARIE
167 Fifth Avenue
(415) 751-2997 (by appointment)

If you're thinking of lilies of the valley or hellebores for a wedding bouquet, Claire Marie is the thinking bride's talented confidante. Arrangements are loose, never tortured or trussed, and the color palette ranges from pinks and pales to shots of fauvist colors.

ORNAMENTA
2035 Cabrillo Street
(415) 668-9624 (by appointment)

Orna Maymon and Bruce Gottlieb design flowers for top restaurants, the Chanel boutique, Bulgari, and a host of hot hotels. Orna's style: dramatic, simple, and elegant, often monochromatic. Fresh seasonal flowers are in abundance here.

palette, shocks the senses, and delights the eye. Fortunate is the guest who is taken by Keller on a seventeen-course culinary journey, and who spins out into the dewy, fragrant restaurant garden long after midnight. Gazing up at the bright stars, inches above, I thank the universe for Keller's dedication, art, and craft.

RAYON VERT
3187 Sixteenth Street at Guerrero
(415) 861-3516

Stop in at this antiques/style/flower shop and ask Kelly for her recommendations. Arrangements are wild and original, brimming with Queen Anne's lace or white garden roses and euphorbia—or a romantic bouquet of palest pink peonies or purple regale lilies. If the shop's open, the sign says OPEN, and if it's closed, the same letters rearranged signal NOPE.

ROSE & RADISH
460 Gough Street
(415) 864-4988

Here you'll find lovely people and boldly beautiful flowers, often in fearlessly constructed forms. They'll find the richest red roses and the prettiest and sweetest jasmine or hyacinths.

VERDURE
(510) 548-7764 (by appointment)

Devorah Nussembaum's taste is for luscious, loose, lovely, and romantically tangled arrangements, with the freshest flowers in season. Hellebores, clematis, vines, and garden roses are all ingredients in her lovely bouquets.

GREENS
Fort Mason (Bldg. A)
Entrance from the foot of
Buchanan Street
(415) 771-6222

The original and still the best vegetarian restaurant, Greens offers pure vegetarian fare in a sunny bayside setting.

KABUTO A&S
5121 Geary (16th Avenue)
(415) 752-5652

Sachio Kojima and his family run this friendly neighborhood sushi restaurant with spirit and humor. Traditional and playful sushi are spectacular, and the sake list shines with exceptional selections.

MASA'S RESTAURANT
648 Bush Street (at Stockton)
(415) 989-7154

Pure flavors, expert classical French technique, and beautiful presentation have become hallmarks of executive chef Ron Siegel. The Masa's dining experience is graced with unparalleled service and a wine list that reads like a timeline of the world's best vintages. Masa's inventive desserts and *mignardise* cart created by Masa's pastry chef Keith Jeanminette, features innovative creations, as well as house-made lollipops, petits fours. The ultra chic interior decor is by Orlando Diaz-Azcuy.

OLIVETO
5655 College Avenue
Oakland
(510) 547-5356

Chef Paul Bertolli celebrates seasonal cooking with extraordinary menus showcasing organically grown vegetables.

ROXANNE'S
320 Magnolia Avenue
Larkspur
(415) 924-5004

Vibrant chef/owner Roxanne Klein is a pioneer in seasonal, healthy, sensual cuisine. She and her talented team create 100 percent organic, vegan foods: all raw, all artfully presented. Extensive wine list. New: Roxanne's To Go juice bar and delicatessen.

SLANTED DOOR
1 Ferry Building
Embarcadero (at Mission Street)
(415) 861-8032

Charles Phan, who developed a ravenous following for his modern Vietnamese cooking, works passionately with fresh local ingredients, sensual textures, and lively flavors. The curvy new outdoor/indoor architecture is by Olle Lundberg.

TABLESPOON
2209 Polk Street (near Vallejo Street)
(415) 268-0140

Chef Robert Riescher and his youthful team enliven this sleek space alongside Swallowtail, a favorite neighborhood antiques shop. Riescher confidently creates memorable dishes honoring seasonal fare. Great artisan cheese selection.

ZUNI CAFE
1658 Market Street
(415) 552-2522

Chef/owner Judy Rodgers creates memorable rustic Italian-inspired menus honoring California's best organic produce and grains and the freshest fish. Zuni is the San Francisco chefs' favorite for supper. Locals come late afternoon for a Chardonnay or Pinot Grigio—with matchstick French fries—or a compelling assortment of cheeses with superb accompaniments.

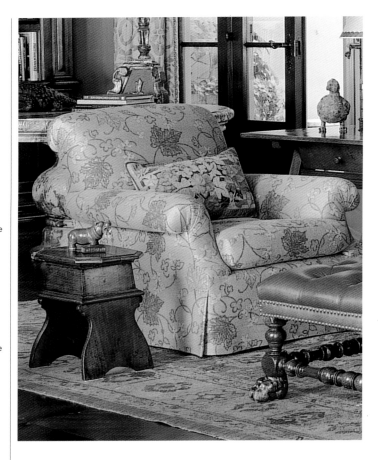

ACKNOWLEDGMENTS

A design book is enriched and enlivened by the style, passion, gifts of the spirit, and creativity of many people. I would especially like to thank the highly talented interior designers for their devotion to polished, superb, eccentric, lavish, spare, worldly, poetic, and quirky interiors.

To their fortunate clients, merci.

At Chronicle Books, I have had the pleasure of working with Leslie Jonath, Vanessa Dina, and the meticulous and witty Laurel Mainard. Bouquets to these talented and engaging women.

Madeleine Corson and her staff created the crisp, elegant and classic book design.

It has been a great pleasure working with David Duncan Livingston (between his trips to Hawaii), and I appreciate his devotion to this project.

To my friends and family who have encouraged me from Book One to this, Book Fourteen, I send love.

Renata Adler said that there are certain things one cannot do alone: conspire, be a mob or a choir or a regiment. Or elope. To her eloquent list, I would add … or write a book.

—DIANE DORRANS SAEKS

STYLE IS THE RECORD OF POWERFUL EMOTION REACHING THE SURFACE THROUGH FINE CONSCIOUSNESS, NETS OF RESTRAINT, CAUTION, TACT, ELEGANCE, TASTE, EVEN INHIBITION—IF THE INHIBITION IS NOT WITH-OUT HONOR.

—Arthur Quiller Couch

INDEX

CLASSICS ❖ DESIGNERS ❖ ARTS ❖ COLLECTORS ❖ CL

DESIGNERS ❖ ARTS ❖ COLLECTORS ❖ CLASSICS ❖ D

RTS ❖ COLLECTORS ❖ CLASSICS ❖ DESIGNERS ❖ ART

OLLECTORS ❖ CLASSICS ❖ DESIGNERS ❖ ARTS ❖ COL

CLASSICS ❖ DESIGNERS ❖ ARTS ❖ COLLECTORS ❖ C

DESIGNERS ❖ ARTS ❖ COLLECTORS ❖ CLASSICS ❖ D

RTS ❖ COLLECTORS ❖ CLASSICS ❖ DESIGNERS ❖ ART

OLLECTORS ❖ CLASSICS ❖ DESIGNERS ❖ ARTS ❖ COL